TALKING PHOTOGRAPHY

Viewpoints on the Art, Craft and Business

Frank Van Riper

W9-BYK-989

ALLWORTH PRESS
NEW YORK

07 06 05 04 03 02 5 4 3 2 1

Published by Allworth Press
An imprint of Allworth Communications
10 East 23rd Street, New York, NY 10010

Cover photo by Frank Van Riper
Cover and interior design by Joan O'Connor

Page composition/typography by Sharp Des!gns, Inc.

ISBN: 1-58115-208-6

Library of Congress Cataloging-in-Publication Data
Van Riper, Frank.
Talking photography : viewpoints on the art, craft, and business / by
Frank Van Riper.
p. cm.
ISBN 1-58115-208-6
1. Photography. I. Title
TR145 .V26 2002
770—dc21
2001005811

Printed in Canada

Dedicated to the memory of
Lars-Erik Nelson (1941–2000)
Colleague and cherished friend;
artist of life and the newspaper column.

Contents

SHOOTING PEOPLE

TECHNICAL TIPS

PRACTICALLY SPEAKING

EQUIPMENT: THE GOOD, THE BAD, THE BASIC, THE CLASSIC

Introduction

I inherited what talent I have as a writer from my father. But if Pop taught me to appreciate everyone from Shakespeare to Hemingway, and to revel in the rhythm and music of the spoken and written word, so did my mother casually, enthusiastically—subversively—turn me into a photographer.

It's not that she was a good photographer. She could cut heads off with the best of them. But my mother instinctively appreciated the camera's ability to record, and therefore to stop, time.

Film never stayed in her camera from one season to the next. She was always there taking snapshots at every holiday, every family gathering. What her images may have lacked in technical expertise, they made up for in immediacy.

Without ever telling me how or why, she made me appreciate photography—just as her listening to the Metropolitan Opera on the radio every Saturday as she cleaned our apartment in the Bronx instilled in me the same love for this music.

As I grew up I gravitated to journalism—again, a natural progression given my father's unrequited love for a field that he never was able to enter. For more than two decades I made my living as a reporter in the Washington Bureau of the *New York Daily News*, at the time the largest newspaper in the country. Given journalism's natural affinity for words and pictures—hell, the *Daily News* back then even was called "New York's Picture Newspaper"—you would think that my photography and my writing would go hand in hand.

But they didn't.

In 1968, during my first presidential campaign, I made a black-and-white picture of Vice President Hubert H. Humphrey, informal and in shirtsleeves, as he spoke to us on his press plane after a cross-country-and-

back campaign swing just weeks before the Democratic National Convention that would nominate him for President.

That picture—along with an agate type credit line—accompanied the full-page op-ed piece I did about the trip, one that I wrote "had everything: cheers, jeers, kisses, celebrities, arm twisting, fence mending, pickets, and noise."

The byline on the article was huge, but I got more of a kick out of that tiny photo credit.

When I went in to work the day the piece ran, expecting the congratulations of my colleagues, my bureau chief Jerry Greene, a retired Lieutenant Colonel in the Marine Corps, grimly called me into his office.

"Don't ever do that again," Jerry said to me.

It seems the staff photographers in New York, miffed at the temerity of a reporter also toting a camera, had threatened to file a union grievance over my photograph. Except for one other time, when I photographed a convicted murderer in a maximum-security prison hospital, I never again made a picture for the *New York Daily News*.

Which goes a long way to explaining how delighted I am to introduce a collection of my photography columns.

As a writer who also is a photographer, and a photographer who also is a writer, I have the rare pleasure of once again putting into words what I put in my pictures. Or put another way: while I do not think it is unusual for a photographer to be able to write eloquently about his or her pictures, I do think it is rare for a professional writer also to be a professional photographer.

Part of the reason is tradition—and common sense. On newspapers especially, producing what amounts to a small novel every day requires a huge division of labor. It simply would not work for a photographer on deadline to have also to write the story, or vice-versa. And, frankly, the individual who could do both these jobs would be unusual.

What I think I bring to the table here though is an ability to write about photography from the inside: from the perspective of an actual working photographer. Make no mistake: my wife and partner Judy and I make our living by making pictures. We have shot everything from annual reports to weddings and have done so for nearly twenty years. I am proud, as an ex-reporter who once was forbidden to shoot, that my photography now is in the permanent collections of the National Portrait Gallery and National Museum of American Art, and that my book, *Down East Maine/A World Apart*, was nominated for a Pulitzer.

I began writing the photography column in the *Washington Post* almost by accident. In 1992, David Hoffman, then a *Post* White House correspondent and avid amateur photographer, had been doing the column for a couple of years when his dream assignment came through: a posting to the Middle East.

You're the only guy in Washington who can write this column, David told me.

But I turned him down, thinking I already was too busy, with my first photography book, *Faces of the Eastern Shore*, about to be released.

Judy, wise as always, urged me to give it a try, knowing how much I loved writing and sensing a perfect blending of two things I love: photography and words.

That was in the summer of '92 and I have been at it ever since, first in the *Post*'s Friday Weekend section, and now online and worldwide in the Camera Works section of *Washingtonpost.com*.

This is a distillation of my favorite columns and other photography writing since that tentative beginning. It has been fun selecting my greatest hits. I hope you enjoy them too—and leave humming the tunes.

FRANK VAN RIPER
Washington, DC
2001

SECTION I

State of the Art

A Few Days in the Life

One thing about being a professional photographer: Your days are varied. They can be hectic, maddening, and frustrating—and exhilarating, challenging and exciting. Earlier this month, the work my wife and partner Judy and I did on three successive days illustrated this better than any lecture I could give on what it's like to make your living with a camera:

SUNDAY, OCTOBER 3

Another wedding. Nothing unusual there since we do about fifty a year, concentrated for the most part into a mad spring and fall—when our friends know better than to invite us to anything on a Saturday or Sunday.

This wedding was the second of the weekend for us, and it took place on one of those days every bride hopes for—pleasant temperatures and picture-book skies. It was an outdoor affair and the music was provided by an energetic Jamaican steel band. The wedding couple was delightful, and Judy and I pretty much cruised through it. An enjoyable job, but nothing much out of the ordinary.

MONDAY, OCTOBER 4

Portrait shoot with actor Martin Sheen. Now this was more like it—a chance to play a bit and make some good pictures for the client, as well as a few keepers for the portfolio. Sheen was in town for the premiere of his new film, the Civil War flick *Gettysburg*. Sheen used the trip to D.C. also to record a series of public-service announcements for Refugee Voices, a Washington-based organization that raises money and monitors refugee issues worldwide.

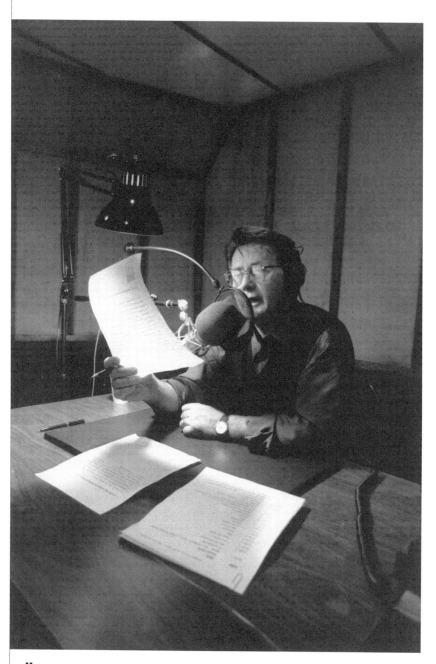

High-speed black and white film and harsh downlight combine for a gritty, dramatic portrait of actor Martin Sheen as he rehearses a public service radio announcement. I was able to work quickly and unobtrusively, leaving the booth when Martin was ready to record.

Two radio spots and the voice-over narration for a slide show were to be recorded at a local studio, and I'm happy to say that not only did the spots turn out great, but the pictures did as well. And through it all, Sheen was a gravelly voiced teddy bear.

Refugee Voices was my client and they wanted photographs of Sheen at work—as well as maybe a few shots of the staff with the big-time Hollywood actor. Knowing that a recording booth can present a stark, harshly lit backdrop, I wanted to capitalize on that for my own photographs, but chose to use ultrafine-grain Ilford XP-2 as well as a bracket-mounted flash for the client's pictures, to even out the light.

For my stuff I decided to shoot available light using Kodak T-Max 3200 rated at 800 to minimize grain. As I suspected it would be, Sheen's face was lit by a harsh downlight that illuminated not only his script, but his facial lines—the effect I wanted. I carefully metered his face with a spot meter and photographed directly in the booth with him, as he rehearsed before each spot.

Though the job only lasted a couple of hours, everyone got what they wanted. I love it when that happens.

TUESDAY, OCTOBER 5

All day doing interiors followed by an unsettling phone call. If the Martin Sheen job was reasonably quick and simple, this day was just the opposite. The client was a family-run architecture/construction firm in need of beautiful pictures for a new full-color brochure. Judy and I already had made site visits and had a rough idea of what was in store. For today's job, it meant doing at least half a dozen lighting setups, both exterior and interior, at a lavish Potomac residence that featured an Olympic-size swimming pool attached to the house and covered by its own pool house, as well as a renovated kitchen that included its own fireplace.

Our lighting ranged from studio strobes and tungsten floods to small Vivitar 283s and Morris Minis artfully hidden and remotely triggered. You don't just point and shoot a job like this; you burn a lot of Polaroid film making sure all is perfect before you make the actual photographs. By six in the evening when we finished, Judy and I were exhausted, but happy.

By day's end, all we wanted to do was order in some Chinese food, watch a little TV, and go to bed early. But it wasn't to be. After I ordered the fried rice and garlic chicken, Judy started returning phone calls. Suddenly, the operator broke in: "Could you please hang up in order to take an emergency phone call," the operator said, mentioning the name of the caller.

Judy's heart would have been pounding even more, but she recognized the name given as that of a former client.

The client was a guest at a posh, black-tie dinner thrown at the F Street Club to mark the seventy-fifth birthday of Robert Strauss, the for-

mer U.S. ambassador to Russia, confidant of presidents and one-time head of the Democratic Party. Seems the decision to hire a photographer wasn't made until the last minute, after Hillary Clinton had shown up, raising the prospect that the president might appear as well. So assorted underlings, their lives doubtlessly flashing before them, were falling over themselves calling hotels and who knows how many other places trying to shake loose a shooter for the event.

"I'm going to make one phone call," our former client said, "and if these people are gracious enough to come down here on such short notice, you'll be fine."

We got dressed again and raced out the door. Hillary had gone by the time we arrived—Bill never did show up—but there were enough political, showbiz, and media heavies to keep us busy a good while.

Once more, the gods smiled and the pictures turned out great. And the fried rice and garlic chicken tasted even better 'round midnight.

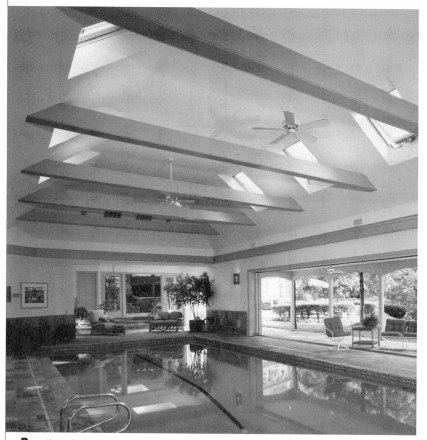

Beautiful indoor swimming pool shot required multiple strobe lights and careful balancing of indoor and outdoor light. It was a long day—and would shortly become a long night after an unexpected phone call from a former client. (© Goodman/Van Riper)

The Fictionalized Photograph

02/18/94

I am looking at an 8" × 10" glossy of Ted Kennedy deep in conversation with former CBS anchorman Walter Cronkite at a Washington reception. I made the picture several years ago at a dinner honoring the then-chairman of the Democratic Party, Paul Kirk.

It's a perfectly ordinary picture, except for one disturbing fact. Cronkite was nowhere near the dinner that night. The photograph is a fake. Only when I look at what I know to be the original photograph—of Kennedy deep in conversation with a much younger, much thinner man wearing the same suit, gesturing with the same hands—is it obvious that the Cronkite picture is bogus.

I am amazed at the degree of computer magic that went into making the new picture, but I am disturbed as well.

Doubtless because of my own background as a journalist, photography has always seemed to me first a medium of reportage and of story-telling. It literally is the only one of the visual arts in which the subject depicted determines absolutely what that depiction will be. Put simply: A painter can create an image from memory; a photographer cannot. For this reason photography has gained a reputation for truth-telling ("the camera never lies," though in fact the camera always lies by translating a three-dimensional image into one of only two dimensions).

Ever since the halftone printing process permitted the quick and mass dissemination of photographs, a picture in a newspaper or magazine was a kind of editorial underpinning for the text it accompanied. A reporter might, through ignorance or intent, slant a story, but the picture was there—"in black and white"—to give the reader a reasonably objective look at the players involved, or the action or object described, the better for the reader to reach an opinion.

Now, however, even photographs can be suspect. The ease with which an image or negative can be scanned, its final incarnation altered, has cre-

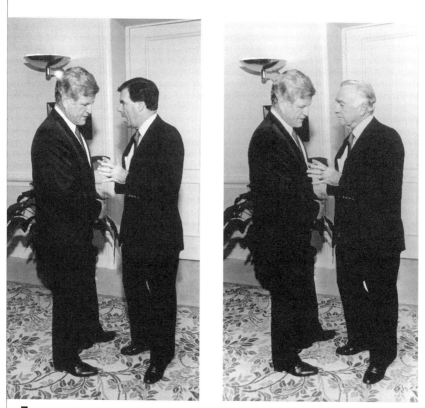

The fictionalized photograph. It took computer whiz Andrew Child less than thirty minutes to stick Walter Cronkite's head onto another man's body and make it appear as if the ex-CBS news anchor was deep in conversation with Ted Kennedy. The process is as amazing as it is chilling in how photographs will be perceived from now on as vehicles for the truth.

ated an understandable uproar among journalism ethicists. It's not that an evil cabal of editors is putting bags under Hillary Clinton's eyes every time she appears in the paper, or that the Pope is shown dancing at a nightclub in Paris when in fact he was saying Mass in Rome.

The fear and uproar is over the fact that these admittedly farfetched examples could happen, so sophisticated has digital manipulation become.

For example, when my friend and colleague Andrew Child agreed to work his magic on the Kennedy photo, it took him maybe all of thirty minutes. Basically all he did was scan the original picture and another picture (of Cronkite at a totally different function), and electronically substitute Cronkite's head for the original.

Incidentally, Cronkite's head was facing the wrong direction. No problem: Child "flopped" it with the push of a button. For good measure, he enlarged the body of the man talking to Kennedy to make it look, as Child put it, "more Cronkitely"; electronically changed the shading on

Cronkite's face to match the angle and direction of the light on Kennedy's; and even matched the tone of Cronkite's face with that of the younger man's hands.

I defy anyone to look at the picture and not believe it is real.

It used to be commonplace for totalitarian regimes to remove "nonpersons" from official photographs or to otherwise manipulate images, often with laughable crudeness. Now, obviously, the same can be achieved seamlessly, quickly, and almost effortlessly. The computer doesn't care—and it doesn't leave fingerprints.

This is one reason there was such hell to pay a few years back when *National Geographic*, for purely aesthetic reasons, digitally moved one of the great pyramids of Egypt so it would fit better on its cover. If a magazine of the caliber of *National Geographic* could manipulate an image anonymously and with impunity, argued the ethicists, it would not be long before every image in the public press could be suspect.

Outlandish though it might seem, the same drive for a compelling picture that produces a shot of Bill Clinton deep in conversation with an extraterrestrial in a supermarket tabloid is also what may entice a serious picture editor to remove an extraneous person from the middle of a group photo, or to truncate or expand an image to better fit onto a page. It is worth noting that, because of this potential for abuse, major publications, including the *Washington Post*, have forbidden the use of electronic manipulation on any photographs in their pages.

Years ago, author Truman Capote, using the brutal murder of a Kansas farm family as his basis, blended his talents as both a novelist and a journalist to create a chilling masterpiece of reportage, *In Cold Blood*. He created the "nonfiction novel." Now, the technology of computer manipulation has given us the ability to create the fictionalized photograph.

There is no denying that computer imaging is becoming not only a way to change or improve upon the silver image, but an entire art form as well. Nevertheless, photographers should realize that anything that removes the "photographness" of their pictures not only can change their work, but diminish and devalue it at the same time.

Should the day ever come when photographs in mainstream newspapers or magazines are greeted with doubt as to their content or origin, something terrible will have happened to our democratic free press in the name of higher technology.

Hunting for Bear with a Hasselblad, Part 1

04/07/95

The joke among the field biologists in Maine's Department of Inland Fisheries and Wildlife is that, when tracking bears in the snowbound North Woods, you go until your truck gets stuck, switch to snowmobiles until they get stuck, then switch to snowshoes until you get stuck.

Actually, I misspoke. It's said only half in jest, as I found out last month when I accompanied a team of hearty souls to Ashland, Maine, (near Presque Isle and Caribou) as they conducted their annual survey of Maine's black bear population in the most sophisticated animal survey of its kind anywhere in the country.

It also was the most difficult location shoot of my life.

My team leader was Randy Cross, a strapping, loquacious thirty-six-year-old whose love of the great Maine outdoors led him to field work some thirteen years ago. It's a measure of the folks you meet up there that Cross ate no store-bought meat through much of his childhood—all that his family needed they either grew, cultivated, shot, or fished.

My goal this trip was to make black-and-white portraits of Cross and his colleagues for my book on Down East Maine. Located far north, Ashland is not really Down East—my strict definition covers only the state's two easternmost counties. But I fudged a bit because Cross's base of operations is Bangor, which is in my narrow "circulation area." And, besides, for pictures of cuddly bear cubs, who wouldn't disregard geography?

As I had for previous winter trips to Maine, I traveled as lightly as I could because I was going by plane and could not risk being separated from things like light stands and tripods that I would have checked as luggage. Also, I only could bring what I could carry with me into the dense, snow-packed woods once we took our snowmobiles as far as they could go and switched to snowshoes.

If I mention snowmobiles with the casual aplomb of someone used to

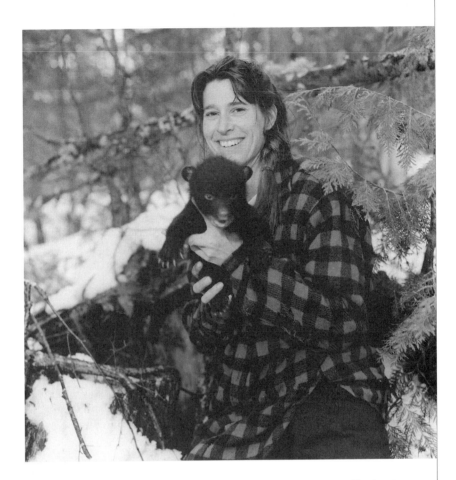

It may have been the most arduous location shoot of my life, but with pictures like these to show for it (of field biologist Lindsay Tudor cuddling an infant black bear) the trip was well worth it. (Note: Fill flash on camera helps open up shadows and show detail on bear.)

careening down ice-covered logging roads at up to 40 mph, it's because I'm lying through my teeth. There was nothing casual about the first time I ever drove one of these things. Cross's lesson lasted maybe fifteen seconds ("To go, you squeeze this; to stop you squeeze this") and I spent the first harrowing minutes on my "Arctic Cat" trying to avoid a quick and embarrassing death—or at least trying to keep my bungee'd camera bag full of Hasselblads and lenses from jumping out of the Cat's rear basket onto the cold, hard ground.

My padded Tamrac bag was loaded with thirty-one pounds of gear: one Hasselblad 500C/M body, three lenses (the "normal" 80mm, a wide-angle 50mm and a 150mm portrait lens), a Hasselblad Super Wide C/M, two twelve-exposure film magazines and eighteen rolls of Ilford XP-2

black-and-white film. I also carried a Polaroid back and five ten-exposure packs of PolaPan 100 black-and-white proofing film.

Lighting for this job was to be rudimentary—a lone Vivitar 283 flash unit with a plastic bounce card. Of necessity, I'd be relying a lot on available light.

Ours was a four-person team. Besides Cross and myself, there was Lindsay Tudor, a biologist whose expertise includes not only bears but birds, and Duggins "Doogie" Wroe, a field technician who has tracked and surveyed wildlife not only in Maine but in the American West.

The initial foray into the woods, on a cold, overcast day, proved both arduous and frustrating. We were guided by a hand-held receiver that picked up signals from the battery-powered transmitter on each tagged bear's neck collar. Deciding on one promising area, we trudged more than a mile into the woods, following an ominously uniform signal. Each bear's transmitter is sensitive to motion and will vary its signal whenever a hibernating bear moves in its sleep. The fact that our bear's signal never varied meant a dead bear—or worse. When we finally reached our destination, and Cross began digging to find the den, we found out what that meant.

There, a few yards down, was, not a hibernating bear and her cubs, or even a dead bear, but a broken collar that probably had been caught in a branch or tree limb and torn off. Our trip had been futile.

Despite the cold, I was soaked through with sweat. I had yet to see—much less photograph—my first bear. The light was failing and the weather was turning nasty. Next week: Ursa Mama and her young.

Hunting for Bear, Part 2

04/14/95

"Let's find Frank some bear cubs," Randy Cross said to his colleagues after we had spent hours trudging—first on snowmobiles, then on snowshoes—through the dense woods only to find a torn transmitter collar—and no bears.

It would be my last chance to photograph the annual survey of Maine's black bear population, and I was hoping luck would be with us.

It was. We found a hibernating mother bear and three newborns curled up in a huge, rotted-out cedar trunk, not even a half mile from the road. But as we neared the site, drawn both by the beeping of Mom's battery-powered collar and the audible cries of her three cubs, a near-freezing drizzle began to fall. Just what I needed as I screwed my Hasselblad and portable flash unit onto a bracket and tried not to get in the way of the survey team, or fall over my own snowshoe-clad feet into the hip-deep snow.

The field survey is vital to estimating Maine's black bear population. Conducted every winter, it enables Maine's Department of Inland Fisheries and Wildlife to extrapolate the bear population throughout the state and also help determine the number of bears that can be taken during the fall hunting season. I was there to photograph the operation for my book on Maine—provided I could keep my glasses and lenses from fogging, shield my equipment from the rain, and not drop the Hasselblad's film magazine into the snow each time I reloaded. It was like working underwater with blinders, and with weights attached to both feet. Cross's first goal was to anesthetize the mother bear, that lay in partial hibernation in the century-old trunk, her wide-awake young huddled beside her. He readied a spring-loaded dart stick and gingerly lowered it down the hole, then stuck the bear in the rump. She let out a startled growl but fortunately didn't come roaring out of the tree trunk. (When I first approached Randy about this job months earlier, by phone from my com-

fortable home in Washington, I thought I simply was voicing the obvious when I asked: "Now Randy, these bears are asleep, right?"

"Well, fer the most paht," he replied.)

How dangerous are black bears? Though not as aggressive or large as grizzlies, they nonetheless are "killing machines," Randy reminded me as I tried to stay upright in the frozen woods while we waited for the anaesthetic to work. The bears' jaws are like vises, Cross said, and their long claws knife sharp. It's not for nothing that each survey team leader carries a loaded .357 Magnum on his hip.

"We'll wait ten minutes and see how she's doing," Cross said. Because he only could reach the bear's fat-laden hindquarters, there was a chance the anesthetic would dissipate into her fat, not her bloodstream. To be on the safe side, he gave her a second shot. That did the trick.

With the bear out cold, Cross and his colleagues, Lindsay Tudor and Doogie Wroe, reached into the tree trunk and brought out the squealing cubs. Barely a foot long and not at all happy, the cubs clambered frantically over the team members but quickly calmed down when they were held close and protectively.

Because my movement was so restricted, I relied on my Minolta Spotmeter F to calculate exposure. It let me stay put and read light reflected from my subjects. It also served as a flashmeter when I hooked in my portable strobe. I could not have made pictures without it.

I wound up using my "normal" 80mm lens throughout the shoot—as the team weighed and measured each bear, tagged the cubs' ears with numbered plastic markers and gave the mother bear (now snoozing on a tarp outside the den) a teeth-to-tail examination. It was during this time that I made my best shot: with the exam nearly complete, Randy gently stroked the unconscious sow as Lindsay, kneeling above, cradled the bear's head in her hands—a pietà in the Maine woods.

The only technical glitch I experienced was with my flash—which operated only sporadically in the chill wet rain because it was impossible to keep the flash contacts completely dry. So I just shot the same picture over and over until I was sure I got some with the flash.

With all data collected, mom and her cubs were placed carefully back in their den, but not before each cub was rubbed with a viscous mixture of cedar oil, to mask any human scent they might have picked up during their exam. That final chore done, we began our trek back home.

Exhausted after our thirteen-hour day, we reached our motel and ate a hearty dinner before turning in at 9:30.

Dawn would come soon enough, when, for Randy and his crew, the entire operation would be repeated, until the survey finally was done.

Max MacKenzie Must Have a Great Camera

ASMP, *Focus*, Spring 1996

The snow had turned into a blizzard and, even in a 4 × 4, the driving was treacherous. The road, in rural Everts township in Otter Tail County, Minnesota, was bad enough, but now it had become invisible. Suddenly, all alone in the howling wind and frigid temperatures, Maxwell Mackenzie lost control of his truck and veered off the road.

He had ventured down the road the previous summer, to make a panorama photograph of the brilliant red Everts township schoolhouse—abandoned now like so many of the other stark wooden buildings in this rugged corner of the world—and wanted to see how it looked in the winter. He found out and, in the process, got himself stuck in a snowdrift.

There was nothing else to do. He made the picture.

Then after stowing his gear and laboriously digging out, he drove to someplace warm.

Over the past decade and a half, Max MacKenzie has earned a reputation as one of the best interior and architectural photographers in the country. A master of elegant light—much of it his own creation—he is hired by deep-pocketed architectural firms, developers, law firms, and others—to show off their wares or their workplaces. He works in large format almost exclusively and mixes or manufactures light sources with a sorcerer's skill. He collects magazine covers the way kids used to collect baseball cards and speaks about them with the same exuberance.

Yet it's a safe bet that the work for which he will become famous will not be his views of conference rooms where $400-an-hour lawyers pile up their billable hours. He will be known instead for the work he is producing now, of unpeopled spaces where no one does lunch.

The recession of 1991 and early '92 took a great toll on freelance photographers. Some wound up taking second jobs to pay their bills; some quit photography altogether. Happily for MacKenzie, the downturn in his

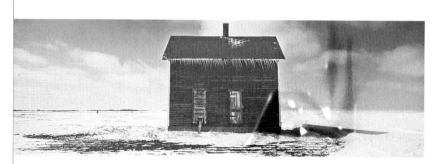

It takes more than a good camera to make images like these. It takes a phenomenal eye and a sense of composition—as well as being in the right place at the right time. (© Maxwell MacKenzie)

flourishing architectural photography business gave him the chance to pursue a life's dream: to document the poignant decay of the farmhouses, barns, churches, and schoolhouses of his native Otter Tail County, Minnesota.

"When you work for other people, shooting what they want . . . you get more and more hungry to do your own thing," Max said. "So I sort of stored it up. And the only reason I did this was that the recession came and all of a sudden I had time. Nobody wanted me to shoot anything, so I said, 'Hell, I'll shoot my own thing.'"

"Luckily, I had saved enough money that I really could take a couple of months off, and that's when I did half the shoot—in the summer of '92. We were out there for eight weeks. Then, in the winter of '93 I went out there for ten days, and in the summer of '93 I completed it."

The pull of rural Minnesota came naturally to MacKenzie, a native of the land, whose Scandinavian forebears had come to it more than a century before. Among the thousands who braved the unforgiving frontier on the edge of the Great Plains, near the North Dakota border, was MacKenzie's great-grandfather Lars Erick Lundeen, who emigrated to Otter Tail County from Norway in 1880.

"As I drove the hundreds of back roads," Max wrote in the preface to his book, *Abandonings*, "I felt the need to document some of what remains before all traces disappear and we have no reminders of what went before. . . .

"To me, this landscape and these buildings—sad, empty, silent houses and falling-down barns—possess a profound beauty, not merely for their spare, simple designs and weathered boards, but as monuments to the men and women who, like my own ancestors, made long journeys and endured great hardships to reach this remote part of America and build in it a new home."

The body of work he produced over the course of two years—a massive and beautiful archive of abandonment—was published by Elliott &

Clark last year to rave reviews. That success, coupled with the sheer joy of working this way, prompted MacKenzie to immediately plunge into panoramic photography of rural primitive architecture in Europe. He dubbed that body of work "Origins," and hopes it will form the nucleus of his next book.

And only a few weeks ago, MacKenzie received the best kind of reinforcement one can get after investing years of money and effort in a personal project: Lands' End, the mega-outdoor outfitter, commissioned him to make moody panoramas of rural Wisconsin to grace its glossy catalogs.

Every so often, Max noted, someone who is not a photographer will look at one of his huge prints (some as wide as eight feet) and say, "You must have a really good camera."

"Does anyone ever go to a writer like, say, John Updike, and say, 'You must have a really good typewriter'?

"Technique has nothing to do with it, really."

Well, yes and no.

If technique means only knowing which button to push on the Fuji 6 × 17 camera that Max uses for his panorama work, then, no, it has nothing to do with the final outcome.

That comes from the heart—and from decades of learning to see. Still, it's a long and expensive learning curve when you're shooting on your own dime. "I've got about three loose-leaf binders of crap," Max laughed during a conversation at his Washington home, where he lives with his wife, artist Rebecca Cross, their two sons, and one gloriously rambunctious Jack Russell terrier.

In fact, the first images for what ultimately became *Abandonings* were made in 1990 and '91 in 35mm. They were nothing special. "I found it didn't work for me," MacKenzie recalled. "I was getting the building, but I wasn't getting the feeling of the horizontal landscape out there. So I bought the camera."

"The camera," the massive Fuji 6 × 17, eats up 120 roll film like so much popcorn—four shots per roll. The early model 6 × 17 that Max bought, with a fixed 105mm f/8 Fujinon lens, set the photographer back some four grand—and the damn thing didn't even have a rangefinder, only a barely adequate viewfinder. ("I didn't use the first thirty rolls I shot because I cut off the tops of the buildings.") Still it offered the size of image that could produce massive exhibition prints showing every nail and splinter.

To overcome the composing problems, Mackenzie put himself through a tortuous regimen each time he shot. After guessing at an initial camera position, he would open his empty, tripod-mounted camera and insert a 6 cm × 17 cm piece of vellum onto the film plane. Then he would place a focusing cloth over his head and view the image transmitted through the lens onto the vellum—upside down, of course—so he could achieve the exact composition he desired. Only then could he load his camera and shoot.

A maddening ritual, especially when the light is changing before your eyes, or when you're shooting in the middle of a blizzard.

"You can ruin your camera," Max noted, recalling that day in the snowdrift. But fortunately for him, the brutal cold of a Minnesota winter tends to be dry as well. Snow will pile up on your equipment, but it won't melt. Of course that also meant he had to keep his car as cold as possible, so he wouldn't emerge into the freezing temperatures with warm gear that would invite condensation and snowmelt. "But try threading the !@#* film that way!" MacKenzie said, remembering his frozen, sluggish fingers.

To cover every exposure option, Max shot almost every image on both color negative film and slide film (Fuji Reala and Velvia, respectively). With no option of interchangeable backs, he had to first shoot with one film, bracketing exposures, then quickly reload with the other before the light changed appreciably. Add to this the fact that he made most every shot both with and without warming filtration (along with a polarizer to intensify color). Sometimes, especially near sundown, when light can drop like it's falling off a table, he'd only be able to make a shot on color neg.

How much film do you burn this way? For the twenty-eight images that appear in *Abandonings*, MacKenzie estimates he shot five hundred rolls.

In producing the panorama images of rural primitive architecture in Europe, some of it centuries old, MacKenzie still relies on transparency and negative film. But now, thanks to generous support from Theo Adamstein of Georgetown's Chrome, Inc., Max's transparencies are now translated into massive and beautiful cibachromes by master printer Lisa Missenda. The largest of these are 12" × 38"—the largest size Chrome can accommodate. Though it would be nice to have eight-foot-wide C-prints, of the type Dodge Color produced for him for the *Abandonings* exhibition, Max noted that printing and archivally framing one of these images can cost him upwards of $1,600 each. You have to sell a ton of books to recoup costs like that, and even though *Abandonings* is now in its third printing, it goes without saying you do not get rich doing this kind of work.

Which is why the call from Lands' End was so welcome.

The great architect Frank Lloyd Wright once wrote that, "The true basis for any serious study of architecture still lies in those indigenous, more humble buildings everywhere that are to architecture what folklore is to literature and folk song to music."

Notes MacKenzie: "What we're building now seems to me to very rarely have any grace or beauty. . . . These [structures in *Abandonings* and *Origins*] were made by people one stick at a time" and reflect a sense of permanence and worth rarely found in today's glass and chrome behemoths.

Obviously, these simple, eloquent structures won't last forever. But at least now we have pictures.

Portraits Under the Big Top

08/02/96

I never wanted to run away from home and join the circus, but I do have fond memories of seeing the Ringling Bros. show in Madison Square Garden when I was a kid.

Fast forward forty or so years and there I am standing near the center ring of the Ringling Bros. and Barnum & Bailey Circus, making color portraits of the ringmaster under the watchful, not to say hungry, gaze of several Bengal tigers. (I love this job!)

Ringling had hired us to make portraits for a series of recruitment brochures for some of the many behind-the-scenes jobs that help make the circus magic happen. The first day of the shoot was basically a bunch of location portraits in an office building—nothing out the ordinary, right? Normally, no, but Ringling's corporate headquarters in Vienna, Virginia, are anything but ordinary. Get off the elevator at the main reception desk, and you are confronted with a riot of color and clowns. Larger than life clown faces adorn the walls above the receptionist, the staircases look like calliopes, and the entire reception area is dominated by a miniature old-time circus train. This is going to be fun, I thought, and it was.

We spent the better part of a day photographing in various locations throughout the building, trying to incorporate as much of the colorful surroundings as we could. It was the opposite of what we often do on a corporate job—trying to eliminate as much boring gray background as we can. But the best part of the job—and the biggest challenge—was to come the next day, when we moved cameras and lights to the D.C. Armory to photograph with the circus as a backdrop.

Though we were not there to photograph the acts, the ambience and atmosphere were vital to our pictures. For one shot, which required a lot of timing, we photographed one of the circus road managers—Filofax and walkie-talkie in hand—as she stood near a concession stand, the action of the show visible over her right shoulder. Because this was a live

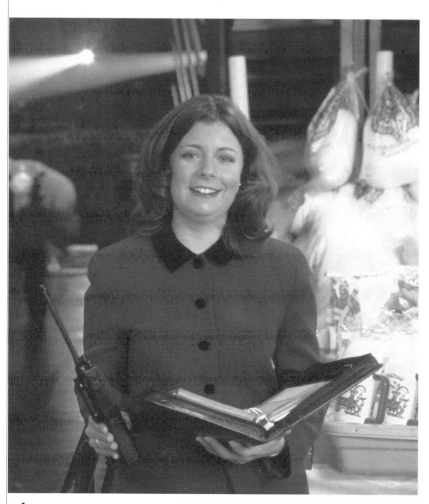

It may look like a straightforward shot, but there was chaos all around us as we made this picture for Ringling Bros. Because we could not block fire lanes during this actual circus performance, we relied on only one strobe light and used as slow a shutter speed as we possibly could to bring up the light behind our subject. After this shot, we played with the tigers. (© Goodman/Van Riper)

show, and spectators were walking in and out all the time, we had to keep our equipment out of the fire lanes. We used one studio strobe unit fired through a white umbrella and waited until the distant circus action was bright enough and still enough to register during a long exposure. It took several tries, but we got some great stuff. The subject was lit beautifully by the strobe, and the long exposure—some as long as a quarter of a second!—registered the background as if we had lit it ourselves.

This was almost the same procedure we used for the ringmaster portrait after the show, but the setup was more elaborate and the surroundings more interesting. As the armory emptied of people and the circus had

some downtime until the evening performance, Washington designer Pat Marshall, who creates much of Ringling's printed material, took us over near the center ring. There, I set up two strobe units and umbrellas, on either side of some colorful platforms. Ringmaster Eric Michael Gillett—who just minutes earlier had bade farewell to the Armory crowd with the stirring cry, "May all your days be circus days!" hung around in his glittery red jacket and high-top boots, waiting for the first test Polaroids. He was to be photographed with Arthur Ricker, a Ringling vice president and senior marketing manager.

I'd asked the crew to put up all the house lights in the Armory. These tungsten-balanced lights would go pleasingly warm in a long exposure using daylight-balanced Fujichrome Provia 100. (As an added bonus, some of the trapeze artists began practicing in the background high above us—circus performers are always practicing—and their blurry forms can be seen in some of the final shots.)

Just as we were ready to shoot in earnest, however, what looked like an awfully flimsy flexible cage was raised to enclose the center ring and out came Ringling's star animal trainer, Mark Oliver Gebel, preparing to put some of his big cats through a practice. Boy, were they gorgeous, and boy, were they big, sitting on their little platforms barely fifteen feet from us.

I had turned my attention to setting my lights when Gebel came over and asked me if I could refrain from moving my light stands. I looked over my shoulder and saw a huge cat following every move I made with more than casual interest.

Needless to say, I quit fooling with the lights and made the picture.

Playing with (Really Big) Trains

09/13/96

Any time a photographer leaves behind the comfort zone he or she is accustomed to—whether it's the studio of a professional, or the home or neighborhood of an amateur—there is the potential for disappointment. Location photography is something of a high-wire act. You're out there all alone, with nothing but your skills (and equipment) to get the job done. A false step can mean disaster—when's the next time you're going to be in that location under those conditions? For a pro, it can also mean an expensive re-shoot.

In most commercial photography, the weather, the client's timetable, and, most important, the client's budget dictate getting the job right the first time.

That's why when we work on location, the trusty sport utility vehicle is filled to capacity with all kinds of gear for who-knows-what kind of contingency.

For four days this summer, my wife and partner, Judy, and I traveled all over Maine, shooting for the venerable Bangor & Aroostook Railroad. By the time it was over, we had used just about every lens, light, and camera we own—and came back with great pictures.

We photographed trains, trestles, train yards, and track, in bright sun, gorgeous late afternoon light, and at dusk, venturing as far afield as Moosehead Lake in Maine's scenic interior, making pictures for the railroad's new promotional brochures and annual reports. Once we even rode a high-rail truck—a truck equipped so it can ride on train tracks—as we lumbered upcountry to an isolated trestle bridge, where we photographed a shiny new B&A engine in the gathering dark amidst a swarm of deliriously happy mosquitoes.

To someone who grew up with a fairly decent set of Lionel trains (and who even fantasized as a kid about being a railroad engineer), this hardly was work at all—though we got back to our hotel room exhausted after

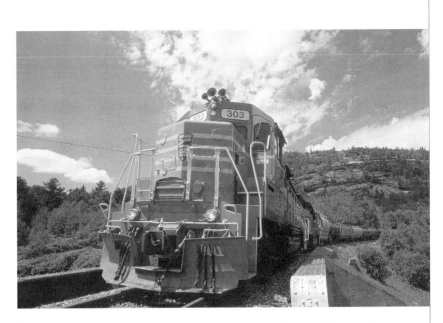

Location photography doesn't get much more enjoyable than this. Perfect Maine weather, accommodating clients—and really big trains to play with. © Frank Van Riper

each day. That'll happen when you spend the day laden with camera gear, climbing on top of boxcars and mountains of logs to get a good angle. At times like these, our 24mm wide-angle lens was a great tool—wide enough to throw things into dramatic perspective from a low or high angle, "normal" enough to render a wide scene normally when held level.

Our first two days of shooting were blessed with the kind of weather Maine is famous for: comfortable temperatures and brilliant blue skies peppered with fluffy white clouds. Our second two days, the following week, were not quite as beautiful—in fact we had to cancel a scheduled aerial shot from a helicopter because of fog, but the other pictures still turned out beautifully.

On location—whether shooting for an annual report or making holiday snapshots—you want as few variables as possible, the better to increase your odds of getting great pictures. We stuck with one familiar film throughout: Fuji's great Provia 100, in both 35mm and 120 format. In 35mm, I consistently rate Provia at ISO 64, finding it gives me the best exposures, especially when shooting outdoors by available light. Indoors, shooting in 120 medium format, I tend to rate the film at 100.

Though in-camera exposure meters are excellent for most shooting, I relied exclusively on my Minolta Spotmeter F for highly accurate pinpoint exposure calculation—especially critical on sunny days when you want to hold detail in the shadows. Most often I would make a reading of the brightest part of the sky, store the reading in the meter's memory, then

read the darkest part of the picture. I'd store that second reading as well, then press a button to get an average reading of both extremes. This provided the baseline exposure from which I worked. I would bracket my exposures one full stop each way in quarter- and half-stop increments to ensure that I would get a decent range of slides from which to choose the keepers.

Indoors—when, for example, we also set up four studio strobes on stands to light a vast shipping dock—we shot test Polaroids to make sure our exposure was on the money.

Once, to render a dramatic shower of sparks from a welder rebuilding a freight car in a fairly dark repair facility, we set up our strobes and asked the worker to stand as still as he could during exposures ranging from a quarter- to a half-second.

It was a great job all around. But we did miss one shot. As we rode in the back of the high-rail truck, trying to keep the mosquitoes out of our faces, someone yelled, "Moose! Moose!" It was a young one, with no antlers, running along the side of the tracks. It ran off before I could get a shot—and frankly, it was too dark to make a picture. But just seeing the great beast was a gift. There were high-fives all around as we headed toward the trestle.

Shooting a Star

(Nailing Hale-Bopp with a Drink in My Hand)

04/25/97

Until a month ago, my only photographic connection with the Hale-Bopp Comet was a magazine assignment to photograph three astrophysicists who were tracking the thing across the heavens with telescopes as long as telephone poles.

I was more than happy to leave photographing the "Comet of the Century" to others—especially after I read a "simple" how-to guide in *Scientific American* that involved building a wooden camera platform, lining it up with the North Star, and gingerly turning the platform every fifteen seconds during a minutes-long time exposure to eliminate pesky "star trails" caused by the rotation of the Earth.

I have a hard time finding the right way on the Beltway, much less the North Star. And I'm really not all that good at building things out of wood. But, wouldn't you know it, I got a great picture anyway—at a wedding no less.

We were shooting the affair at an inn near Washington, Virginia, on March 29. During dinner, I happened out to the open-air patio and saw that a handful of people were looking up at the night sky. "It's the comet!" somebody said.

Starkly silhouetted against the cloudless sky, as hundreds of stars shone alongside, Hale-Bopp lived up to its billing as a heck of a show.

I had to make a shot. Who cared about *Scientific American*? I decided to treat the comet as if it were a lightning or fireworks display. I broke a rule or two, at least according to the scientific purists, but the results speak for themselves. Here's what I did:

Obviously, I used a tripod. But since I was more interested in getting an image as quickly as possible, to minimize star trails and possible camera movement during long exposures, I used a really high-speed film—Fujicolor 1600, instead of the recommended films of ISO 400 or 800. Sure, the 1600 is grainier than the slower films, but the 16" × 20"s my lab has

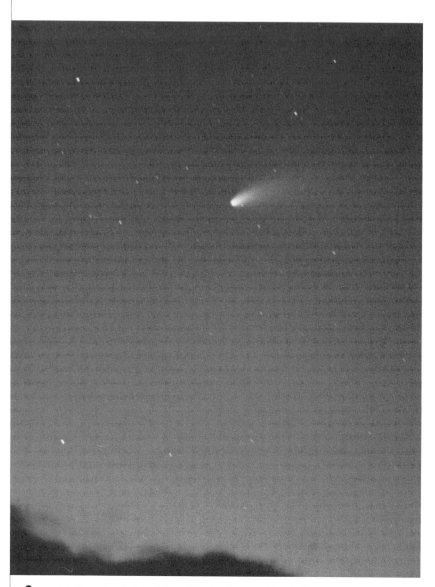

Comet Hale-Bopp. I made this picture while shooting a wedding in Virginia, using high-speed film, and a zoom lens—things the purists frowned on. But I'll let the picture do the talking for me.

made look phenomenal. My lens was a Nikkor f/3.5, 75–150, another no-no since the purists look down on zooms as not being as sharp as fixed focal-length glass.

I was lucky in one respect: I started shooting just after sundown, before the sky went totally dark. This allowed the trees at the bottom of the frame to stand out. I preferred these shots to the more telephoto ones

I made later, since the earlier ones provide the viewer with context and connection with the Earth.

How did I calculate exposure? Virtually the same way I do when photographing lightning, and not that much different from when I shoot fireworks. Remember: The night sky is dark and can tolerate a lot of exposure. I knew that from my vantage point on Earth, Hale-Bopp, though quite visible to the naked eye, was not as bright as a fireworks explosion or a lightning array, as far as the film was concerned. Therefore, I opened the lens aperture all the way and bracketed my exposures by time—five and ten minutes. (Note: When shooting fireworks, good results often can be had even with ISO 100 film and an aperture of f/5.6, with multiple arrays captured over the course of several minutes. It's always a good idea to cover the lens with cardboard until a great burst occurs.)

Lightning displays are more like comet and star shots, in that you can simply set your camera on "Time" or "Bulb" with your lens wide open and have a drink while the camera and your subject do the work.

I know it sounds simple, but who can argue with the results?

Vultures with Cameras

09/26/97

The joke wore thin quickly.

For a while after Princess Diana's death, every time we would shoot a job, some joker would make a crack like, "Here come the paparazzi."

"Yeah," I sourly told one guy at a financial seminar as I was about to photograph him with Louis Rukeyser, "I got my motorcycle outside."

The death of Diana, Princess of Wales, after a high-speed car chase in which she was pursued by tabloid and picture agency photographers on motorcycles, made me sick. Sick over the needless waste of life. Sick over the sleazy tabloid mindset that made the late-night pursuit inevitable. Sick that contributing agents of her death—aside from her apparently drunken and drug-impaired driver—were photographers.

It needs to be repeated that celebrities (be they in sports, politics, entertainment or the House of Windsor) need the press as much as the press needs them. Diana was no exception, either when telling her side of the story of her troubled marriage, or when touting the numerous good causes she championed. It is a symbiotic relationship—one helping the other to remain in the public eye; the other helping to sell newspapers or airtime—and for a long time the system worked fairly well.

I remember talking to one news photographer friend, long before any of this happened, about his attempt to make some pictures of an often-testy Frank Sinatra as he was rehearsing for a concert. "I told his flack all I needed was ten minutes and I'm outta there," my friend said. The deal was struck, the pictures made, and both shooter and crooner were satisfied. Little negotiations like that occurred all the time—I took part in many myself during more than two decades as a newspaper reporter. The understanding was that for a certain access, a certain privacy was granted in return.

But now, obviously, that has changed.

Though it is popular to blame the supermarket and British tabloids

for raising the ante in star-stalking by routinely offering huge amounts of money for embarrassing or sensational pictures—I think the mindset that encouraged this behavior actually began much earlier. Ironically, I believe it began in the mainstream press.

In the early 1970s Watergate was a legitimate (and legitimately covered) political scandal in which the President of the United States and many of his aides were shown to have conspired to obstruct justice—crimes that led to Richard Nixon's resignation. Since that time, any number of penny-ante political schemes and maneuvers have had "-gate" suffixed to their name in an attempt to gain for those covering them the career-enhancing luster of an honest-to-God scandal.

Should it be any surprise that, in the process of such often-fruitless digging, the hurdles over which the press jump in covering controversial stories have been lowered to include a public figure's personal life, sexual leaning, childhood trauma and who knows what else? In government, the hoary argument that a (usually male) politico's sexual appetite is fair game since it may reflect on his public performance is accurate up to a point. But let's not forget: Sex sells.

In considering today's stalker-paparazzi, how much of an ethical stretch is it from one reporter's staking out then-Senator Gary Hart's Washington town house (taking him up on his self-destructive challenge to reporters to investigate his personal life) to a British tabloid shooter's secretly photographing Diana a decade later in her gym?

But more troubling now is the confrontational way reporters and photographers—though mostly photographers—"cover" their subjects. To call them vultures with cameras is to be kind. (Likewise, to describe as photographs the grainy, often out-of-focus images they sell insults the rest of us who make our living with cameras.)

A public figure willingly gives up a degree of privacy—it comes with the territory of fame, renown or notoriety. But the boundaries to that privacy now have been obscenely and frighteningly stretched to give any thug with a camera license to stalk, harass, heckle and shoot.

For too long, the mainstream press has ridden on the back of the sleazy tabs and TV shows, printing or broadcasting their dirty work after the fact—all in the name of supposedly reporting all sides of the story.

Where is it set in stone that the press always must descend to its lowest common denominator?

If everything in a person's life is fair game, it is only a matter of time before it becomes fair game to do anything to cover it. Given this tawdry climate, it was only a matter of time, too, before the stalking of Diana turned deadly.

Why Black-and-White Is Better

10/10/97

Aperture magazine, the respected journal of photography, is offering for sale a selection of limited edition black-and-white prints personally made by the late Brett Weston. The prints, lush and beautiful scenics and still lifes, are likely to increase in value because, as you often hear on late-night TV sales pitches, "this offer can never be repeated!"

Why?

Because shortly before his death in 1993 at the age of eighty-two, Weston shocked many in the fine art photography world by throwing virtually all of his negatives into the fireplace and burning them. His rationale was that no one but he could print his negatives the way he intended them to be printed and that the destruction of his negatives ensured that his sole photographic legacy would be contained in prints that he himself had made. The Weston estate granted *Aperture* exclusive rights to sell from Weston's remaining prints.

It is unlikely that a similar display of artistic temperament ever would be made by a fine art photographer who worked in color. And therein lies the reason my own personal preference in photography has become, and likely will remain in, the multifaceted, monochrome world of black-and-white.

It was the late Ansel Adams, a friend not only of Brett Weston but of his more famous father, Edward, who coined the spectacularly apt construction, "The negative is the score; the print the performance," largely as it relates to black-and-white photography.

Simply put, this means that an individual negative can be interpreted different ways by different printers. Or, more to the point, a negative can be printed different ways over time by the same photographer, as his or her artistic vision changes or matures. (This is precisely what Adams did late in his career, printing some of his best-known black-and-white images in strikingly different ways.)

In color work, the talent and skill of the photographer tends to be centered on the actual moment when the shutter is released. What is captured on the color negative, or especially on the color slide, often is exactly what the photographer will want to see in the final print.

That is why, in the years that I was almost exclusively a fine art color photographer, I had no qualms about letting a custom lab make exhibition Cibachrome prints from my slides and transparencies, or why today I can have computer-generated Iris prints made of this color work with comparatively little effort.

"Just make the print look as much as possible like the chrome," I'd say, and leave it at that. Conversely, it would be impossible for me to do the same thing with a black-and-white negative—there simply are too many variables as to shadow, contrast and tone to be so off-handed and detached.

(Of course, one way to have a lab make a fine black-and-white print for me—say a three-foot-wide exhibition print—would be for me to make what I regarded at the time as a perfect 8" × 10" or 11" × 14". Then I either could tell the darkroom technician to match everything he or she saw in my work when printing the negative or, even easier, have the Iris printer make a high-resolution scan of my "perfect" print so that that scan could be translated into a gorgeous archival Iris print. But that only makes my point: To get what I want, I still have to be part of the creative process when it comes to making the final print. I couldn't simply farm out the job, as I did with my color work.)

In this vein it is fair to ask whether I think less of great photographers who do not—or who no longer want to—print their own black-and-white work. Frankly, I do. In my mind, anyway, shooting, then printing, one's black-and-white photography—at least once to create one's optimal interpretation of the negative—goes hand-in-hand. It is this secondary creative process that, for me, places black-and-white photography on a higher plateau than color photography.

(It also is what makes original vintage prints so valuable: images made by the photographer him- or herself, one at a time in the darkroom—not spat out in volume by a high-res computer after the negative or chrome has been scanned by yet another pricey inanimate gizmo.)

Being a first-rate photographer takes talent enough; being a first-rate photographer and a first-rate printer moves the entire process into the first ranks of fine art. And, to be fair, there *are* superb color photographer-printers, only not nearly so many as there are working in black-and-white. For example, Joel Meyerowitz's landscape work in large-format color print film is spectacular—his classic book *Cape Light* attests to that—and Meyerowitz printed his own work for that great book.

Then, too, there is the entire question of how vastly different these two related art forms actually are.

Obviously, images by photographers like Jay Maisel, Ernst Haas, and Pete Turner display their genius to use color to tell a story, especially one

image at a time. But too often, in my view, color creates an almost hyper-reality that distracts the viewer from the content of the image, especially when people are involved or when multiple images are displayed. Color will always give me a fascinating look at the surface of my world; black-and-white will always bring me deeper.

In looking over the numerous Brett Weston prints offered for sale by *Aperture* (none larger than 11" × 14" and none cheaper than $1,200), I could understand Weston's drastic action, but I do not agree with it.

I don't believe Weston destroyed the negatives to increase the value of his prints for his heirs. I'll take him at his word about wanting to keep his "legacy" pristine. But I also think he did a disservice to any number of museums that would have been proud to preserve his negatives—and to print from them only when they needed to, and as closely as humanly possible to the tonal and other values in his original work.

Finally, serious students of photography can learn much about a photographer from his or her negatives, especially as they relate to the prints made from them. Weston eliminated that possibility when he struck the match.

The Making of the 100-Person Millennium Portrait

07/09/99

Paul did it! Working on adrenaline and aided by a team of technical experts, photographer Paul Hosefros made his historic portrait of more than one hundred people in front of Philadelphia's Independence Hall last Sunday, capturing on film a capsule portrait of America at the Millennium.

"I'm going to Disney World!" an exhausted yet exuberant Hosefros said by phone within hours after he made the shot—or shots, actually. With nothing left to chance, several different versions of the photograph were made in various photographic formats and on various films, with the final results beamed around the country and the world on the Internet. The city of Philadelphia billed the picture as the Photo of the Century and the idea was to picture at least one United States citizen with a July Fourth birthday from every year of the twentieth century, from ninety-nine-year-old Betty Marx to newborn Sara Elizabeth Kitz.

The historic picture also included Paul himself—in the lower center, wearing a white blazer and black shirt ("my homage to black and white," Paul told me). This was not done out of ego, but simply because, in a delicious bit of coincidence, Paul himself was born on July Fourth. Of course, this also meant Paul had to trip his shutter remotely, yet another bit of technical finesse on a day that had more than its share of potential disasters.

In fact, in the humid light of morning, it's a wonder this picture got made at all.

Last month I had accompanied Paul, senior Washington photographer for the *New York Times*, on the first technical run-through for the mammoth group portrait. On that day in mid-June, the biggest concern was that the Powerlight 2500 DR strobe units being supplied for the shoot by Photogenic Professional Lighting would have the firepower necessary to let Paul work at his desired aperture of f/22 for such a large photograph.

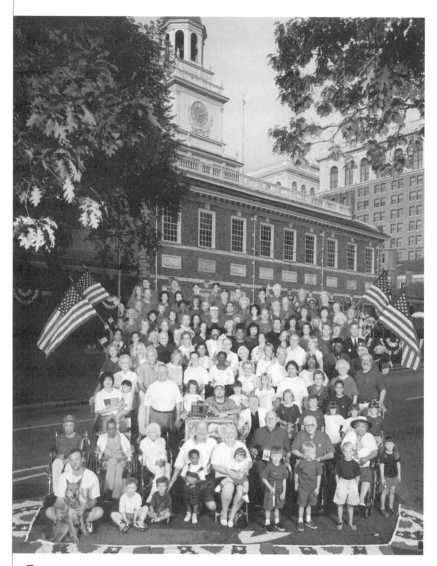

The Photo of the Century: from newborn to "centurian," Paul Hosefros captured a cross-section of America at the Millennium. Look closely and you'll see Paul, in white jacket and black shirt in center of third row, holding the remote trigger that fired his camera and strobes. (© Paul Hosefros)

(Reliable and sturdy though these units are said to be, they are more often the tools of wedding and studio portrait shooters.)

It was touch-and-go for a while, Paul reported. It didn't help that a TV boom knocked over one of the lights right before the session—but ultimately the Photogenic units did the job. (Fortunately Paul got a welcome eleventh-hour technical assist from Baltimore lighting wizard Carl Caruso. Carl came to Philly the night before the shoot to help the tech

crew get the most out of the lighting at hand.) Paul also got additional on-the-ground help from Bill Auth, lab chief at *US News and World Report* as well as from Scott Andrews from Nikon Professional Services in Washington. Each had experience with making technically challenging photographs of large news events.

"I'm just so relieved," Paul told me. "The crowd control was impossible." In fact, it appeared that none of the assembled media—there to photograph Paul taking a photograph—was interested in making his job any easier. Listening to my friend describe how he had to ride herd on more than 100 of his subjects as well as on an equally large and unruly gaggle of newsies, I thought to myself there was no way I could have handled such an assignment without going loudly and publicly ballistic, and probably ruining the shoot.

But Paul, who is nothing if not cool, maintained his and did the job.

The main cameras involved were 35mm digital units (used mostly as backup), as well as a 4 × 5 view camera and a Hasselblad 503C with a 50mm wide-angle lens. As Paul and I had thought, the best shots of the day came very early in the shoot, when everyone's energy was highest. Besides the gorgeous Hassy shots, the view camera image blew everyone away for its sharp detail as well as for the fact that these shots (made on Kodak's amazing new Portra 400 NC color print film) reflected the best ambient lighting of the day, with the sun just kissing the top of Independence Hall.

In the triumphant aftermath of the session, little things like falling light stands, or the fact that a city electrical crew didn't supply juice to the site until right before the photo session, were forgotten.

By the way, Paul didn't really go to Disney World. But he did say he was looking forward to a triumphal and large lobster dinner.

The Incredible Shrinking Overhead

08/11/00

Remember when air travel was an adventure, not a punishment?

You look back to newspaper morgue photos of people flying across the ocean in those gorgeous and roomy Pan American Clippers and what strikes you—aside from all the smiles—is that people dressed for air travel. It was an occasion. Now, however, if you're like me, you wear clothes that are one step above sweats, the better to cope with the crummy service, cramped seating, lousy food, long lines to the toilet, and assorted other indignities that attend the average non-high-roller's venture into the wild blue yonder.

And if you travel out of major American airports—like say Dulles International on the east coast or San Diego Airport on the left coast—things have just gotten worse, especially if you are a traveling photographer. As I first reported last fall and as recent events have borne out, you and I are being plagued by a double whammy that seriously threatens our ability to work, or simply to take pictures we like. The double whammy consists first of the new high-powered, film-destroying scanners for checked luggage, combined with increasingly restrictive policies for carry-on luggage, unveiled in the Washington area with a vengeance just a few weeks ago. The most recent of these restrictive carry-on policies was instituted last April 15 at Dulles: a blanket prohibition against any carry-on luggage that was larger than a puny 9" × 14" × 22". The new carry-on rules were designed to thwart travelers who try to walk on a plane with what amount to trunks on wheels. But these new rules are, I think, counter-

In the awful aftermath of the worst terrorist attack in our history, restrictions on air travel have become understandably tighter, with more stringent security, mandatory identification checks, and greater limits placed on carry-on and checked luggage.

No sane person would deny the need to protect the traveling public. It should be said, however, that the tragedy of September 11, 2001, was not caused by undetected explosives in on-board luggage.

productive, if not downright silly. Recently, Continental Airlines sued Delta Airlines to force its competitor to stop using a plastic baggage-sizing template at security checkpoints shared by the carriers at San Diego International Airport. Continental, whose rules were not as restrictive as Delta's, complained that the new restrictions created traffic jams and other inconveniences. "Continental customers shouldn't be penalized by Delta's imposition of its unfriendly baggage polices," said a Continental spokesman. And this was precisely the argument Continental made in a separate federal antitrust lawsuit last April against United Airlines and the Airline Management Council at Dulles. It should be noted that Continental's beef was purely economic. The carrier had just spent millions to retrofit its fleet with humongous overhead storage bins, the better to allow its frequent business fliers—the most lucrative segment of the flying public to airlines—to indulge their desire never to have to check a bag. Anyone who has spent time as I have, watching people trying not to brain fellow passengers as they wrestle bags into the overhead, can view Continental's position with decidedly mixed emotions. In fact, I wouldn't have any beef at all with stricter carry-on requirements were it not for the maddening specter of film-destroying CTX security scanning. CTX scanning—similar to CAT scans on humans—is better able than conventional X-ray to detect explosives and weapons in checked baggage: an admirable goal. But it also fries unexposed and undeveloped film. I have seen the damage take the form of fogging literally blanketing an image, or streaking that runs all across the image area. Either way, the photograph is destroyed. Kodak's Professional Photography division issued this bulletin recently to its subscribers: "This [CTX-5000] unit performs two types of scans. The first is a general sweep, which is harmless to film. The second is a focused, high-energy scan targeted at any suspicious-looking items identified by the system in the initial sweep. If this second scan happens to strike unprocessed film, it will be ruined."

The new scanners are being deployed at airports around the world and photographers should know that they if they put film into checked luggage, they do so at their peril. The obvious remedy is to put film in carry-on luggage since, happily, the X-ray machines for this luggage have been shown—so far, anyway—to be harmless to film, even at high ISO's.

But here's where the double whammy comes in. New restrictions on carry-on luggage adopted by many U.S. airlines severely limit the traveling photographer's ability to carry both film and equipment, leaving the photographer with the uncomfortable option of checking valuable and fragile cameras as luggage. This, frankly, is something I simply will not do. On commercial jobs, I happily check through tripods, light stands and strobes, but never—never—my Nikons, Leicas, or Hasselblads.

The other day, NBC News reported that more than 6,500 pieces of luggage are lost or delayed *every day* by U.S. airlines. And that assumes all such incidents are innocent. Painful though it may be to say, the CTX imprint of a valuable and easily hockable camera might prove an impos-

Tamrac's rolling strongbox camera bags are great—if you can get them on board the plane. I had to retire the larger carry-on model in favor of the smaller one pictured here to meet more stringent carry-on regulations. Now, even tighter carry-on rules may limit even this small bag.

sible temptation to a larcenous baggage handler working out of sight of the general public. I don't think it was coincidence, for example, that when I led a photo tour of Venice a few years ago, the only item of value missing from the luggage of one of my companions was a brand new camcorder, packed in among his family's clothing.

So what can you do? For now the only thing is to be prepared. Last month my new Tamrac Rolling Strongbox (pictured here next to the larger version I used to carry on) managed to squeeze through the luggage template at Dulles. When Judy and I return to Venice this winter, to finish work on our next book, I intend to jam as much film and as many cameras as I can into this bag and check through everything else.

I also intend to buy film on site. In third world countries this might be a problem, but in Western Europe even professional film is widely available. I'm planning, for example, to go back to the Venetian photo shop I visited in '98 and have my pal Daniele order bricks of T400CN for me once I arrive. Since his pro shop is a good one that souped film for me the last time, I even might have him develop and contact our work, since airport X-ray has no effect on film once it is processed.

The American Society of Media Photographers notes that "ASMP has been told that most carriers (FedEx, UPS, Airborne, etc.) do not X-ray packages they transport. So shipping your film to location and then shipping it back home for processing [also] may be a viable option."

When Technology
Weakens Technique,
Part 1

10/20/00

An e-mailer from White Hall, Virginia, raises a good question or two about where photography may be heading. Like many of us of a certain age—and I suspect reader Ray Wirth may be a contemporary of mine—he has doubts about the worth of cameras that are so automated that they do all of the thinking for you. In addition, he fears for the future of "film-based photography," and that a headlong rush to digital may "sacrifice beautiful image quality for point-and-shoot and mouse-click utility."

I share Ray's concerns, but not his fears. I am reminded of all those mail-order and other courses that promise to teach good writing with surprisingly little effort. Or of the poor souls who think that by loading their heads with abstruse words they will appear erudite in smart company. In writing, in photography—hell, in life—there are no shortcuts. And to me the shortcuts offered by automated cameras and digital photography in general, though beneficial to all of us at certain times, really do nothing to teach what makes a good picture. That hasn't changed, and likely never will change, even if some genius comes up with a way to *think* images onto a disk.

But first, let Ray tell his story: "I bought my first Leica M2-R (made from a standard M2, with the 'quick load' takeup spool of the then new M4), in 1969. I still have and use it, along with an M4 (simply an M6 without the meter.) Your comments are right on. The lenses are superb—nothing else like them.

"While I agree that a Leica is not the camera for a beginner, I disagree on the reason. It's clearly too costly a camera for someone not committed to serious photography. However, the basic, manual nature of the camera is precisely the reason to hand something similar to a beginner. The making of a photograph is an artistic exercise, and technique is important, an integral part, like mixing paints perhaps, or orchestrating a melody. To automate technique lessens the result. . . .

"I do not paint and do not sculpt and do not compose. But I *can* operate a camera, so this is my way to do art. The manual camera gives [me] the opportunity to make technique choices (not technical choices)." To which I only can say amen. Because, in truth, technique will always trump technology (the same way good pitching will always beat good hitting).

The greatest photo equipment geek in the world is unlikely also to be the best photographer in world. Why? Because the person who has technique down doesn't need to obsess over equipment. He or she does not require a multithousand dollar, autofocus, mega-digital Humongoflex to make good pictures. In some cases a simple pinhole camera will do just fine. This is one of the hardest lessons to teach an amateur, especially one of those "if only" photographers. ("If only I had an F5, or an M6, or a D1, or, etc., etc. . . . I would take great pictures," they lament, clueless to the notion that great photographs are made in the mind and the eye, not just in the hand.)

My friend Maxwell MacKenzie is arguably the best architectural photographer in town. His personal work, large panorama views of the Midwest and other parts of the world, are symphonies of perfect composition—reflecting perfect photographic pitch born of years of study and of burning lots and lots of film. Yet once, as he was preparing a show of images from his gorgeous book *Abandonings* Max relayed how every so often someone would look at one of his huge prints (some as wide as eight feet) and say, "You must have a really good camera." "Does anyone ever go to a writer like, say, John Updike, and say, 'You must have a really good typewriter'?" My reader's other fear: that film-based, or silver-based, photography may be a dinosaur, is more pressing.

"I fear for the future of film-based photography," Ray wrote. "I shot Kodachrome, to my generation the gold standard. Had a hell of a time getting it processed. Around here, it's hard to find darkroom supplies. . . ." All of which may be true, but remember: there is a reason silver-based photography has survived in various incarnations for the last century and a half. And that reason is manifold: its usefulness, ease of use—and longevity—have never been successfully challenged. And nothing I am seeing now, or on the digital horizon, threatens to change that equation, amazing though digital photography may be. After all, the automobile replaced the horse and buggy because virtually every aspect of it was an improvement over old Dobbin, especially as reliability rose and costs declined. But in electronic versus film-based photography, digital continues to have serious drawbacks that I'm hard-put to see disappear.

Image quality is not even a factor. Good now, it will shortly be superb and likely will equal (maybe even surpass, in some very specialized cases) that of regular film. Costs, too, will continue to plummet. But how will a medium designed for speed and instant gratification deal with the problem of archivability? Especially when storage and recording media are changing, seemingly every week? Sort of makes one yearn for those lush,

unchanging archival Kodachrome slides and immutable Tri-X negatives, doesn't it?

And let's not forget, too, what ex-National Geo shooter Bruce Dale calls the "photographness" of a photograph—that ineffable quality that puts a fine hand-made photographic print on the same emotional level as an original oil or watercolor.

Back in 1992, when I photographed author Stephen King for my book on Down East Maine, we got to talking about the craft of writing, since we each had spent decades in front of a keyboard.

Noting that he does most of his legwork and research himself, Stephen declared that "it seems to stick better a lot of times if you do it yourself; the questions that you ask go to the heart of the matter."

"That's one thing about writing," King said, "it doesn't change from century to century. It's still hand work."

And so, thank God, is photography. Hand and eye work.

Cuba: Taking Strong (and Wrong) Exception

02/02/01

"Mr. Van Riper," the e-mail began, "It may be, as you say in your article on this subject, that the Cuban trade embargo is 'ridiculous': It has failed to bring down Castro and provides him with a much abused excuse for Cuba's disastrous economic situation. But at least overthrowing a dictatorship is a worthy objective. Instead, this Cuban photographic workshop that you are helping advertise, and which is, at best, a naïve enterprise; and at worst, a propaganda project, will, in either case, help validate the Castro regime. In the latter case, bad faith is the motivation, and in the former, the cause is a profound ignorance. . . ."

The writer, who said his first name is Luis, gave an address in McLean, Virginia. Perhaps he is a Cuban refugee. Or perhaps his parents had to live under Castro before fleeing to the United States. For all I know or care his family has lived here for generations. That doesn't matter. What does matter is his message: that, in promoting and writing about the Maine Photographic Workshops' upcoming series of master classes in Cuba, I am giving aid and comfort to tyranny. This is laughable; the charges are ridiculous. Unfortunately, however, my reader demonstrates the kind of hostility and paranoia one often finds when people are driven to extremes in their fervently held beliefs. And yet, I venture to say that if Luis and I ever were to meet and sit down over a *cerveza* or two, we would find we have far more in common when it comes to Cuba than he might imagine.

"How can you believe," my correspondent says, "how can anybody with the slightest knowledge of totalitarian dictatorships in the twentieth century believe, that this workshop will offer, as you put it, 'a wonderful opportunity for serious photographers and experienced travelers to document this (still fascinating) island'? Such 'documentation' is not possible under a dictatorship, unless you are thinking of projects such as the "A Day in the Life of . . ." series of books, some pretty and pretty shallow pic-

tures. Because the only pictures your 'serious photographers' will be allowed to take are of the type seen in such books and in the sampling in your article: some graceful people, old cars, etc. This type of photography ("unconcerned" photography?) should be easy in Cuba, because, as somebody once said, poverty is picturesque. And in this sense at least, Castro has been spectacularly successful: Cuba is so very picturesque that it breaks your heart."

In his fervid e-mail, Luis exudes the absolutism that true-believers of any stripe exhibit whenever anyone has the temerity to put a human face on a regime/politician/country they hate, or have come to hate because of its system. And who am I to say Luis doesn't have good reason? Still, I find it hard to believe that my correspondent really thinks photographs of a crumbling Havana somehow "validate the Castro regime." Or that tales of food and medical shortages—of the type I alluded to in my column, and which all who travel to Cuba come back with—reflect well on the man who once was Moscow's Poster Boy for world revolution.

Is there anyone with walking around sense who thinks Fidel Castro has *improved* the Cuban economy, rather than driven it into the ground while soaking up as much Soviet aid as humanly possible when it was available? No, what rankles Luis and so many other anti-Castroites is that there are people in that nation of *pobrecitos* who, despite all their hardship, are making a life for themselves. People, who with memories long enough to recall the corruption of the previous regime, actually feel they are better off with the devil they know in Fidel.

What would Luis make, I wonder, of a fascinating new book, *Popular*, by French-born fashion photographer Thierry Le Goues (powerHouse Books, $75). The book's title is meant to be pronounced in Spanish (Pope-oo-LAR) after the ubiquitous Cuban cigarette. In an utterly wordless collection of 220 mostly color images, Le Goues provides a stunning look at a vibrant, sensuous people at work and at play—reflecting great joy amidst great poverty. He also comes up with some simply gorgeous cityscapes, most of them of decrepit, falling down buildings, to be sure, but beautiful in their own way nonetheless.

There is a raw energy throughout this book that belies the popular refugee-based stereotype of a downtrodden people who live under the thumb of Castro's *Policia*, or of ratfink members of the neighborhood political watch. In all likelihood, readers like Luis would not like this book. The people look too damn happy. Yet, ironically, Luis would have some company in his presumed dislike in the person of Fidel Castro.

A few weeks ago Cuba banned the import of *Popular*, saying "themes represented in the book do not accurately reflect the achievements of the revolution." And that's the conundrum of freedom. Different people see different things or the same things differently. Luis and others like him are dead wrong when they accuse projects like the Maine Workshops' "Assignment Cuba" of "validating" a regime, when all they are doing is reporting on it. Fidel Castro is dead wrong if he thinks that in this age, he

is going to be able to isolate his country from more open systems, much less control what people see, hear, and read.

With rare exceptions, like North Korea, we really are a global village, connected even more so by the Internet and the lightning-fast exchange of words, ideas, and images that no politician or dictator can stifle. That's why the Maine Workshops' project is a good one. That's why readers like Luis, well meaning and fervent though they may be, are wrong.

When Technology Weakens Technique, Part 2: Digital Downsides

03/16/01

At Camp David last year, at the Clinton-Barak-Arafat summit, news photographers shoot frantically as the world leaders meet. As the three men walk along a pathway there is a great shot in the making. One photographer nails it; another muffles a curse as he misses it. His digital camera has "hit the wall"—reached the limit of its multiple-shot buffer and shut down to automatically process its images. (The shooter who successfully made the shot realizes how lucky he was: the exposure he made was the last one available before he, too, would have "hit the wall.")

For all the fun I am having with my Canon digital camera, stories like these convince me that I never will abandon conventional film photography—at least not anytime soon.

I add that caveat because a troglodyte like me can appreciate the amazing technological leap that digital photography embodies, even as I revel in the velvet shutter release of my Leica M6 or marvel at the beauty of a print emerging from the developer.

The ease and speed with which images can be made and, more importantly, transmitted great and small distances, is simply unmatched by any other visual medium.

That in itself is a miracle.

But I say with fair confidence that traditional, film-based photography never will be replaced by digital simply because nothing I have seen from digital so far—or, frankly, am likely to see—so changes the playing field as to make film-based shooting obsolete.

And that really is the crux of the matter. It is, as I have said before, the old horse and buggy versus automobile analogy. The Model T replaced the

horse simply because the car was superior to the horse in virtually every category save companionship. (And even there I'm not so sure, given the sentimental attachment that some folks have these days to the buckets of bolts that get them to and fro.)

At best, I see digital becoming a vitally important adjunct to film, especially in newsgathering and reporting. Fine art photographers of a certain type and temperament also will be drawn to it because of digital photography's ability to change, alter, or otherwise transmogrify their images. (By the same token, don't expect any reputable photojournalists to go digital because they want to doctor their images. Or think that a fine art photographer loves digital imaging simply because it is fast.)

For all of the indisputable upsides to digital photography, there are a fair number of obvious and not so obvious downsides as well. Anyone looking to make the digital plunge, from the rank amateur to seasoned pro, must consider the good with the not-so-good.

First, to me, there is an aesthetic difference that I admit may not be all that significant given the computer's ability to change things after the fact.

During a month-long trip to Venice, to make black-and-white pictures for our next book, my wife Judy and I worked with no fewer than five different black-and-white films, each chosen for its specific characteristics. We used Kodak's 400-speed T400CN, as well as Ilford Delta 3200, in both 35mm and medium format, as well as 35mm Polaroid PolaPan instant black-and-white slide film (ISO 100).

A nonphotographer might think that black-and-white film is black-and-white film is black-and-white film, but you know as well as I the differences one gets from changes in film and format. And that is precisely what Judy and I sought, as we worked within our self-imposed monochromatic palette, tailoring film choice to circumstance to create a specific image. We loved the punchy, contrasty grain we got in our 35mm late-night, available-light images, using the Delta 3200. At the other extreme, the comparatively long tonal range and phenomenally tight grain pattern of the T400CN, especially in medium format, created beautiful, even elegant, pictures that were the polar opposite in tone to those made with the high-speed film.

Likewise, the 35mm PolaPan seemed to combine elements of both these films—rendering a subtle tonal range twinned with a tiny, yet still-noticeable, grain pattern.

Had we worked solely digitally, shooting the equivalent of the 150 rolls of film that we actually used, our initial images all would have had the same "texture" or visual "feel." A kind of plastic sameness one often finds on videotape, especially when compared to movie film.

Still, as my friend and colleague photographer Peter Garfield points out: In conventional photography, "you bring to the table what you are looking for in the film base. In digital, the same thing can be said—but it happens in Photoshop."

That is to say, one easily can alter the tone and texture of an image after the fact, adding electronic grain, additional contrast, even out-of-focus blurring, to create whatever kind of image one likes—up to a point. (In this I am reminded of Philadelphia shooter Michael Furman's experience some years back with a client who saw one of Furman's brilliant color images, of several open cans of paint, and asked to use the image, but only if Michael would digitally change the color of the paint.

There is just so much the computer can do, Furman told the client, convincing him that the altered image would look dull and artificial. Furman wound up reshooting—on film.)

Despite this downside, Furman also was fond of telling colleagues that he was amazed at the computer's ability to mine image information from a conventional negative, allowing him to create spectacular digital prints that otherwise would have taken him (or his lab) hours to create in the conventional "wet" darkroom.

Leaving aside the whole question of whether it is ethical to remove or add elements to a photograph once it has been made (of concern to journalists and documentarians, but certainly not to artists or advertisers), there also is one of digital's other dirty little secrets: shutter lag.

Shutter lag—a maddening computer processing lag between pressing the shutter and actually making a picture—is prevalent on even today's highest-end, multithousand-dollar, digital cameras, notes veteran *New York Daily News* photographer Harry Hamburg.

Hamburg, who shoots with state-of-the-art Canons and who can't remember the last time he shot spot news with film, says that digital is "a whole new way of shooting." On the high-end cameras, the fraction of a second shutter lag problem can be minimized, he says, by "tickling the shutter release" to, in effect, fool the camera into thinking a picture is about to be made. However, on less expensive cameras like my $900 Canon G1, there simply is no way for it to work as fast as a conventional camera. For example, when I recently photographed First Lady Laura Bush delivering a luncheon speech, I had to dump one of every three digital pictures I made of her because my camera simply was too slow to catch the expression I wanted. By contrast, what I made with my conventional Nikon F-100 was fine.

Finally, there is the question of archiving and retrieval. I've been down this road before, complaining that any technology that advances so spectacularly so frequently inevitably will leave many of its clients in the dust if they do not follow the technology curve—at their own expense and at their peril if they don't.

Take Peter Garfield. Several years ago, he transferred hundreds upon hundreds of his film images onto DAT high-resolution tape—state of the art back then. But then DAT faced deterioration problems and was succeeded by CD-ROM. So Peter had to spend valuable hours seeing that all his stuff was transferred to CD.

The other day he noted ruefully that it's probably just a matter of time before he has to go through the whole process again for the next new thing: DVD.

Swimming inevitably against the tide of new technology to keep his images alive and viewable.

SECTION II

On Becoming a Photographer

A Niche Takes Time

08/13/93

Consider this scenario: You're on vacation. It doesn't matter where, as long as it's a change of pace and scenery. Of course, you have brought along your camera and tend to carry it with you most everywhere.

During a typical day, let's say you wander about some scenic places: walk past some open fields—a beach or two, perhaps—a range of rolling hills, or mountains capped in snow or swathed in green, and a couple of striking buildings (be they skyscrapers or mud huts).

Throw into this mix the people you encounter during your walk: young, old, male, female, all manner of colors, all manner of dress. Smiling people, somber people, people lost in thought.

Then consider some of the details you've seen: a stall filled with colorful vegetables; a crazy quilt of shapes and forms created by a parking lot full of cars, bikes, and vans; a striking tableau you notice while at lunch—sunlight from a nearby window hitting your wine bottle just right as cigarette smoke creates a gorgeous pattern in the late afternoon air.

Just for a little spice, let's say after you emerge from lunch, you walk into the street and suddenly hear a crash. You turn and see that two cars have collided at an intersection, and that the two drivers have jumped from their vehicles to begin a heated argument over who caused whose bent fender.

Okay, let's say this all happened to you. How many of these things and events would you feel compelled to photograph? Not just interested in photographing for the sake of making a snapshot, but compelled to the point of elbowing your way (politely, of course) past anyone to make the picture?

I'd bet there's at least one of the above situations that would ring your chimes sufficiently to make you forget everything else and concentrate on making the picture.

And that's what separates the snapshooter from the photographer.

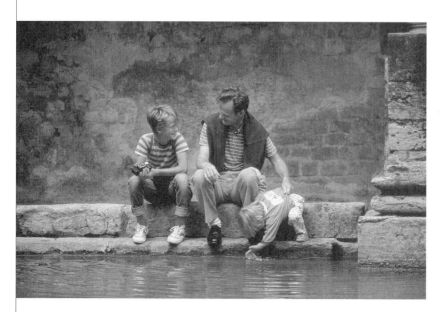

Some of you will be drawn to doing gorgeous tabletop still lifes; others to shooting sports, still others to gritty black-and-white street photography. I am into people, as this gentle tableau of a father and his two boys at Bath, England, attests. © Frank Van Riper

Sooner or later, there will come a time when you will find you want to choose the kind of photographer you are, or want to be. There's no deadline on any of this, by the way, and the process of choosing is half the fun, so don't think you're doing anything wrong by having a whale of a time shooting anything and anyone who comes your way. What I'm saying is that out of this happy mix—if you really enjoy the process of making pictures and do it all the time—will emerge a preference. And the next step in growing as a photographer is concentrating on that preference, sometimes to the exclusion of other types of shooting.

With me, the preference was for people, mostly shot in black-and-white and in medium format in a journalistic style. Maybe this preference was inevitable, since I'm a former newspaper reporter who always has taken pictures. For a colleague of mine, the preference was for still life, and she has built a reputation for herself as someone who can create delicate and beautiful scenes within the four walls of her studio.

For still another colleague, the preference was for architectural photography. He makes his living with medium- and large-format cameras, capturing and enhancing the best efforts of this area's top architects and interior designers. I'm sure he began as a kid, pointing his 35mm camera up at tall buildings and wondering why his pictures always made the buildings look as if they were falling over.

And for yet another colleague, the preference was for aerial photography, a way to combine his two great loves, flying and making pictures.

Photography is a most egalitarian pursuit. The camera couldn't care less if you only want to use it to photograph faces, or still lifes, or buildings.

But you have to make the choice.

So let's go back to our vacation scenario. If you're drawn to shoot the mountains and fields, you may be following in the footsteps of giants like Eliot Porter and Ansel Adams.

If the people you meet make you anxious to photograph, look to the work of Cartier-Bresson or Robert Frank or Diane Arbus.

Details, colors and shapes? Consider the color work of Jay Maisel or Pete Turner or Ernst Haas. Or the the black-and-white abstracts of Man Ray or Moholy-Nagy.

And what about the last scene: the traffic accident and heated argument. Some people might turn away from conflict and potential violence. Others are drawn to it. Look to the pages of this newspaper or of any news magazine and pay your respects to the men and women who cover the news, from the city council to the war in Somalia.

For twenty years as I covered events with a notebook and pen, I saw my colleagues on the other end of the business lugging tons of cameras and racing past me: to a riot in Harlem, a convention in Dallas, a homecoming in Wiesbaden.

To them it wasn't just a job; it was their choice and they wouldn't be anywhere else. It was their preference. What's yours?

Photographing an Icon

08/19/94

Go to an art museum and every so often you may see someone sitting at an easel copying an old (or new) master. The task of trying to duplicate a great painting actually is an exercise in seeing: to try to see what the master has seen and then to hone one's skills sufficiently to approach, if not actually reproduce, what is on the wall.

Photography, like painting, is largely learning how to see, and then growing comfortable with the equipment that lets us turn what we see into something tangible. Obviously since photography captures a fleeting instant that never can be duplicated, it would be foolish to try to clone, say, an Ansel Adams landscape or an Edward Steichen portrait. But we can do a number of things to follow in the footsteps of our own masters.

In still life, for example, one might come close to duplicating what Irving Penn did when he photographed flowers by studying his photographs, then painstakingly trying to build on that.

What I recommend more than merely trying to ape someone else's picture is to try to bring your own developing style and sensibility to a similar, if not identical, subject. In other words, give it your best shot, literally and figuratively. Try to photograph an icon and see how your own effort compares with what had been done in the past.

So it was last April when I stood before the Mission Church of St. Francis of Assisi in Ranchos de Taos, New Mexico, trying to figure out a way to shoot one of the most photographed churches in America.

The Ranchos Church, as it often is called, has come to symbolize the old Southwest in much the same way that the Eiffel Tower symbolizes Paris or the Empire State Building New York City. Some 150 years old, the church sits in the middle of the town's small square, its solid adobe walls the color of pink-tinged toffee. You approach the church from the rear, turning off from the main road, and it is this rear view that has intrigued painters, photographers, and printmakers for so many years. The round

Portrait of an icon: The Mission Church Ranchos de Taos, New Mexico, has been photographed thousands, if not millions, of times. But that doesn't mean you shouldn't give it your best shot as well. Somber predawn light and a surprisingly chill morning helped create a moody image that I like.

adobe buttressing walls at the base of the church lend an abstract, almost sensual, look to this monolith, in contrast to the much more ornate and, I think, visually less interesting entranceway, courtyard, and garden. (Having said that, I should note that Ansel Adams chose this front view when he shot the church; other artists, including Georgia O'Keeffe, Paul Strand, and James Milmoe, opted for the rear.)

In standing, dwarfed, before the church in the golden light of late afternoon, I decided, too, that I preferred the rear view. But how to shoot it?

First, there were some practical hurdles to overcome. Modernity, in the form of overhead power lines, dictated a closer perspective. Fine, since I wanted to be close and shooting up to emphasize the grandeur of the building. But as I looked over to the right I was dismayed to see . . . a gas meter! A gas meter just like the one in my basement, sitting like a carbun-

cle on these grand old walls. Something else to shoot around. And, of course, there were cars.

Viewing the scene through a Mamiya 6 medium-format camera, I saw the composition I wanted. The square format included all of the rear walls and part of the sky. Happily, the angle I chose also avoided all the power lines and obscured the gas meter. Now all I needed was great light where I wanted it. Standing there in late afternoon, all the great light was in the front, not the back, so the choice was made for me: to get up before dawn to catch the rising sun as it first hit the rear church walls.

At least that was my plan; Mother Nature had other ideas.

The alarm rang at 4 A.M. The church was a twenty-minute drive, and as I approached the empty square, the church was still in darkness. As I had hoped, there were no other cars around to mar the shot. But the morning was gray and chilly, if not downright cold. In looking at the church in the predawn—and knowing that this would be my only shot since we were leaving Taos later in the day—I rethought my picture. Instead of a church whose angles and buttresses would be highlighted by the bright dawn sun, I visualized an ominous monolith silhouetted by the cloud-filled sky. Since I had planned my shot for black-and-white, I decided to use all of my Ilford XP-2's ability to render shadow detail while trying to pick up as much contrast as possible from the sky and clouds. I placed a yellow filter on my spot meter and read the sky, the clouds, as well as the dark adobe walls and calculated a base exposure averaging the two extreme readings. Then with the filter now on the camera lens, I bracketed my exposure heavily, shooting two twelve-exposure rolls.

As I shot, I was amazed to see it begin to snow! (This was late April, remember.) Big wet flakes, accompanied by a gusty wind. I was glad to get back into the car and even happier when I stopped on the way back to the hotel for donuts and hot coffee.

Weeks later in the darkroom, the contact sheets showed two frames that captured what I was after—a somber image showing the church almost in silhouette but still retaining enough detail to render those beautiful buttresses. The filter had given me a wonderfully ominous sky, but with well-defined clouds. Now I had to translate all this into a final print.

My first attempt on what then was my standard paper, Portriga Rapid, was dismal—nothing like the contact sheet. Then I realized that this was a photograph with very little contrast and that Portriga was a fairly flat paper. I figured I had to go to extremes to get even a hint of that shadow detail suggested in the contact sheet. So I switched to Ilford's Fiber-Based Multigrade and used a high-contrast No. 4 filter. The test strip was encouraging; the final print gorgeous—evoking to my delight some of the somber architectural work of the late Paul Strand.

This time, anyway, following in the steps of the masters helped me make a photograph of which I was proud. I gave it my best shot and hit, if not a home run, then a clean shot into the outfield that went for extra bases.

Putting a Fair Price on Your Work

02/10/95

In describing my more than twenty years as a newspaper reporter, I once wrote that the "dirty little secret" of most journalists is that we would pay our employers for doing what we do—it's that much fun.

On one level, that sentiment describes life at its richest—doing what you love. On another level, though, that joy can put blinders on you when you have to charge a fair price for your services.

How often have I heard photographers who are just starting out worry about how much they should charge for their work. In most cases, the person in question has a steady job, often unrelated to photography, that pays the bills while he or she develops as a photographer.

Because photography is largely a craft and not strictly a profession (a profession being defined here as a job for which one's skills are certified by a private group or government body), anyone can hang out a shingle and call him or herself a photographer. And for all practicalities, there really are no guidelines beyond the marketplace to help one set rates.

By contrast, skilled union workers are paid at set rates negotiated by contract. Doctors, lawyers, and other (largely nonunion) professionals establish rates of pay based on the level of expertise attested to by their training and certification (as well as on what a client is willing to fork over).

National photographic organizations like the American Society of Media Photographers, of which I'm a member, are prohibited by law from setting rates for their members, though they can suggest general pricing guidelines. So what's a fledgling shooter to do?

Two main things should determine your fee: the cost of doing business and the rate of return you want to achieve.

To a new photographer, especially one who already has a steady job, costs of doing business tend only to include things like equipment, film, and processing. Once you go out on your own, however, the hidden costs

come into play, especially those for insurance. Besides health insurance, a prudent photographer also should carry insurance covering liability, disability, theft, etc. And don't forget all the money you will have to spend to get your message out: stationery, office equipment (like phone and fax machine), not to mention advertising—be it a small classified ad in a local shopper or a full-page, full-color display ad in a creative directory.

All these things should be factored into your cost of doing business, along with the actual cash you lay out to deliver pictures to your client.

As for a fair profit, a new photographer would do well to do some market research—what do other photographers in your area charge for doing similar work? Are there many photographers around doing what you do? One of the biggest pitfalls for new photographers is underpricing—either out of fear that no one will pay what they'd like to charge or, worse, out of the misguided notion that undercutting the competition will bring them work.

Lowballing a job (cutting your price to get an assignment) is a no-win strategy. Aside from generating enmity among your colleagues, it can lock you into a defeatist mindset that your work is not worth a fair return. This is the old "I'll make it up on volume" theory that often leads to bankruptcy and can make you wish you had never quit your day job.

Remember, too, that even the most sought-after freelance photographers have downtime, which also must be factored into any pricing scheme. For example, though as a wedding photographer I currently might charge $450 an hour plus expenses, remember that this fee covers all the unbilled time spent shlepping back and forth to the lab, talking to clients, and preparing their orders. And wedding work is seasonal. Sure, based on a forty-hour week, $450 an hour works out to more than a half million dollars a year, but in fact the typical wedding photographer's income actually is far, far less.

In setting your pricing, remember that, just as with any other profession, a client is paying for your skill, not just for your expenses. That skill—the ability to make images a client either will treasure personally or use to make money for his or her own business—is a valuable commodity. Don't sell it—or yourself—short.

Sacred Space

10/06/95

Our friend, a divorced artist, had moved from Washington to a rambling house in the country, hoping to find contentment, a job as a curator in a small museum, and a congenial place to paint and draw. Instead she found loneliness, budget cutbacks, and enough microscopic bugs in her well water to lay her low for months. It was time to move—again.

"This is one of life's bittersweet episodes," Pat wrote to us last summer. "I wish I could move my enchanted house and garden with me. There is an ancient atmosphere surrounding that locale. . . .

"The chemistry of living is so complex," Pat said. "We need such an exact climate to nurture and cultivate our dreams and visions—not to mention our basic physical survival. . . .

"Everything must mesh just so, to provide us, as artists especially, with peace of mind, love and understanding, financial security, etc. Then, just maybe, the process of creativity can occur."

Pat was talking about her sacred space—the private place where each of us goes to do what we love most. For some, it can be a screened-in back porch where the morning light catches an easel just so. Or a darkroom where the world is temporarily banished while images emerge magically from the developer. The exact place doesn't matter; what does matter is having somewhere to go when we want to be alone with our thoughts, dreams, or ideas.

For a fortunate few a similar contentment can be found in our jobs. For twenty years I was a newspaper reporter and, though I never would have admitted it at the time, I would have paid the *New York Daily News* for those two decades—it was that much fun. Still, working in the chaos of a newsroom, or a law firm, or an emergency room—or a house with small kids—is not the same as being alone, free to follow where inspiration takes us.

This is one reason artists ache to have studios, even if they are noth-

Sacred space can be a darkroom, a sculpture, or painting studio or, in my case, a tiny cabin in the Maine woods where I can write. © Frank Van Riper

ing more than a separate room in the house. My wife, Judy, and I each have our own separate spaces. Judy's is a small studio, first in Takoma Park, D.C., now near Olney, Maryland, where she creates sculpture from found objects. Mine is our guest cabin in Maine, where I can write the texts to my books in wonderful solitude, every so often looking out through huge windows at the evergreen woods and the tidal waters of Morrison Cove in the background. (As you might guess, the basement darkroom in our home in Washington is my second sacred space, a world all my own where I can print my photographs.)

The ability to distance oneself, even temporarily, from the humdrum of daily life is vital to the creative process. And photography is one of those rare pursuits that carries its sacred space with it. Wherever we go to make pictures is where we do what we love best. It's a remarkable and rare gift and one that we should give ourselves frequently, lest inspiration grow more and more infrequent from disuse.

Jay Maisel, a great and prolific commercial and fine art photographer, once declared that "if you want to be a photographer, you must photograph every day." Maisel, a cigar-puffing, Yale-educated bear of a man, carries a camera with him everywhere, and he has produced enough great images of people and things he has encountered spontaneously to bear out his uncompromising dictum.

For the rest of us, regularly setting aside time for our personal work is a good way to start the creative process. For in addition to space, creativity needs the time to happen.

In Praise of Obsession

ASMP, *Focus*, Spring 1996

In the recent movie *Smoke*, cigar store owner Augie Wren, played (brilliantly) by Harvey Keitel is showing his friend, a struggling novelist (played, also brilliantly, by William Hurt), the album of photographs he has made over the years.

The novelist puzzles over the 3" × 5" drugstore prints, with their deckle edges, pasted lovingly into an old photo album.

"They're all the same," Hurt says.

"That's right," Keitel answers. "More than four thousand pictures of the same place—the corner of 3rd Street and Seventh Avenue at eight o'clock in the morning. Four thousand straight days in all kinds of weather. That's why I can never take a vacation. I gotta be in my spot every morning at the same time; every morning at the same spot at the same time."

"I've never seen anything like this," Hurt says, shaking his head.

"It's my project," Keitel says matter-of-factly, "what you'd call . . . my life's work."

There is something to be said for obsession. For the way an idea grabs us so tightly that we are powerless to break free. The painter Monet was so riveted by the way sunlight played on haystacks in a field that he made repeated pastel drawings of them—in the cold light of morning, the warm light of late afternoon, the waning light of evening. They became more than exercises; they became—like Augie Wren's photographs—icons of the passage of time and, viewed together, they are a visual feast.

We as photographers, especially commercial shooters who are hired guns for every passing art director, event planner, magazine or ad agency, may think we haven't the time for such artistic indulgence, especially when we face hard times and the need to make a living. Yet I suggest that the photographer who thinks this way is limiting him- or herself in a fundamental and important way. The project that speaks to us directly—that

stays in the back of our minds at the end of a boring day of tabletops or assembly line headshots—is the one that will maintain our sanity in the humdrum of commercial shooting. Succumbing to obsession, I submit, is a way to stay sane.

Consider these very different photographers:

Richard Avedon's credentials and reputation bear no repeating. There was no need for him to labor as hard as he did over the course of several summers to venture West and produce a body of black-and-white view camera portraits of the working class people, misfits, and miscreants who piqued his interest. No art director had said, "Dick, we need gritty portraits to sell our shoes and perfume." He did it on his own (albeit with the promise of a museum show) and the result, the landmark portrait project *In the American West,* became one of Avedon's many photographic legacies.

Bruce Davidson had just completed a color essay on Central Park for *National Geographic,* but the project left him unsatisfied. It cried out to be done in black-and-white, Davidson recalled, and it cried out to be done without a deadline. For the next four years, he camped out in the park, photographing it and its denizens in all kinds of light and weather. He could not have stopped if he wanted to—and, of course, he didn't. His obsession produced a masterpiece of documentary and portrait photography, *Central Park,* that was published by *Aperture* last year.

Dorothea Lange's obsession with Ireland never bore fruit—until now. Sent by *Life Magazine* to document the "Irish Country People" of County Clare, she made literally thousands of images over the course of six weeks in 1954, and formed friendships there she would keep all her life. The magazine published her essay, but like so many of the strong-willed shooters *Life* employed then (Gene Smith being perhaps the most notorious and brilliant) she was livid that the magazine found space for only twenty-one of her pictures, and none at all for the accompanying text written by her son, Daniel Dixon. Lange never worked for *Life* again. She died of cancer nine years later. Now, thanks to the efforts of freelance journalist Gerri Mullins, who unearthed the Lange archive at the Oakland Museum, her work—as well as an affectionate essay by Dixon—can be enjoyed in the stunning book *Dorothea Lange's Ireland,* published by Elliot & Clark.

And then there is O. Winston Link. Now in his eighties and finally free from the clutches of a wife who literally held him prisoner in his home (telling his gallery in New York that he had Alzheimer's and taking illegal control of his work and profits), Win Link was a successful New York advertising photographer in the 1950s when the idea of documenting the final days of the steam locomotive took hold. "Have you ever noticed the dearth of photographs of railroad scenes at night," Link wrote the PR department of the Norfolk & Western, one of the last great steam railroads. "I would like to make a series of well-planned night photographs of exceptional quality and interest showing the railroad at work. . . . Do you think your management would be favorable?" Happily, the Norfolk &

Western was, and Link's obsession with the iron horse produced a brilliant homage to a passing era. It was all the more amazing that Link worked without the benefit of high-powered strobes and remote control devices. His beautifully lit nighttime scenes were made only with the help of hundreds of hard-wired flashbulbs, placed strategically—and lovingly—by Link and his assistants.

Obsession can come in many forms and many ways. It is the personal project that speaks to you more directly than any commercial job, yet doing it will make you a better photographer all around. It can be the commercial assignment that triggers something totally unexpected and totally different, and if the client doesn't like it, who cares as long as he or she gets what he or she wants, leaving you free to travel your own tangent?

Make room for inspiration; make time for yourself. At the end of a career, that's the work you will treasure.

(Note: O. Winston Link died January 30, 2001, at the age of eighty-six.)

Ignorance and Naiveté

ASMP, *Focus*, Fall 1996

The phone call was from a young photographer I didn't know. She already had taken her client to small claims court over what seemed a clear-cut rip-off—and won—but the client was still balking at paying her.

The facts were distressingly familiar: the inexperienced shooter had entered into a verbal agreement with a local restaurant to make photographs of the location for menu covers. Because of her close ties to the restaurant (she was engaged to the chef at the time), the photographer offered to work for expenses only.

But the photographer declared, "The owners of the restaurant refused payment for services rendered unless I surrendered my negatives to them." In small claims court the judge ruled in her favor, provided that she turn over the remaining contact sheets to the client.

But the client still wouldn't pay—no negatives, no payment.

Sound familiar?

In cases like these, it really doesn't matter if the law is squarely on your side. If the client is ignorant of your rights as a photographer, it only invites hassles, delayed payments, and bad feelings all around, not to mention destroying any possibility of repeat business.

"Basically, you were hired by the restaurant to use your expertise as a photographer to make pictures," I wrote to the photographer. "You did not agree to turn over your entire work product as well as unlimited rights to it. Absent a written agreement that specifically says you agreed to surrender copyright to your work, that copyright remains yours forever."

It's worth noting that this young woman had the right idea—she was not willing to surrender her stuff merely to make a quick buck. From talking to her on the phone, I got the impression that, in later years and with more experience under her belt, she would not be one to agree to "work-for-hire" contracts unless she were to be paid a hell of a lot more than her day rate and expenses in return. She wanted what was coming to her—and

even was willing to go to court to get it. It wouldn't surprise me if she one day joined ASMP—I certainly suggested it.

If ASMP occasionally gets a bad rap for being overly concerned about photographers' rights, it simply may be because our clients have become used to too many of us letting things slide in terms of rights and usage in hopes of landing a job. Maybe none of us would get into the kind of bind in which this young, inexperienced shooter found herself. But who among us, in hindsight, hasn't given up more than we should in terms of rates and rights?

There is, of course, another side to all this. There may be times when holding on to chromes and negatives is more trouble than it is worth—when, for example, a project or program is so specific, or has such a limited shelf life, that there is no reasonable prospect for resale, stock or other usage. Then, I would suggest, a photographer would be perfectly justified in giving up these materials (for a fair return, of course), rather than have them clutter up his or her files.

For example: My wife and I are commercial and editorial shooters. We do annual reports, brochures, magazine portraiture, events, album covers—you name it. And we hold on to our negatives and chromes—or at the very least have an understanding with our client that we can shoot dupes in camera for our own use. (A client who insists on a total buyout must agree up front to doubling our day rate—and even then must allow us to use photography from the job in self-promotion.)

But a sizable part of our annual income also comes from shooting weddings, at an hourly rate roughly double that for our corporate work. We make good money from this end of our business, but it is not the work on which we base our reputation as photographers.

Wedding photography simply helps pay the bills.

And we give our clients their negatives, as well as limited rights to make prints for personal use.

Granted, some of our colleagues think we are crazy, since we could make a ton of additional money selling prints and albums to clients, as most other wedding shooters do. That's their choice, and more power to them. But Judy and I long ago decided that we love making photographs—not spending our valuable time taking print orders, compiling albums, or overseeing a staff of wedding elves doing this for us. Sure, we could become a cottage industry, but then we wouldn't have time for the next magazine assignment, or the next album cover, or the next location corporate job. And I certainly wouldn't have any time to work on the books that have made my reputation as a location portraitist—not to mention enhanced my salability to commercial and editorial clients.

Given all that, what do I want with somebody's wedding negatives?

It is our choice, our decision—and certainly not a one-way street that only benefits the client.

Jay Maisel, the Brooklyn-based editorial and corporate shooter (and no friend of work for hire), tells young photographers to surrender rights

selectively, or put another way, urges clients to buy only those rights they need—it's a hell of a lot cheaper that way.

But as too many of us know, the current trend is toward more unlimited buyouts, not fewer. If I had to pick one reason for this (besides the willingness of too many of us to roll over in hopes of getting a job) it would be the fact that too many clients are being allowed to exercise this outlandish bit of control because they can do so with no appreciable financial harm. That is: as long as they can do so without it hitting them in the pocketbook, they will gobble up as many rights as possible, from as many photographers as possible, for as long as possible.

Obviously, every photographer has the right to refuse to work for hire. But in the real world work for hire is not going to disappear by itself. At the same time, there is no shame in giving up rights—so long as you are paid handsomely for them and intelligently weigh the pros and cons of doing so.

Work for hire may be a reality for photographer and client. But it also should be a client's most expensive option—a punitively expensive option—when negotiating with a photographer.

Sooner or later, the bottom line may do the talking for you.

Stephen King, Photography Teacher

01/05/01

Though he probably didn't set out to do it, author Stephen King has written an insightful, plainspoken, and thoroughly enjoyable book on photography.

Of course, King's latest book, *On Writing*, is about the craft of setting words to paper, as well as a deftly written autobiography describing his Maine boyhood, his enduring marriage to fellow novelist, the former Tabitha Spruce, his successful battle with alcohol and drugs, and of course, his recovery from the 1999 car accident that nearly killed him.

But as someone who has met King and photographed him, and who has spoken with him a number of times about his craft, I finished his book thinking that a lot of what King said about being a good writer can apply to being a good photographer. I respect King greatly for his devotion to what he does best—telling stories that can grip you by the throat, move you, scare you, make you laugh out loud, and then rob you of a night's sleep. And that devotion, I think, can be translated to other art forms.

"This is a short book because most books about writing are filled with bullshit," King says in one of his three forewords. (Don't ask.) "Fiction writers, present company included, don't understand very much about what they do—not why it works when it's good, not why it doesn't when it's bad. I figured the shorter the book, the less the bullshit. . . ."

But in fact King does understand much more than he initially lets on. He understands—and beats the reader over the head with the notion—that devotion to process is what informs craft. And that craft becomes art only after long, hard work.

Hard work is enjoyable work if you love what you do, especially if you do it well. In photography, does that mean you will love taking pictures only after you've produced gallery-quality work? Of course not. You started to love making photographs after you saw the first magical results from your Brownie. Something in you resonated over the process of picture-

taking the same way that riding a horse for the first time, or hitting a ball, or listening to music resonated with other people, with different joys and different inborn talents.

And you kept on doing it.

"Talent renders the whole idea of rehearsal meaningless;" King says "when you find something at which you are talented, you do it (whatever it is) until your fingers bleed or your eyes are ready to fall out of your head. Even when no one is listening (or reading or watching), every outing is a bravura performance because you as the creator are happy. Perhaps even ecstatic."

Part of King's prescription for fledgling writers—those happy souls who view being alone with a blank tablet and pen as a joy not a punishment—is to read and read voraciously because "reading is the creative center of a writer's life." I would say here that looking at, studying, and absorbing good photography serves the same purpose for a beginning photographer. That is because learning the components of a good image—composition, lighting, gesture—and seeing those elements used differently over and over by different masters, makes it easier for a person to achieve the same end on his or her own over time. And there simply is no alternative to this, no shortcut.

"If I had a nickel for every person who ever told me he/she wanted to become a writer but 'didn't have the time to read,' I could buy myself a pretty good steak dinner," King observes. "Can I be blunt on this? If you don't have time to read [insert: study photographs], you don't have the time (or the tools) to write [insert: to photograph]. Simple as that."

It is instructive to see that nowhere in his book does King have anything to say about his "equipment." From my own conversations with him I know that he writes on everything from a computer to the back of napkins. Keep this in mind the next time you are tempted to think that your creative output would be doubled if you just spent the rent money on a better camera. Better you should spend a fraction of that total on a few more photography books so you can study the images therein to better use the camera you already have.

But what about developing a personal style? In photography, this often is called "a personal vision." Once again, except in very rare cases, style/personal vision is developed with time and effort. It is almost never inborn.

The new writer, King says, may find him- or herself adopting a style that seems particularly exciting, "and there's nothing wrong with that."

"When I read Ray Bradbury as a kid, I wrote like Ray Bradbury— everything green and wondrous and seen through a lens smeared with the grease of nostalgia. When I read James M. Cain, everything I wrote came out clipped and stripped and hard-boiled. When I read Lovecraft, my prose became luxurious and Byzantine . . ."

Blending these styles together, into what even King admitted was sometimes "a hilarious stew," is all part of developing one's own style. In

my own career, shooting color, I can distinctly remember slavishly aping my heroes: Ernst Haas and Pete Turner. I make absolutely no apology for all of the photos I made of walls with peeling paint or of countless images, both color and black-and-white, of artfully abstract (read: unrecognizable) auto parts.

It's all part of the process.

Finally, there is the issue of frequency. In my view, a photographer is someone who photographs. Not someone who thinks about photographing, or who wants to photograph, but someone who does it, preferably day in and day out.

"The truth," says Stephen King, "is that when I'm writing, I write every day, workaholic dweeb or not. . . . And when I'm not working at all, during those periods of full stop I usually feel at loose ends with myself and have trouble sleeping. For me, not working is the real work. When I'm writing, it's all the playground, and the worst three hours I ever spent there were still pretty damn good."

As a photographer (who also happens to be a writer), I sure can relate. So can you, I'll bet.

SECTION III

Shooting People

Photographer
of the Bride

07/17/92

You've always liked Cousin Mary and were delighted when she got engaged. You were even more delighted when she invited you to the wedding.

So how come you're not happy that she's asked you to be her wedding photographer?

Wedding photography is part art, part science, part psychology, and part preparedness. The most nerve-racking thing about shooting a wedding is that there's just one chance to get it right. No reshoots another day; no shrugs that you'll get it next time it happens.

So to make sure that nothing goes wrong during this important assignment, go through the same drill the pros do before any important job—with these added tips on dealing with the "client" and her family.

Above all, make sure your equipment works. Regardless of how fresh the batteries in your camera and flash are, change them for the big day.

Bring plenty of film. For most of our wedding work, my wife and I use garden-variety Kodacolor Gold 200, a great all-around film, preferring it to the more "professional" Kodak Vericolor because it has richer color saturation and warmer flesh tones. (Vericolor always looks too pastel to me. It may be able to register detail in a black tuxedo next to a white wedding gown, but I find the flesh tones too insipid.)

Speaking of film, if you are allowed to photograph the ceremony (always check beforehand to avoid embarrassment), do it without flash. Flash pictures during the processional and recessional are fine, but virtually every church or synagogue that allows photographs during the ceremony insists on available-light shooting. (At least that's what the written rules tell the professional. There rarely is any admonition against flash picture taking posted or announced beforehand, so camera-toting guests frequently flash from their seats while the official wedding photographer works unobtrusively from a tripod.)

When shooting Jewish weddings, great hora pictures can be made if you stay inside the circle of dancers and shoot up at your subjects with a wide-angle lens. Keep one eye open to avoid being elbowed or tripped up by exuberant celebrants.

Flash during a ceremony is intrusive, boorish, and largely ineffective, since an on-camera flash unit cannot light something thirty feet away. So bring along a roll of Fujicolor 1600—a great low-light film. It's so fast you may even be able to hand-hold the camera during the ceremony, but if your exposure meter indicates otherwise (anything a fifteenth of a second or slower) use a tripod or monopod; otherwise you'll just be wasting your time taking blurry pictures. With permission, you should be able to set up your tripod in either the center aisle or the choir loft during the proceedings, so you won't have to shoot over heads or between shoulders.

Most amateur photographers rely on one zoom lens, and this may be fine, provided the low end of the lens is wide enough—at least 35mm—to make group shots. When Judy and I work a wedding, for example, we have between us 24mm and 28mm wide-angles, as well as 35–105mm and 35–135mm zooms (not to mention a total of four camera bodies and spare battery packs in case any should fail).

So let's assume your equipment and film are okay. At best, that's only half the job. In fact, the success or failure of a wedding shoot is how well you've covered the event and caught all the important action—as well as the major players.

It amazes us to hear horror stories about photographers who failed to shoot the important guests or who spent all their time in the wedding couple's face looking for the "perfect" (read: perfectly staged) shot. The latter is a matter of style: The more formal portrait-style wedding shoot-

ers, who generally prefer to work in medium format, have been doing it this way for years. But missing important pictures is simply inexcusable.

The best way to make sure you get everything covered is to sit down with the bride and groom and work up a couple of lists beforehand. The first list should specifically name all the people in each formal group shot to be made either before or after the ceremony. Don't rely on the newlyweds to think up a dozen different group photo ideas amidst the excitement of their wedding day. Having a list also lets the couple know whom they must ask to stick around for the photographs.

The second list is less detailed, but equally important. It covers the group shots to be made at the reception: "friends from law school," "people at work," etc. We recently had one groom ask to be photographed with his "fellow bodybuilders."

Another good idea is to have a spotter from each family point out the important guests—the special aunts, for example, or the close family friends. These folks will probably not be wearing corsages or boutonnieres to make them stand out, but you can bet the bride and groom and their parents will be thrilled that you got them on film.

Check with the bride before the wedding, or with the band leader or DJ at the reception, about the sequence of events: when dinner will be served, when the cake will be cut. Will there be a garter and bouquet toss? Are there any special dances or special toasts? At Jewish affairs, the bride and groom often are lifted up on chairs during an exuberant hora—a great picture if you are in position for it. I prefer to be in the middle of the circle with a 24mm wide-angle and shoot up at the couple. The shots are always dramatic.

The long and short of all this is that shooting a wedding is work—and Cousin Mary should know that when she asks you to do this. She is in effect asking you to forgo being a guest. When you normally would be eating, for example, you will be following Mary and her husband around as they table-hop. These times create some very warm moments, but don't get you fed. Sure, you could try to be both a photographer and a wedding guest, but I guarantee your pictures will suffer for it.

The bottom line is that wedding photography—once-in-a-lifetime photography—is best left to a professional, or to an amateur who acts like one.

And if you do get tapped for the job, just remember to load up on the hors d'oeuvres.

Photographing Children, Part 1

08/21/92

Children have a way of breaking your heart—especially when they are doing something incredibly cute and you're standing there without a camera. But getting really good pictures of your kids is more than being in the right place at the right time with the right equipment. It takes practice, thought, a little luck, great attention to detail and, occasionally, someone holding a puppet of Big Bird.

I will outline some simple techniques—and a few tricks—that have given my wife and me some world-class photos of children. When Judy and I used to shoot kids together, we'd often leave the session ready for a nap or a drink. But it was worth it for the beautifully composed photos we made and for the natural, unposed expressions we were able to coax out of even the most recalcitrant two-year-old.

Here's how we did it:

When shooting in color, it's always best to keep the number of different clothing colors to a minimum. Try to have the child's clothing be compatible with the background so that you don't create a cacophony of color to pull the viewer's attention away from your child.

Try to avoid very light or very dark colors—they make it harder to achieve good detail in prints. Bright colors are OK, but they can tend to make a child look pale. Likewise, bold stripes can detract from a child's face and dominate the image.

Once you've narrowed down the field, let a child who cares about such things wear something he or she likes and feels comfortable in. (This is one reason that wedding photos of ring bearers and flower girls show them either ecstatic or miserable, depending on how each child feels about the unfamiliar outfit.)

Locations and props can make or break a photograph. If ever a case can be made for less being more, it is here. A cluttered background—be it

Waiting for the right moment and creating an uncluttered background made Judy's picture of these twins a winner. They had been allowed to touch their older brother's electric guitar (briefly) and were fascinated by it. (© Judith Goodman)

busy wallpaper or extraneous furniture—can quickly turn your photography into just another snapshot.

Think about locations beforehand. Parks and playgrounds are obvious choices, but not necessarily for the play equipment. You are looking for nature's equivalent of a seamless gray backdrop: seamless green grass on a rolling hillside, or trees and woods. But be careful to watch for distracting shadows on faces caused by overhead branches and leaves.

In the summer months, a sprinkler for kids to run through is a natural—I guarantee they will forget all about you and concentrate on getting soaked. For toddlers, a baby pool is a good choice, as is letting them hold a hose with water trickling out—they'll be fascinated by it. In cases like these, the younger the children, the cuter they will be with no clothes at all.

Washington, of course, is a city of monuments and these monuments, or more correctly, pieces of the monuments, can provide beautiful architectural details and backdrops for your pictures. One of the most enjoyable jobs we ever shot was of two little sisters playing hide and seek and generally having a ball running around the giant pillars of the Jefferson Memorial. The girls were there with their dad and the idea was to make

some pictures of Megan and Kaitlin in Washington that their father could show the folks back home in Michigan. The first shots we made were pedestrian: Dad and the girls sitting on the grass with the Washington Monument in the background. The Jefferson Memorial ones, however, were just right: The girls' exuberant faces were the focus while the staid white pillars of the memorial suggested, but never shouted, the presence of the Federal City.

More mundane but just as appealing are places and things that can frame your children and set off their faces. Sometimes this simply can be a tire suspended from a jungle gym, or possibly a window frame. Never underestimate the power of an image of a curious child looking over, under, around, or through something in which he or she is fascinated.

When it comes to props, the universe of choices is limitless. For example, besides toys, they can include: hats, soap bubbles, clothes that are too big, dogs (provided they don't always face the kids and point their rear ends toward the camera), tools, telephones, wooden spoons, towels—you get the idea.

Babies respond animatedly to surprising (but not shocking or frightening) noises: from music boxes, a jack-in-the-box, squeaky toys, etc. Toddlers are crazy for hand puppets, ice cream, and books, either ones they hold and peruse themselves or ones their parents read to them, either in the photograph or out of the frame, behind or to the side of the photographer.

Clearly from some of the above, you are going to need help at times. Get it. You can't concentrate on making good photographs while shaking a rattle or a Big Bird hand puppet at a baby. Have someone familiar with the child—a parent, friend, or grandparent—get his or her attention while you concentrate on looking through the lens at the child's expression. This alone will improve your pictures—and preserve your sanity.

Photographing Children, Part 2

08/28/92

Baby-in-a-basket and "How 'bout them O's?" actually are two of the many different techniques we have come up with for photographing children.

Sometimes the techniques are simple common sense; sometimes (as when working with teenagers) they provide an artful way around a reluctant subject. Somewhere in this list should be something that will improve your children's pictures considerably.

First of all, when shooting kids, consider using two cameras, if possible. Load one with color film, the other with black-and-white. Or you can have your 28mm wide-angle lens on one body and your 35–70mm zoom on the other. Anything that keeps you from fumbling with your equipment is a plus.

When photographing babies who can't yet sit up by themselves, prop them up in a large basket, tub, or carriage filled with pillows. Once, when doing a studio portrait of an infant, we simply layered a pretty blanket in the baby's car seat, covering the straps, then placed the little guy in it. The result was a beautiful backdrop, and the child was both comfortably secure and happy.

Babies who can hold up their heads often can be photographed on large beds (be careful of what appears in the background) while the photographer is on the floor, face to face with the child.

Incidentally, babies don't last long. Stop shooting when they grow hungry or tired; otherwise you are just wasting film. (Obviously, it's a good idea to time your photographs for just after nap time.)

A parent holding a child close to the face is always a wonderful shot. One perfect example: a mother holding her baby shot by available window light.

Toddlers are very curious. Everything they do is a photograph if the background is cleaned up. Note the difference between a messy, haphaz-

Not every picture of children must be taken from the front. Photographing with Judy at a Montessori school, I was able to make a wonderful—and universal—"portrait" of children climbing stairs.

ard background and a child surrounded by interesting, related items like pots and pans or identical items like leaves or pumpkins in a patch.

Young children seem always to want their friends with them, and they can be used to entertain while you concentrate on the child's expression. And during the shoot, make sure to ask the child's opinion of what he or she wants to do. More often than not, the child will want pictures with his or her friends. Take them. Burn lots of film. Then you can more easily ask them to pose the way you want them to.

In that vein, there simply is no way around it: Teenagers and preteens can be difficult, but you at least can try to get on their good side. Never be condescending or abrupt; always ask their opinion. Try to get them to feel you need their help (which you most assuredly do if you hope to get decent pictures). Treat them as equals; hardly anyone else does.

Sometimes, though, the kid may be willing, but the attention span is weak. Once, Judy called me from a shoot a few doors away and said she could not get one perfectly nice ten-year-old boy to look anything but bored. After all, the photo session was cutting into his Little League practice. I hurried over, borrowed one of the kid's baseball gloves, and threw the ball around him while Judy took some great shots of a young boy doing what he loved best—talking baseball and playing catch.

If you have a child who likes to pose for you, make one shot for the child, but be ready to take the next picture immediately afterward because then is when you are likely to get a natural and appealing shot.

Try different angles—everything doesn't have to be full face. With toddlers, for example, a shot totally from behind as they struggle to get into a chair, or climb the stairs, or wander down a path, can be as much of a winner as the best portrait.

By the same token, when you are photographing faces, expression is the only thing of importance. If you are looking through the viewfinder and the expression is wrong—no matter how lovely the setting, no matter how great the light—it is no good and not a picture. (Practical tip: Always focus on the subject's eyes.)

When shooting more than one child, have them put their faces close together. It'll feel funny to the kids—probably making them crack up in the process, which is good—but it can make for a terrific photograph. In fact, all groups or pairs of people should somehow be connected to one another, either by touching one another, or holding onto a common element like a railing or banister—or even the family dog.

To freeze moving activities like a soccer game, shoot at a high shutter speed, of course, but also try prefocusing on a particular place and wait for the action to come to you, not vice versa. Children love to jump. Ask them to do one or two jumps to set your focus before you actually shoot. Conversely, to show motion via a blurry background, you can use a slower shutter speed ($\frac{1}{60}$ or slower) and pan the camera with your child as he or she runs by you. It takes some practice, but it is worth it. The child will

be in relative focus because you (that is, your camera lens) and the child were moving at roughly the same speed.

During your shoot, don't forget to make a number of different poses: full length, profiles, some of just the head, some with head and hands. But always leave a little bit more room at the edges, because most commercial labs' machine processing always cuts off some part of the photo at the edges. Also, when you want to put a photo in a frame, it is best to have the frame beforehand: Measure the opening exactly, then have the print made to fit exactly as you want. There is precious little uniformity among frames. Where one frame may have an opening of exactly 8" × 10", another may have only 7½" × 9½". It pays to measure.

Finally, picture stories are great, especially for grandparents who are out of town and don't get to see the kids regularly. Anything makes a story: a trip to the zoo—even a trip to the mailbox. One of the easiest is a birthday party. To get the whole sequence, you need someone else in charge while you photograph. Plan ahead—think about opening and closing sequences, overall views as well as closeups.

Who knows, if you plan it all right, you may even have time for a piece of birthday cake. You will have earned it.

On Location with Stephen King

12/09/92

Anyone who takes pictures regularly knows that great picture opportunities and great picture-taking conditions don't always go hand in hand. Remember the time you wanted to get the family together for a group shot in front of the beach house, only to find that Hurricane Hugo had other ideas?

To anyone who thinks stuff like this happens only to amateurs, think again. I really believe the pros who make it in this business are the ones who can bounce back when things go wrong, which they do with maddening regularity. And that shouldn't be a surprise when you consider the fact that someone who makes pictures every day probably increases exponentially his or her odds of experiencing some kind of glitch.

A recent experience of mine—on location in Bangor, Maine, photographing the author Stephen King—is a good example of how to take a less-than-perfect situation and still produce an excellent image. The secret is in not getting rattled—and in knowing your equipment.

I had been after King for months, hoping to get him to pose for my book on Maine. I made contact with King (or more correctly, with his office) last summer and found that he was willing to sit for me in the fall. Fine, I said, I know just how I'll shoot him.

In fact, I did have a very specific idea: to photograph King "against type" on the mound of the beautiful Little League stadium that he and his wife Tabitha had built for the Bangor community. I had visions of shooting in late afternoon on a crisp fall day, with fluffy clouds on the horizon, the diamond pattern of the field adding to the composition of the portrait. No, this was not going to be yet another shot of the master of horror looking ghoulish. King, like me, is a baseball nut, and I wanted to capture his joy for the game.

So what happened? First, King's schedule kept pushing our date back. We finally settled on Nov. 4, the day after the '92 presidential election. This

Mega-author Stephen King could give me only thirty minutes for a portrait on this cold rainy November day in Bangor, Maine. But I had gotten there twenty-four hours early, set up the shot in advance, and was ready to go when King and his wife arrived on location. The picture, which King loved, is in the permanent collection of the National Portrait Gallery in Washington. © Frank Van Riper

meant I would have to travel to Maine on Election Day, meaning also that I would have to vote absentee. But to an old political reporter like me, that was old hat. I had been voting absentee in presidential races for years, since I always managed to be on the road with a candidate come Election Day.

Then King's office said the only time he could give me was midday (so much for great late afternoon light). Then, when I flew up the day before the shoot , the weather was cold, dank, and drizzly—with the promise of more to come.

Faced with these conditions, the first thing I did upon my arrival twenty-four hours before the shoot was to go back to the ballfield to see if there were any way I still could work there. It was important that I be at

the site exactly twenty-four hours before the outdoor shoot, so I could gauge the sun's position—even if there was likely to be precious little of it to work by the next day.

I looked around for some covered areas and finally hit upon the space under a concrete ramp leading up to the grandstands. Though this camera position was under cover, you still could tell it was a sport field by the chain-link fence, as well as by the scoreboard and light pole visible in the background. In addition, the ramp created an interesting angular shape at the top of the frame that I hoped to mimic with the subject's body placement.

I wanted to show as much of the background as possible, so I decided to use my Hasselblad Super Wide C/M. I placed a Polaroid back on it and made a few shots just to check angle and composition. Since I deliberately did these tests exactly twenty-four hours before my appointment with King, and with the weather unlikely to change, I could figure the light would be about the same. To open the shadows under the ramp, I placed a small Armatar 100 flash unit on a light stand at camera left and diffused the light with a Norman 2D diffusion head. To camera right, also on a light stand, was a tiny Morris Mini self-contained flash unit, also to help fill in the shadows.

The final Polaroid of the site looked fine. I was ready. I made a mental note of where all the equipment had to be the next day, packed everything up, and got in out of the rain. That night I watched a young Bill Clinton beat George Herbert Walker Bush for the White House.

The next day, I went back to the site, set up, and waited. King and his wife Tabitha showed up right on time. I had asked King to wear something he might wear when he coached Little League. He obliged in spades, wearing a baseball jacket with a huge letter B, and a cap saying Bangor Baseball. He even wore high-top sneakers with his well-worn jeans. I could have kissed him.

"I've only got about a half hour," Stephen said. "Is that okay?" Having done all my tests beforehand, that was plenty of time. I placed King where I wanted him, made a final Polaroid, then started shooting. Fifteen minutes and twenty-four pictures later, the shoot was done. The Kings could not have been nicer.

As they pulled away in their car, the cold drizzle was still falling, but because of the advance planning I had done, it had not rained on my parade.

And I'm proud to say that the portrait of Stephen King I made that day is now in the permanent collection of the National Portrait Gallery in Washington.

Better Portraits

03/18/94

Turning a picture of a person from a snapshot into a portrait isn't really difficult, just a tad more time-consuming than simply pointing and shooting.

If you take a look at the work of top-notch portrait shooters, be they editorial, fine art, wedding, children's, or corporate photographers, I'm willing to bet you will find marked similarities in their best work—not slavish copying, but simple adherence to a few basics that can turn a bad picture into a good one, a good picture into a great one.

Backgrounds. Even in environmental portraiture that aims to depict the subject in his or her milieu, you will not find clutter distracting you. Remember this unforgiving dictum from photographer Jay Maisel: "You are responsible for everything in your frame." In portraiture, this often means framing your picture so that the subject's face or upper body is the dominant element of your picture—not the distracting bright red floral arrangement off to the side, or the bookshelves filled to bursting in the background. In cases like these, it often helps to shoot with a medium telephoto lens like a 105mm, opened all the way, to help throw the background out of focus and concentrate the viewer's attention on the subject.

Finding the right level. In most portraiture, it is wise to keep the camera roughly at a level with the subject's head, but keep in mind that different effects can be achieved with different angles. For example, shooting up at a person from an extremely low angle can make the subject loom large, or even sinister, in the picture, whereas shooting up from only slightly below head level can lend an air of importance to the person being photographed. Keep in mind, though, that when shooting a seated figure, low-angle shooting can make the person's knees appear distorted if they are included in the picture.

By contrast, in glamour photography, you often see the camera raised slightly above the subject. In photographing women, especially younger

Portraits often can be improved by including a subject's hands in the frame, as was the case of this portrait of the late Washington art dealer and photographer Franz Bader. Judy's beautiful, elegant portrait of a young woman with a striking profile was made by window light. Black-and-white Infrared film adds to the mystery of the image. © Frank Van Riper (Bader); Judith Goodman (woman)

women and girls, this can lend a demure quality to the picture. On a more practical level, in trying to achieve the most flattering picture, a higher elevation (combined with the lighting I describe below) often can minimize a double chin, or perhaps an unflattering neck line.

Straight on versus angled. The classic snapshot pose is looking right into the camera. This may be great for kids, whose faces are treasures no matter how you see them, but in adults it often means that the picture will take on the unwanted look of a driver's license or passport shot.

A simple solution is to have the subject turn slightly to one side, then look over toward you and the camera. We often use this technique in full-length portraits of brides. It will give you a flattering rendering of the subject's figure while at the same time removing that awful static feeling that comes when a subject's shoulders point squarely at the camera.

One caution, however: Be careful not to have the subject turn toward you from too sharp an angle. In older people especially this can create a hard line at the neck.

Don't forget hands. I think almost any tight shot of a subject's face is enhanced by one or both of the subject's hands. If your subject is sitting in an armchair, have him or her rest the chin on a hand. During a portrait shoot a few years ago with art dealer/photographer Franz Bader, the best

shot I got came when Bader was commenting on my lighting setup and stroked his chin contemplatively.

Lighting hints. When using flash, move your subject away from walls to prevent a hard shadow line. You also can achieve this by raising your flash so that shadows fall away from and behind your subject, out of frame. Keep in mind that harsh light, especially from one side, will emphasize lines or blemishes on your subject's face. If you want your subject looking like the Marlboro Man, fine, but that may not be the effect you want when photographing grandma.

The closer the flash is to the camera, the more flattering the light will tend to be. When using two lights, you will see a marked difference—not necessarily in the exposure, but definitely in the picture—if the lights are to your immediate left and right as opposed to a couple of feet from you on either side of the camera. Raising the lights above the subject's head also can create a shadow under the chin that can minimize a troublesome neck.

Looking for something new and different. Take your handheld flash (a Vivitar 283, for example) and tape a toilet tissue roll to the end so that the emerging light comes out in a round circle. Try some experiments with your subject in a darkened room, using the flash off the camera and aimed at his or her face. You'll be surprised at what you get, I guarantee.

Work with, not against, color. When shooting color, always remember that bright things attract the eye, and that a cornucopia of color can leave you visually exhausted. In group portraits, try to have your subjects wear similar or complementary colors. One reason outdoor portraits tend to be so pleasing is that the photographer has created a basically all-green backdrop to concentrate our eye on the people photographed.

Obviously, the above are only a few basics, but they should give you a start toward turning your pictures of people into real portraits, not something you'd expect to see hanging in the post office. Good luck!

Portrait of
a Jazz Great

Burnett Thompson, who plays great jazz piano, needed a new publicity photo. The old one had been made several years earlier and was perfectly adequate. But, with its formal pose and standard lighting, there wasn't a whole lot to distinguish it from hundreds of other publicity stills of hundreds of other musicians.

So Thompson called us.

The shot, we figured, should be made on location, at Thompson's "office"—the cocktail lounge of downtown Washington's West End Cafe, where he used to play evenings every week. Working on location would be more convenient for all concerned and also would give us the option of including Thompson's grand piano.

The photo—done in an hour and a half, just before the lunch crowd—offers a good lesson in location portraiture and how a picture evolves slowly, one Polaroid at a time, until all the elements come together.

Actually, my wife Judy and I shot Thompson's portrait on our second visit—the first was simply to scout the location and get ideas. One of the first things we decided was that the kind of shot Thompson needed, a fairly tight head shot, should not include the piano. That was fine since the lounge is also part of the restaurant and dozens of tables and chairs made piano-moving an unlikely option.

What I did like was the mirrored wall at the far end of the room. I had the idea of using the wall to create a double image of Thompson, to make the picture a little out of the ordinary. Given the tight confines in which we had to work, the mirror also would act as a reflector to bounce light back into his face and possibly eliminate the need for a second light.

Before we began to set up the shot, Judy and I made a "baseline" Polaroid by available light just to see what we had, on the off chance that the shot could be made without additional lighting. (Since we were shooting in black-and-white, we didn't have to worry about color shifts from

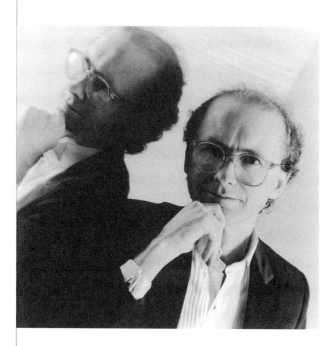

One of Washington's best-known jazz pianists and composers, Burnett Thompson, posed for this portrait in the cramped nightclub where he performed. Since we couldn't move his piano, or much furniture, Judy and I had to improvise. (© Goodman/Van Riper)

tungsten bulbs or fluorescence.) The one-second exposure was flat and, worse, the overhead lights made Thompson's forehead glare. Also, so long an exposure would invite unsharp pictures, no matter how still the subject stayed.

So we set up a softbox to Thompson's left.

The next Polaroid revealed a much better tonal range, full of rich blacks and crisp whites, but the right side of Thompson's face was too dark, even with the mirror. Since the mirror kept us from putting a reflector to Thompson's right, I set up a light stand with a small Morris Mini flash unit and aimed it at the shadow area on Thompson's face. But not before I diffused the light from the Morris with a couple of layers of handkerchief.

The Polaroid looked fine—but something still was missing.

"Try turning the camera," Judy suggested.

That did the trick, creating a pleasing off-center image.

"There's nothing like a great final Polaroid to make a photographer confident the picture's gonna turn out fine," I told Thompson. "Probably like a good final rehearsal before a recording, right?"

"Actually," Thompson said, "I'd rather have a bad final rehearsal, concentrating just on the mechanics." That way, he noted, he and his accompanists wouldn't fear they'd left their best take in the rehearsal hall.

Breaking the Rules at the Kennedy Center

04/26/96

A recent assignment to create a series of dramatic portraits for a magazine layout offered a good look at how breaking some photographic rules can lead to some dynamite pictures.

We had been hired by *WebMaster Magazine* to illustrate an article on how the John F. Kennedy Center for the Performing Arts is expanding its reach to the theater-going public via the Internet. What the art director for the Massachusetts-based magazine did not want was yet another photo of someone sitting at a computer screen. What she did want was a series of pictures, each in "a grandiose setting" that shouted Kennedy Center while rendering a good portrait.

Location portraiture almost always begins with site visits and a ton of phone calls. The good news was that each of our three subjects was happy to oblige; the bad news was that they only could spare a half hour each—and on only one day.

Fortunately, the Kennedy Center was full of grandiose settings. For one shot we chose the balcony of the Eisenhower Theater—with a bare stage visible in the background. For another, the center's massive grand foyer, with the famed bust of JFK looming to the subject's left. For the third shot, we chose the long Hall of States, festooned now not only with state flags, but also with a huge banner marking the center's twenty-fifth anniversary.

We chose the latter site for the layout's key shot, of Scott Stoner, the Kennedy Center's director of online services. The Hall of States not only was a dramatic setting, but the anniversary banner literally spelled out the location.

My wife and partner, Judy, and I arrived with our equipment two hours before the shoot, to set our lights and make Polaroid test shots, so that when Stoner arrived the session could go quickly. We chose to work in medium format instead of 35mm. The photographs were scheduled to

The Hasselblad Superwide CM is supposed to be held level, and almost never looking up at the subject. But, for this magazine portrait at Washington's Kennedy Center, the slight distortion added to the grandeur of the Center's Grand Foyer. But a more extreme angle would have made the subject's head too small.

run large—as much as eight inches square—which dictated using a larger format, for maximum detail and sharpness.

To emphasize the background, we had to work in wide-angle. I selected our Hasselblad Super Wide camera, the main advantage of which is its ability to render wide vistas without any distortion—provided the camera is held absolutely level. But to make the scene look even more dramatic, I decided to shoot slightly up. This broke the rule of using the SuperWide straight on—the camera even comes with a built-in bubble level—but the Polaroids looked great, the distorted background looking even more dramatic. To be sure, we could not have been too much off-level; otherwise Stoner's legs would have looked ridiculously long and his shiny pate would have turned into a pinhead. It was all a matter of degree.

The second rule we broke was using a long exposure—¼ of a second—even though Stoner was lit by two powerful strobe units and theoretically could have been shot at, say, ¹⁄₂₅₀ of a second.

But the long exposure accomplished two ends. First, it allowed us to render detail at the back of the long hallway, which was not hit by the strobes. Second, it gave us the chance to clearly show an image on the screen of Stoner's laptop computer, which lay at his feet. It was a key—if small—element of the portrait.

Working this way does have one drawback in portraiture: It requires your subject to stay very still, unless you want to create a slight halo around him or her—sometimes a great effect. This time we wanted Stoner to freeze—which he did admirably. The prints were tack sharp, broken rules and all.

Focused Flash for Great Portraits

01/31/97

Think of the average driver's license photo or passport picture and you'll conjure up the worst of flash photography. Second only to flash snapshots made with the subject up against a wall, these pictures have the raw, unpleasant quality of photos illuminated by truck headlights.

It's no wonder that professional photographers who rely heavily on the equivalent of flash units—studio strobes—often seek to modify the output of these units to make their photos less stark and more pleasant.

But not always.

Sometimes, in trying to make a dramatic image, direct flash can be a terrific tool. It all depends on how one uses it.

During a recent assignment for *New Scientist*, a London-based magazine specializing in scientific stories geared to the lay reader, I had to photograph three astrophysicists who have been tracking the progress of the Hale-Bopp comet, expected to soar across the heavens this spring in what scientists hope will be "the astronomical sight of the century."

There were to be three separate black-and-white portraits at three separate locations: the University of Maryland observatory at College Park, the Space Telescope Science Institute at Johns Hopkins University in Baltimore and the Goddard Space Flight Center in Greenbelt. For the first two portraits, of Mike A'Hearn at College Park and Hal Weaver at Hopkins, lighting was fairly straightforward: The main light was a White Lightning 10,000 strobe unit in a 3' × 4' softbox. The softbox would diffuse the harsh direct light of the strobe into a soft wash of "window light" creating a pleasant directional light on the subjects' faces. I made a fairly tight shot of A'Hearn, using the softbox to highlight his luxuriant white beard. I shot Weaver in the lobby of the Science Institute, shooting from below to incorporate a one-fifth life-size hanging model of the Hubbell Space Telescope—as well as to eliminate such extraneous elements as the nearby security desk.

For a cover article in London's *New Scientist Magazine*, we did portraits of a number of the scientists who were tracking the Hale-Bopp comet. Bearded Mike A'Hearn is lit by a softbox to his right and another strobe aimed at the upper ceiling to his left. But for Mike Mumma (next page) at the Goddard Spaceflight Center Observatory, I used a direct flash and aluminum "blackwrap" to create a dramatic circle of light around him—and also to leave a lot of black space for type.
© Goodman/Van Riper

But for the third portrait, of NASA astronomer Mike Mumma at Goddard, direct flash with a slight but important modification was just the ticket to create a dramatic environmental portrait that led off the magazine article.

The most challenging—and for me most enjoyable—thing about environmental portraiture is quickly surveying a subject's surroundings and deciding how to incorporate those surroundings effectively into a striking photograph. During a pre-portrait site visit to Goddard, Mumma and I looked at a number of possible picture sites. The Goddard visitors' center was one possibility, but the various displays seemed too distracting.

Mumma's office was the kind of cluttered book- and chart-decked space one would expect of a scientist—but there really wasn't anything that shouted "comet-watcher."

Then we drove to Goddard's observatories. Bingo!

There on a hillside were several huge round-topped observatories, each housing a humongous telescope. Inside one of the observatories was the telescope that I knew immediately would make a perfect backdrop for the portrait.

The following week, on a gorgeous sunny day, I worked both in the sun and in comparative darkness. For my first shot, I photographed Mumma with the observatory's roof rolled completely open. Standing on a ladder, I used a Hasselblad Super Wide camera to include the large expanse of the observatory floor, the telescope, and Mumma himself, looking out the opening at a cloud-decked sky. It was a great available-light shot, but I also needed a tighter one, to complement the two I had made previously. I pressed the button to close the observatory roof and set to work setting up my lights.

I wanted to spotlight Mumma—literally—in front of the telescope, his arms above him holding onto one of the telescope's massive beams. To do so, I used a powerful White Lightning Ultra 1200 flash unit aimed directly at him from a distance of about ten feet. But to focus the strobe's direct light, as well as to create a dramatic dark background, I taped a focusing scrim of Blackwrap onto the strobe unit's reflector. This would direct the light exactly where I wanted it. The Blackwrap—very heavy duty aluminum foil that is coated on both sides with heat-resistant matte black paint—let me create a pinpoint spot of light aimed at Mumma from above and slightly to his left.

To keep the dark background from going completely black, I made the shot at a long exposure—varying from a half-second to a full second—so that some detail of the telescope base would be visible in the final print.

Though made with direct flash, the resulting portrait was anything but a passport picture.

In trying to do this yourself, bear in mind the following:

Pose your subject away from walls. That will eliminate that ugly edge of shadow so common in direct flash pictures.

Hold your flash unit away from the camera—via a long PC cord. That will let you determine where shadows will fall. The higher the unit, the more the shadows will fall below your subject. And vice versa, of course. Fresh out of Blackwrap? With small handheld flashes, a cardboard toilet paper tube, taped to the front of the flash with black gaffer's tape, will do the trick nicely.

Simplified Location Portraiture

If photographers from Mathew Brady to Cartier-Bresson produced gorgeous portraits by available light, why is it that so many portraits today, made with the latest in electronic flash and computer assistance, look so dreadful?

Whenever I teach a seminar on portraiture, I always ask to see students' previous work. More often than not, I see two things: A cluttered background that creates a visual cacophony that diminishes the portrait, and harsh, unflattering direct flash that turns any portrait into a mediocre point n' shoot passport picture. I'll discuss a few easy techniques that can vastly improve your portraiture without breaking your budget. A couple of the techniques I'll describe do involve tools that can be pricey, but their effects can be duplicated with mundane materials you probably already have.

Take a look at the accompanying family portrait, of a couple whose wedding Judy and I shot several years ago. It works on a number of levels. First, there are great expressions on everyone, including the baby—a product not only of my wife's superb timing, but also of my jumping up and down behind her to get the baby's attention. Second, there is absolutely nothing in the background to take away from the faces—a result of posing the trio against gray seamless paper. Third, the lighting is uniform and pleasant, almost as if the family were lit by gentle window light.

In this case, the window light is electronic: studio strobe light diffused through a softbox that has been suspended on a light stand above and slightly to the left of the subjects. All these elements combine to create a first-rate portrait. But take a look at the setup shot and you'll see a fourth element that is just as important as all the others. Note that mom, dad (and baby, obviously) are all of different heights, but that Judy has made sure that in the formal portrait their heads are fairly close to each other to create more intimacy and therefore a better picture. Here, this has meant

An ideal family portrait that looks spontaneous and natural. Actually it's the result of planning and the right equipment. Setup shot shows gray seamless paper creating uniform background. Having mom stand and dad sit places their heads closer together. Finally, to get baby sufficiently in the frame, he is placed on a pillow in Dad's lap.

that mom stand, while dad sits on a stool. He holds the baby, but in order to get the little guy up at the right level, the baby also is propped up on a pillow while in his father's lap.

None of the props (stool, pillow, light stands) is visible in the final shot. The portrait has the wonderful immediacy of a spontaneous moment caught on film. (But we all know better.) To get a similar look in your own work without resorting to seamless paper, see if you can work against a smooth wall, even if it means removing a picture or mirror. If you have enough room, move your subjects away from the wall. This will help throw the wall out of focus, minimizing any blemishes or imperfections in the wallboard or plaster. Such a move also will minimize, if not downright eliminate, harsh shadows from your strobe unit that can create the dark outline on the background that fairly screams "flash picture!"

To further soften your flash light without resorting to a softbox, you might try firing your portable flash unit through a diffusion medium as mundane as a white bedsheet suspended from two light poles, or other means.

In this picture, because there are three subjects, we wanted the light to be fairly uniform. For this reason, I also set up a second strobe light to the right of the family. However, this light was pointed, not at them, but at the ceiling, and set to about one-third the power of the main light in the softbox. The effect was simply to open up the shadows to make the portrait light more uniform. (A similar effect can be achieved without resorting to a second light by placing a reflector opposite your main light, to kick light back at your subjects. What kind of reflector? Over the years I've used expensive collapsible ones, as well as large pieces of scrap white cardboard—to almost the same effect.)

Reflectors can be your and your subject's friend in a number of ways. In simple lighting setups involving, say, one softbox slightly above your subject, a reflector held directly below your subject's face can kick light back up into your subject's face, effectively eliminating shadows under the eyes as well as the deleterious effect of bags or crow's feet. It's no wonder that this is a standard technique for fashion photography. Next I'll discuss another technique that you probably would not want to use on your average high fashion model. But it does create a dramatic effect. And it requires nothing more than a tiny portable strobe—and a toilet paper tube.

Dramatic Location Portraits

Often the most dramatic portraiture is not the most flattering.

One look at today's cutting edge magazines and you'll see any number of arresting photographic portraits that go far beyond the standard, cookie-cutter studio shot whose basic setup often involves a softbox for the main light, a hair light, and perhaps a light aimed at the seamless backdrop to create a halo-like glow around the subject's shoulders.

While there's nothing wrong with this setup, I do find it pretty boring. Pleasing, but boring.

Take picture 1, of my friend Jim. It's a fairly straightforward location portrait, made with only one light, diffused in a softbox to approximate window light. The only modification I've added is a reflector opposite the flash to bounce some light back at Jim to fill in the shadows on the right side of his face (photo 2).

Note: When photographing subjects with glasses, the light often has to be placed either well to the side or high above, to eliminate reflections. Otherwise your subject—even a rugged guy like Jim—can wind up looking like Little Orphan Annie.

But what if you wanted to try something different, more edgy?

This is a trick I learned from Washington photographer Tom Wolff during a great workshop years ago at Photoworks at Glen Echo Park. Using what arguably might be the most mundane photo prop of all—a simple toilet paper tube—you can turn any portable flash unit into a directed spotlight that can create really dramatic shadows and, I think, a bizarre and wonderful portrait.

Photo 3 shows my wife and partner Judy aiming the light at Jim from below as I snap the picture. The flash is simply a workhorse Vivitar 283, in this case powered by a Lumedyne battery pack in Judy's right hand. The flash is connected to my camera by a long PC cord so that it will be trig-

Sometimes a tool as simple as a toilet paper tube can help transform a picture into something really dramatic. The difference between the final shot of our friend Jim and the more conventional ones I made before is hard to believe.

gered when I release the shutter. I have attached the paper tube to the front of the 283 with black gaffer's tape.

The final result, in photo 4, shows how the directed light has create a punchy, contrasty image, with far more snap than photo 1. In addition, since Jim is sitting in front of a gray seamless backdrop, the shadows created by the flash make a wonderful pattern behind him.

Granted, Jim is having fun during all of this and is flashing a big smile. But think back to all those classic black-and-white monster movies we used to love. Can't you see Boris Karloff in the same setup, only without the flannel shirt and glasses?

Incidentally, the sinister nature of this light is accentuated by the fact that it comes from below the subject. (This seems to be a universal reaction to such light placement. We are used to seeing light normally from above—i.e., from the sun. The opposite immediately seems somehow "wrong" or frightening.)

Obviously, though, the light can be held wherever you like. Held high above and to the side, you can mimic the effect of a streetlight at night. From the side: the look of approaching car headlights.

Amazing what you can do with a toilet paper tube and one of the cheapest flash units on the planet.

When trying this technique, you may want to experiment with your exposure. I have to admit, being a professional, with all a pro's expensive toys, I was able to gauge flash output with a handheld flash meter, then confirm the reading by making a Polaroid picture using a special Polaroid back on my Hasselblad. But since all you really are doing is shooting by direct flash (albeit direct flash targeted precisely), the little exposure guides on the side of the flash unit should work just fine. And if you are shooting negative film, either color or black-and-white, there usually is a stop or two of wiggle room built into the film anyway.

During Tom Wolff's workshop, he also demonstrated a variation on the paper tube theme that can create an even more atmospheric image. When I made photo 4 of Jim, I was shooting at a fairly high shutter speed (probably $\frac{1}{60}$ of a second or better). But shooting at a much longer shutter speed—say a full second, especially if your camera is handheld—you can create cool shadow outlines of your subject, all the while your subject appears tack sharp.

This small photographic miracle is simply the result of the flash acting in effect like a second, very high speed shutter (the duration of the average flash unit's output is much faster than the highest shutter speed on most cameras). Thus shooting "drag flash"—combining flash with a slow shutter speed—creates two pictures in one: a sharp flash image (usually your subject) and a soft background.

SECTION IV

Technical Tips

Perfection
in Platinum

08/05/94

To look at a platinum print is to look at the most beautiful and perfect manifestation of black-and-white photography. A lushly printed color photograph—an Ilfochrome or dye transfer print, for example—may be a joy to behold. But platinum is magical. I must confess my personal bias toward black-and-white. I come by my bias honestly, having been for years a color photographer almost exclusively. But black-and-white, the medium in which I began, finally drew me back, and forever.

Think of a platinum print as a traditional black-and-white, or silver, print squared. Where even the finest silver-based image might offer ten to fifteen separate tones, or shades of gray, a platinum print from the same negative might have forty or fifty. This incredible extension of tonal range can offer shadow detail and bright-end subtlety that must be seen to be believed. So rich and diverse is the effect that highly detailed platinum prints can have so much depth as to seem nearly holographic. Since the nature of the process dictates that all platinum prints are contact prints, each shows precisely and accurately all the detail that is contained in the negative, with no loss of image due to projection through an enlarger.

Another important aspect of this process is its permanence. Where even the most carefully printed silver print might visibly change in one hundred years, platinum and its related metals are chemically as stable as gold. It is widely held that a platinum print is simply the most permanent image that can be put on paper.

The platinum process is at once exceedingly simple and maddeningly difficult. Prints can be made on any high quality paper—100 percent rag content artists' paper is a common medium. The paper is first coated with a solution of platinum salts and other chemicals. When dry, a negative is placed upon the paper, a clean sheet of glass holding it in place. Ultraviolet light is shined through the negative onto the treated paper and the resultant contact print is developed in subdued light. But this is like

saying that brain surgery is simply going into the brain with a sharp knife and removing all the bad parts. Technique, skill, and the patience of Job make all the difference.

All of which is not to say that any black-and-white photograph is improved if it is printed in platinum. There is a subtlety to photographs printed in the "platinum metals"—platinum and its sister element palladium—that inevitably lends a softness of feeling, if not actually in detail. Such a feeling easily could be discordant if the content of the photograph were stark, unsettling—even violent. The late Robert Mapplethorpe's sensually beautiful floral studies were perfect for platinum; his controversial homoerotic pictures were not. Walker Evans's timeless large-format, black-and-white interiors would surrender even more of their detail in platinum, but Diane Arbus's hard-edged, direct flash portraits of the people on society's fringe would lose much of their punch.

John Stevenson is codirector of the Platinum Gallery in Santa Fe, New Mexico, the only photography gallery devoted exclusively to platinum and palladium prints. With more than one thousand prints in inventory, Stevenson's is the largest nonmuseum collection of platinum and palladium prints in the world. On a recent visit to his gallery, at the top of Santa Fe's Canyon Road, I talked with Stevenson about his fascination with platinum while poring over scores of stunning photographs. He came to his admitted obsession late in life, after a career as a commercial photographer and then, of all things, as a marketing executive for American Express.

"There is simply more visual data in a platinum print than in any other form of photography," Stevenson told me. He likened the difference in feeling between a platinum print and a silver one to the difference one feels listening to a trumpet and then to a viola. The process is an old one, in fact one that dates back to the invention of photography itself. As John noted in a monograph on the subject: "In the period between 1900–1914, it was one of the most preferred media for amateurs and professionals alike. More than twenty companies in England and Europe were manufacturing ready-made platinum photography paper.

"But at the outbreak of World War 1, platinum abruptly could no longer be obtained. Russia had almost 90% of the world's supply; and the little platinum that was available went into the strategic needs of the war."

The golden age of platinum printing came in the post–Great War years, with such giants as Alfred Stieglitz, Paul Strand, and Clarence White using the process extensively. But the price of materials remained high. Even today, if an average 8" × 10" black-and-white print costs between $1.50 and $2.00 to produce, a platinum print can easily cost at least ten times more.

The current renaissance of photography as fine art has increased interest by photographers in platinum and the more easily obtainable palladium. A number of specialty companies have begun to once again manufacture commercial platinum papers. But anyone thinking of trying this process should be warned: While printing in platinum can open up creative avenues you never thought possible, it can just as easily drive you crazy.

The Archival Portfolio, Part 1

01/20/95

Creating, keeping, and displaying a portfolio of photographs requires thought, preparation, and a bit of practice. I'll describe the steps necessary to go from actually making a print, to storing it, to hanging it on the wall.

It should go without saying that a photograph worth keeping is worth keeping archivally—as immune to the ravages of light, time, and chemical change as humanly possible. Color photography always has been the stepchild here: Dyes in color prints, especially those in the mass market, simply did not compete in terms of stability or longevity with their black-and-white counterparts—the silver halide, platinum, palladium or other chemical salts that can make up the black-and-white photographic image. But that is changing. Today, the most reasonably priced means of creating an archival color print is via the Ilfochrome process (formerly Cibachrome). An Ilfochrome print is made from a positive image (slide or transparency) and offers remarkable depth, sharpness, and stability. Prices for Ilfochromes today average about $25 for an 8" × 10" and up to $65 for a 16" × 20". Permanence of these prints generally is measured in decades. It is on black-and-white printing, however, that I want to concentrate.

When printing your black-and-white work for posterity, remember this rule: All archival photographs should be printed on fiber-based paper. Resin-coated (RC) papers, though in many ways easier to work with, do not yet have the same fade-resistant properties as fiber, though the difference may not be as great as once feared. For now, in terms not only of longevity but in richness of tonal range, fiber-based papers are simply superior. Traditionally, archival prints are made on heavier double-weight papers like Agfa Portriga, Zone VI Brilliant, Kodak Elite, or Ilford Fiber-Based Multigrade. Fine art papers can come in both single grades of varying contrast (grades 1–4, for example), or in variable contrast forms that let you adjust contrast with filtration. Each type is equally archival when processed correctly. Black-and-white printing has changed little in the last

hundred years: exposure of the negative image onto the paper, development of the paper for a standard time (usually two minutes with agitation), immersion in a water or acid stop bath to arrest the developer action (about thirty seconds or so with agitation), then immersion in a fixing bath of sodium thiosulfate (hypo) to neutralize the chemistry and help render it stable. It is this last step—as well as the final water wash—that can make the difference between an archival print and one that will deteriorate.

Your key goal at this point in the printing process is to remove the unused light-sensitive silver salts from the print—the only reason for the hypo bath. (In fact I use two hypo baths to ensure my prints get a full dose of silver-clearing power.) These salts literally can tarnish on exposure to light over the years and degrade your image. But too-long immersion in the hypo can create as many problems as it solves—bleaching the image as well as soaking into the very fibers of the printing paper and becoming maddeningly difficult to remove. I have become far more careful over the years to limit my fixing bath to only a few minutes—carefully timed—before putting my prints into a water holding bath until all my printing for the day is done.

The final water wash is crucial. I use a Kodak darkroom siphon to rush clean water over my prints as they sit in a 16" × 20" tray. The siphon continuously changes the water, assuring removal of harmful chemical residue. After ten minutes or so, I transfer my prints to a dilute bath of a hypo clearing solution (like Heico Perma-Wash or Sprint Hypo Remover) then, after five minutes I put the prints back in the water for a final wash of at least ten more minutes. Note: Some photograhers go the extra step of toning their prints in a dilute bath of selenium to further ensure print permanence, but selenium is such a poisonous chemical that l choose not to use it—the prints are plenty archival already. After squeegeeing my prints individually, I set them to air dry on fiberglass screens rather than in blotter rolls that can contaminate prints if they are not totally clean. Once the prints dry, I am ready to make them presentable.

The Archival Portfolio, Part 2

01/27/95

An archival print literally can be ruined by poor, ill-considered presentation.

A cheap, nonarchival mat, for example, can ooze acid fumes and, over time, stain even the most carefully made photograph.

Even dry-mounting—a popular way of ensuring that a print lies flat when framed—can devalue an image in the eyes of dealers and collectors.

But before talking about dealers and collectors, let's go back to the darkroom.

Even dried between fiberglass screens, fiber-based black-and-white prints will curl and need flattening. I use a dry-mount press, but prints can be flattened perfectly well under simple weights—books, bricks, whatever—provided the prints have a protective surface over them.

Once flattened, prints should be spotted, covering up white dust spots with pigment. It's a painstaking but necessary process to eliminate any stray white dots or squiggles remaining on the negative after cleaning. (You did clean your negative with an antistatic brush, or a soft cloth and liquid film cleaner, before printing, didn't you? And after all that, you did blow off the whole business with canned air, right?)

Spotting colors, like SpoTone, must be used carefully, with a tiny, all-but-dry soft bristle brush. Instructions will help you match the tone of your paper by mixing drops of color from different bottles. Hint: Always spot light-to-heavy, building up tone to avoid turning a white dot into one that now is darker than its surroundings.

When matting your photos, remember that mats for fine prints simply must be acid-free. There can be no compromise on this. Top-of-the-line archival, or museum, board is 100 percent rag, made from cotton fiber. But a more moderately priced archival board, made from purified wood pulp, such as Exeter Conservation Board, can fill the bill nicely. It is made by Light Impressions of Rochester, New York, a great source of

archival artists' materials: (800) 828-6216. Note, however, that this so-called buffered conservation board, which neutralizes the naturally occurring acid (lignin) in wood pulp by adding calcium carbonate, may not be suitable for some color prints, in which case the rag museum board may be necessary.

Acid-free must be the rule in all portfolio making—from the tape used to fasten prints to mat board, to the mats themselves, to the boxes holding the prints. Otherwise, you are just wasting your time. After all, you've just gone to great pains to make archival prints; it'd be a shame to damage them with less than archival presentation.

In matting, a thick (usually four-ply) piece of mat board is cut to create a window for your photograph. Prints traditionally are fastened to a piece of thinner two-ply archival backing board that supports the work and also provides an acid-free buffer, should subsequent framing materials not be archival. The window mat and backing board usually are hinged at the top with acid-free linen tape—never masking tape or plastic tape! Besides giving your work a more formal look, matting also allows your photographs to be handled more safely.

Cutting mats is an art in itself, and one that I choose not to master. I always have mine professionally cut, with top and sides roughly equal, the bottom slightly wider, or "weighted." An excellent source is Framer's Workroom, 4431 Wisconsin Ave. NW; (202) 363-1970.

Rather than dry-mount their work, many fine art photographers "float" their flattened prints by securing them only at the corners to the two-ply backing board, using linen tape. I go a step further, preferring to use acid-free paper or plastic corners (also from Light Impressions). The corners are secured to the backing board by the linen tape so that the tape never touches the print itself. This also gives me the option of removing the print unharmed in the future.

Portfolio cases are many and varied, as simple as a cardboard box, costing less than $10, or as elaborate as a handmade portfolio covered in linen, costing ten times as much. But, once again, all must be acid-free.

Your framed prints should never touch the glass—another reason for a mat. Some prefer nonglare glass, but I find that this can obscure detail in the print. I opt for simple window glass. As for signing your work, do not sign the mat. (Did Rodin ever sign the pedestal of one of his sculptures?) Sign the print itself, either in pencil or with archival black ink just below your image on the right, so it shows just above the lip of the mat. Or you can sign the image under the mat. But signing mats themselves is the mark of an amateur.

Taming the Green Fluorescent Monster

02/17/95

Mention "The Green Monster" to a photographer who also is a baseball fan, and you'll likely get one of two responses. Either the photog/fan will cite the left field wall at Fenway Park, or he or she will talk about shooting under fluorescent light.

Shooting color film under fluorescent light can be a nightmare to the amateur photographer because fluorescent light—so bright and normal-looking to the naked eye—turns everything a bilious green in the final print or slide.

This is because the color temperature of fluorescence differs marked-ly from that of daylight—the light most color film is geared to. Different color temperatures react differently to daylight film. That's also why sub-jects shot under household, or incandescent, light can appear very "warm" or, in extremes, downright orange. But a little bit of preparation and a lit-tle bit of calculation can tame even the greenest fluorescent tube.

The key to shooting normal-looking photographs under fluorescent light is in color compensation filters or gels. The ones most commonly used are called simply "30-Magenta" and "30-Green."

The trick is to add enough complementary color to your image to, in effect, neutralize the greenish cast of the fluorescent light illuminating it. The slightly pink 30-Magenta filter (the number refers to the degree of magenta used) compensates for the color temperature of the greenish fluorescent light to render a "normal" tonal range to everything lit by the fluorescence. (Note: Though fluorescent tubes come in a maddening vari-ety of color temps, the filters described here will do the job in most cases, especially on color print film.)

Thus, if you are in a brightly lit office and want to shoot by available light, a magenta filter or gel over your camera lens will render normal-looking pictures. (When shooting with any color correction filter you are letting less light onto your film. Always determine the "filter factor" of

your gel or filter when calculating exposure, or rely on your through-the-lens meter. A 30-Magenta—or a commercially available "FL" filter—usually requires you to open up a half stop or so to get proper exposure.)

But that's fine if you are shooting only by available light. As a practical matter indoor shooting almost always means shooting with flash. How many times have you seen flash pictures made under fluorescent light in which the subject looks fine, but the background is still that awful green? That's because the subject has been lit by the (daylight-balanced) flash, but the background is still dominated by fluorescence. Short of turning off all the fluorescent lights or setting up studio strobes all over the office, is there any way to get rid of that green? Yes, and it really isn't that difficult, even if it seems a little complicated to understand at first.

Again, the name of the game is color compensation.

Think of your photograph as having two components: the foreground subject and the background. Putting a magenta filter over your lens means that your camera literally is seeing everything through rose-colored glasses. If you were to make a flash picture this way, your background would look normal, but your subject would now look pink. However, by adding a 30-Green gel to your flash, you will be undoing the magenta cast on your subject while at the same time allowing the magenta filter on your lens to do its compensatory job on the background.

It sounds confusing—adding green when you are trying to eliminate it from your picture. But think of the green gel over your flash as doing a very specialized and limited job—compensatory light to your subject while totally ignoring the background. The two elements of your picture will get the filtration they need, and each will look fine in the final picture.

A word about filters and gels: Traditional filters are made of optical glass and screw onto the front of your lens. Gels (short for gelatin) generally are much cheaper, though far more fragile, and come in plastic sheets of varying sizes that can be cut to size. (A nice compromise is using heavy plastic resin filters, which are far more durable, but pricier.)

Again, when using any filtration, be it on camera or flash, you will have to determine how it will effect your exposure setting. I use a sophisticated (and very expensive!) flash meter; spending a little extra time shooting a test roll of film will accomplish the same end much more cheaply.

Photographing Artwork, Part 1

03/17/95

Photographing works of art is an art in itself, and one that can demand a lot more than two floodlights positioned at the same distance on either side of a painting.

Lee Stalsworth, chief photographer for the Smithsonian Institution's Hirshhorn Museum and Sculpture Garden, has spent more than a decade not only documenting the museum's glorious holdings, but creating images that add his own talent as a photographer to the final picture.

And, as Stalsworth would be the first to tell you, he oftentimes does it with surprisingly little equipment.

Stalsworth, forty-six, grew up in Northern Virginia and learned photography in the army during the Vietnam War. Taking naturally to his craft, Stalsworth quickly surpassed his photography teachers and had a few high-paying offers when his enlistment was up. "But I opted to take a low-paying job as a printer at the Smithsonian," Stalsworth said with a laugh.

During a recent interview at his studio at the Hirshhorn—and earlier during a lecture to the Washington Sculptors Group—Stalsworth outlined some basics about photographing artwork.

"A photographer is a two-dimensional thinker; you are three-dimensional thinkers," Stalsworth told the assembled artists. "The best person to photograph your work is yourself."

Having said that, however, Stalsworth went on to describe how flabbergasted he is every time he sees howlingly bad slides made by people who are supposed to be visually attuned. He has seen slides of paintings leaning against car fenders in the sunshine; slides of sculpture sitting amidst the distracting clutter of the artist's studio. Not to mention bad exposures and wrong color temperatures.

Good slides, Stalsworth insisted, "get you in the door" at galleries and

To photograph Judith Goodman's "The Last Winged Chamber of Her Heart," we positioned lights behind the large metal screen (once actually bus doors) to illuminate the Duratrans transparencies in each panel. Then we lit the brushed metal front of the sculpture with diffused light from camera left and right.

museums. They are the artist's calling card. In today's world, a less-than-excellent slide simply is not worth showing.

So how do you shoot good slides? Let's find out. For virtually all of Stalsworth's studio work, he shoots with tungsten film (almost always Kodak's fine-grain Ektachrome 64), relying on tungsten floodlights, rather than on expensive studio strobes, to light the art.

Why floodlights? Because this so-called "continuous" light lets you see immediately—and continuously—how your light is falling on the artwork and whether you are creating any distracting hotspots.

Among Stalsworth's favorite floodlights are Lowel Totalites and Omnilights—both high-wattage workhorses that can take years of rugged use without a whimper. A couple of these lights can run you several hundred dollars, but Stalsworth notes that similar results can be had with simple 150- or 300-watt tungsten-balanced, photoflood bulbs in low-cost aluminum reflectors.

Stalsworth almost never aims light directly at an artwork, especially if it's a painting. Often he will direct the light away from the piece, into a sheet of white foamcore board to create a diffuse, not too harsh, effect over the entire work. For smaller paintings, two floods should do the job nicely.

An interesting sidelight and one that illustrates what a perfectionist Stalsworth is: When I visited him in his Hirshhorn studio, he had just finished shooting a very large painting. To my surprise, the work, featuring heavy brush strokes, was positioned sideways. Stalsworth had turned the painting this way to bring out the brush strokes.

What he had done was to make the light on the left (top) side of the painting stronger than that illuminating the right side (bottom), so that the shadows of the brush strokes would show up as they would when viewed in a gallery, where the main light source is from above. The brush strokes' shadows, subtle though they were, would fall from top to bottom.

A little thing, but one that can make a big difference in the final image.

Photographing three-dimensional works like sculpture is more challenging and, if you like that sort of thing, a lot more fun. Again, less is more. Stalsworth says it is rare for him to use more than four lights on any three-dimensional piece.

Perhaps even more than painting, sculpture requires a simple background, most often seamless paper, to keep the eye focused on the work. Gray seamless is a hardy perennial, though Stalsworth notes that he has been taken recently with a chestnut colored paper that offers a pleasantly warm background to many pieces.

When shooting in 35mm, Stalsworth says he relies most heavily on his 55mm macro lens. He says this "normal" focal length serves him best. As a rule of thumb, he initially will position his camera approximately three-quarters of the way up the sculpture.

But, as Stalsworth notes, "sculpture is like a problem child—there are different problems with each one."

We'll see in more detail how Stalsworth handles some of his children.

Photographing Artwork, Part 2

If every three-dimensional work of art presents its own problems in terms of photography, it's nice to know that there are a few tried-and-true photographic methods to solve them.

Lee Stalsworth, chief photographer for the Hirshhorn Museum and Sculpture Garden, has described his belief that "less is more" in terms of photographing artwork. He noted that he rarely uses more than four lights when shooting conventional (i.e., nonheroic-size) sculpture. This week, we'll go into some of the finer points of how he does it.

Shooting sculpture is really portraiture of an inanimate object, and some of the same rules apply. Exposure readings should be made from a gray card once all your lights are set, and you should bracket exposures liberally—up to two full stops on either side, in half-stop increments.

First, position the main or key light—the light that will provide the most important illumination of the sculpture. This light most often should be comparatively soft or diffuse, so it might be wise to bounce the light into a sheet of foamcore board or through a white fabric umbrella. Since you are using continuous, tungsten-balanced floodlights, take advantage of the fact that you can see the effect of your shadows as soon as you move a light higher or lower, to the left or to the right.

Important though the main light is, it will almost never give you all the light you need. Make note what areas of the sculpture remain unacceptably dark and use that knowledge to position your fill light, often at a 45- to 90-degree angle to the main light. Depending on your preferences, the fill light should do just that—fill in the shadows, not blast them open, overpowering the main light. In fact, one mark of uninspired lighting is competing shadows falling in different directions from your subject. In most conventional photography of artwork, the goal is to have shadows fall from only one of the lights in use.

The intensity of the fill light can be regulated in a number of ways.

118 Section IV: Technical Tips

First the light can be moved farther back. Second, the light itself can be modified by a film of spun glass diffusion material, or bounced into foam-core board, like the main light. However, a significant lessening of intensity can be achieved if the foam core, or other reflective material, is black, not white. Black will absorb a significant portion of the light, while still reflecting enough to fill in your shadows.

Sometimes—especially with smaller pieces—a separate fill light may simply be too much, regardless of how its light is toned down. In those cases, a simple white or shiny aluminum or gold reflector might do the trick, by bouncing back into the shadows some of the light from the main light.

Next, one might consider a rim light to separate the sculpture from its background of seamless paper. In portraiture, this light often is called a hair light, because it is used almost opposite the main light to illuminate the subject's hair and give it a pleasing sheen. Rim lights are among the brightest lights in the shoot, since they are used to create a bright border along the edge of the sculpture. Because of their position, there is always danger that light from this source will flare into your camera lens, degrading your photograph. That's why it is wise to fit your floodlights with barn doors. These metal light baffles let you mask off any stray light heading into your lens. (Remember: The only angle that counts is the one visible through the camera. Sometimes it's more convenient to have an assistant move the barn doors ever so slightly while you look through the camera. The same applies to light positioning as well.)

With three lights in place, a fourth you might consider is one to light the seamless paper, to create a dramatic light pattern, depending on the angle. Sometimes this fourth light can be placed on the floor, out of camera range and pointing straight up at the seamless. Other times, the light can be directed down at the background paper from a boom.

Stalsworth notes that one of the easiest ways to accentuate an open space in a sculpture is to shine a light on the seamless and have the bright area visible through the hole in the sculpture.

The above guidelines will work in most all cases—except one. Sculpture made of highly reflective material like shiny metal can drive you nuts. In those cases, photographers often create a large tent of translucent material to surround the subject and minimize the chance of distracting reflections—like the photographer and tripod—appearing in the picture.

Admittedly, this is a very involved and tedious process, and definitely not one you should try when just starting out.

Marilyn Monroe Loved Tungsten Film

08/01/97

Tungsten film—film made for use under tungsten light—often is used by interior and architectural photographers when shooting indoors. In cases like these, the photographer either hopes to "ride" the ambient incandescent light for a moody available light shot, or he or she will light the scene with a number of tungsten-balanced photo floods of varying intensity and direction to create precisely the look desired.

The great advantage to using these so-called continuous lights, rather than studio strobe lights, is that the photographer can see precisely what he or she is getting and can fine-tune the effect without having to resort to multiple Polaroid proofs to gauge each change in strobe light position or intensity.

Because tungsten film is calibrated to the warmer color temperature of tungsten light, the resulting photographs appear "normal" and do not have the sometimes garish-looking orange cast of photos made with daylight film under incandescent light.

But tungsten film also can be used outdoors with great effect.

Artist John Bailey's monumental mural of Marilyn Monroe has become something of a Washington icon, dominating the intersection of Connecticut Avenue and Calvert Street NW. For years I wanted to photograph her, but not just in one photo. I wanted to create a diptych, to illustrate the mural's two distinct looks: during the day, and then at night, when Marilyn's face is illuminated by a bank of floodlights.

The situation was made for tungsten film.

One great additional benefit of this film is what it does to skies. Under most circumstances tungsten film can render even the most lackluster sky a brilliant, almost electric, blue. That was great in this case, where the sky was to form a major part of the "daylight" picture and Marilyn's face would be in comparatively subdued light just at dusk. Then, at night,

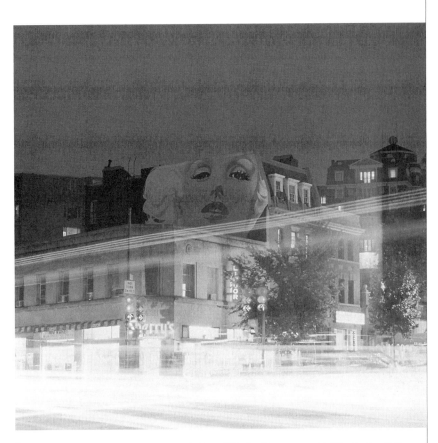

In color, this "portrait" of artist John Bailey's famed Marilyn Monroe mural in Washington, D.C., shows a rich blue twilight sky created by tungsten-balanced film. Note how the long exposure creates striking light patterns of passing cars and buses.

when the mural was lit by tungsten floods, the film would render Marilyn's spectacularly floodlit face normally, without an orange cast.

There remained the decisions on camera, lens, height, and exposure. I viewed the picture as a square one, so that meant shooting with my medium-format Hasselblad. Theoretically, I could have made all my other technical decisions on the evening of the shoot, but theory is rarely as good as practicality.

For one thing, these photos had to be made within a short time of one another—at dusk and then at dark, after the floodlights came on. That didn't leave much time for experimentation as to camera position, elevation, exposure, and lens choice. To do the job right meant making a preshoot site visit to get most of the technical stuff out of the way.

The site visit determined two things: First, my 80mm "normal" lens gave me the angle of view I wanted; second, the higher elevation I needed

to eliminate pedestrians meant I would have to be on a ladder, with my tripod fully extended. With those decisions made, along with my film choice, all I needed was a fair spring night.

The evening of the shoot went almost without a hitch, but not without a few surprises. To my chagrin, after all that planning, the batteries in my exposure meter decided to go dead, so I had to guess at my seconds-long time exposures. However, since I was making Polaroid test shots beforehand, this was less of a problem than it might have been. The second, more welcome, surprise was seeing the wonderful streaks of light that literally underline Marilyn's face in the final photographs. What were they? I knew that in the long exposures I'd be making, automobiles would disappear, leaving only the trails of their headlights and taillights at the bottom of the frame. The colorful other lights were the happy result of serendipity—and, I will admit, taking a chance. On some of my exposures, I deliberately waited until a Metrobus raced across the frame. The lights near the top of the bus are what make the distinctive light patterns that bisect each version of what I call "Black and Blue Marilyn" (after the color of the sky) and give this diptych an important and satisfying unifying element.

Capturing Venice at Night

04/10/98

Venice is a centuries-old engineering miracle—a city built on water, or at least built so close to its muddy canals and waterways that all its streets are water-filled and all its commerce waterborne.

The symbol of this romantic city at the mouth of the Adriatic may be the gondola, the sleek, black oar boat that once served as a key means of transport and that now is a ceremonial and tourist-pleasing throwback to another time. Having visited Venice once before, I recalled how the gondolas would bob up and down at their moorings on the Grand Canal near St. Mark's Square, and provide both a visual and auditory counterpoint to the elegant skyline of Venice's palazzi, museums, and churches.

So, when I returned to Venice in mid-February to lead a photography tour during the week-long pre-Lenten festival of Carnevale, I had one goal in mind: to make a late-night black-and-white picture that combined the beauty of the Grand Canal with the elegance of the Venetian skyline. I also wanted to capture the motion of the gondolas as they lay at turbulent rest.

Why night? Night was more dramatic and would make the lighted elements stand out better. It also would let me use long exposures to render motion in the bobbing gondolas and simultaneously paint the boats with multiple flash pops and bring out detail in the stationary mooring poles in the foreground. (In any motion photography, it is wise to have at least one point of sharpness or definition to let the eye rest upon.)

Why black-and-white? Mostly because of my own aesthetic preference, but black-and-white also would let me ignore the different color temperatures of other light sources in the picture—the fluorescence of a nearby vaporetto stop, for example, and the tungsten lights on passing boats.

A perfect skyline for this photograph—one that provided a bright centerpoint without being obtrusive—was the brightly lit church of San Giorgio Maggiore. Sitting like an operatic stage set across the Grand

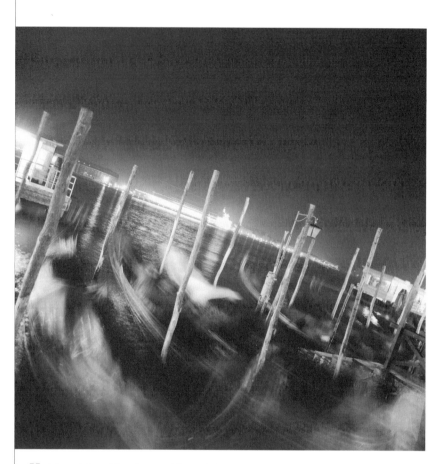

My interpretation of Venetian gondolas at night involved a tripod-mounted camera at a dynamic angle, multiple flash pops to create the look of an elaborate lighting setup, and a very long exposure to record the motion of these ancient boats. © Frank Van Riper

Canal, it was built between 1559 and 1580 and is one of the crowning works of the Italian architect Andrea Palladio.

On a clear, crisp February night, I set up my medium-format Mamiya 6 camera and 50mm wide-angle lens on a tripod and composed the photograph with the skyline in the background, the gondolas in the foreground, and with the whole scene slightly skewed for visual interest.

Then I made a spot meter reading of the brightly lit church. This reading would be the underpinning for the rest of the picture, since I would want multiple pops of my Vivitar 283 flash to approximate the brightness of San Giorgio Maggiore when I lit the gondolas. For reading the light I was creating on the gondolas, my Minolta IV flash meter was invaluable because it allowed me to gauge the effect of multiple flash pops until they equaled the reflected brightness of the distant church. (Note: Because I couldn't actually stand on the boats and hold the meter while

someone else on shore popped the flash, I had my wife, Judy, hold the flash meter on the dock at approximately the same distance that I was from the gondolas, then pop the flash.)

I had the composition that I wanted as well as a fairly good idea of what constituted a base exposure. All that remained was making the picture.

If I were working with my more bulky Hasselblad equipment instead of my compact rangefinder Mamiya 6, I'd have made a series of test Polaroids beforehand. But this time, with nothing to go by but my reckoning, I made ten different exposures, all on Kodak T400CN film. Most lasted ten to fifteen seconds. I "bracketed" by length of exposure and the number of flash pops.

I hope you like the results as much as I do.

To recap:

1. For late-night photography, a tripod generally is a must, especially to create a point of sharpness to anchor the eye while the rest of the picture's elements are in motion. Like all rules, this is meant to be broken occasionally—like the time a few nights later when I held the camera by hand for a view from a bridge that lasted several seconds. Only this time, the light trails from a passing motor launch gave the appearance of sharpness in the photo—well-defined lines that contrasted with the surreal blur of the buildings.

2. Film speed is not critical since you'll be working with long exposures that will render images on even the slowest films.

3. Using a handheld flash to "paint" with light can create wonderful accents and light up otherwise invisible details. (Note: Precise exposure is not crucial, especially in black-and-white or with color print film. Experiment with lots of variations.)

4. Remember: The idea is to create an image that would have been impossible to either see with the naked eye or to make with a more conventional exposure.

Dash of Flash
Adds Substance

01/15/99

Flash photography enables us to see in the dark and freeze motion. When used creatively, it also can approximate—even duplicate—natural light and produce images that under less-than-ideal conditions would be difficult or impossible to make.

Professional photographers often will bring to an assignment multiple cases of flash equipment to have available just the right kind of "light in a box" to create a desired look or effect. When my wife Judy and I traveled around the country last year shooting a series of print ads for the U.S. Postal Service, our traveling light kit was infinitely more complicated than that which we bring to, say, event or wedding photography. (On those occasions we rarely use more than on-camera flash—though never pointed directly at the subject without some measure of light-softening diffusion.)

For the Postal ads we had between us no fewer than five studio-power strobe units, a bag full of light stands, photo umbrellas to bounce or modify light, one large softbox, yards of power cord, as well as several small flash units to kick light into tiny spaces. But for all that firepower, our goal was always to mimic the sun—to make our pictures look as natural as possible.

Any flash photography, whether done with a single on-camera flash or with a multiple strobe setup, can too easily appear harsh and unnatural if the light is used indiscriminately. Harsh direct light—you've seen it on your driver's license or on poorly done passport photos—makes the subject look as if he or she has just been whacked upside the head with a fish. Though this stark look sometimes can be used to effect in certain editorial or fashion layouts (think gritty urban with lots of attitude), most well-done flash photography tends to use some kind of indirection to achieve its end.

So can you.

The dramatic morning light that I had seen time after time in this country kitchen in Lubec, Maine, was nowhere around when I set up to photograph it. So I created the same effect with my trusty workhorse Vivitar 283 portable flash.

Light from a portable flash or from a more powerful studio strobe unit generally is modified in two ways: via bounce or diffusion. Bounced flash occurs when light from a flash or strobe is fired away from the subject and onto a flat surface in such a way that the light is bounced back onto the subject. The simplest bounce—and one of the most effective—is achieved by firing a portable flash unit—a Vivitar 283, for example—into a white plastic bounce card that is attached to the unit, and with the flash head pointing straight up. This technique, especially when used with the flash on-camera, significantly softens the light on the subject and tends also to minimize "red-eye," the phenomenon that occurs when direct flash literally reflects blood on the retinas as light passes through a subject's dilated pupils.

If you think of a beam of light as a stream of water, you can visualize how this diffusion occurs. Aim a hose directly at a person and water will

hit the subject, hard, in one spot. Point the same hose at the ceiling and the water will splatter out and douse the subject more broadly.

Diffusion occurs when flash light is fired directly at a subject, but through a diffusion medium—a photo softbox, a "shoot-through" photo umbrella of white silk or other such fabric, or even a bedsheet. This technique is most useful when re-creating the soft but directional look of window light, one of the most sought-after looks in portraiture, as well as in some product photography. But for such an effect to be most pronounced, the light must come from the side, which brings up the other key to effective flash photography: positioning your light.

Amateurs often feel their creative options are limited to bouncing light from an on-camera flash unit. In fact, purchase of a simple flash extension cord can open up a world of creative options. It was an almost giddy freedom I felt when I no longer was forced to have my light come from over my head. The simplest way to work like this is to extend your arm while holding the flash, though it is lots easier screwing the light into a light stand. Once you do that, you'll want to consider using a second light—maybe a tiny battery-powered and self-contained Morris Mini flash unit—to act as an accent light or a hair light. The options—and number of lights—are up to you.

A final thought: Look at the accompanying photo, of a country kitchen in Maine. When I first saw this scene, there was morning light pouring through the windows, but when I decided to shoot it, the light was gone. Solution? A Vivitar 283 fired remotely from the right.

Mixing Light Sources Adds Spice to Your Pictures

09/29/00

As a native New Yorker who all but grew up on the world's greatest subway system, I was predictably skeptical of Washington, D.C.'s brand-new Metro system when it opened for business some twenty years ago ("DC's Toy Train" was how I described it in a feature for my old newspaper, the *New York Daily News.*)

But the gleaming new cars, the easy to navigate pathways—not to mention the dramatic vaulted ceilings—quickly made a believer of me, even if the lack of bathrooms and the silly rules against eating in the station gave this Metro an antiseptic sterility one doesn't find, say, in the Metro in Paris, or on the "T" in Boston.

But one thing D.C.'s Metro does share with other great subways—Moscow's for example—is an appreciation of art and a willingness to display it. Just the other day, for example, Judy and I made a special trip to the Chinatown station to view the huge and beautiful work of sculptor Foon Sham that hangs over the station's subterranean main platform.

It was a similar monumental work—by artist Connie Fleres—that prompted one of my most enjoyable portrait shots, and provided an object lesson in how to combine different light sources for dramatic effect.

Connie's large wall sculpture, entitled *Yellow Line*, featured a brilliant band of yellow neon against a high-tech grid pattern, and formed a striking accent to the platform level of the Gallery Place Metro stop.

At the time Connie and I were fellow artists at D.C.'s Touchstone Gallery, where I had begun a personal project of photographing my fellow artists in their environments. Seeing Connie's work convinced me that I had to photograph her in the subway station. (FYI, one just doesn't lug a

Mixing light sources can be maddening—or exhilarating, if you let different color temperatures work for you. In color, this image of sculptor Connie Fleres shows a fluorescent green archway, the warmth of tungsten light illuminating Connie's face, as well as other elements to make the picture work. (© Frank Van Riper)

bunch of studio photography equipment into the subway. I got written permission from Metro—after I showed I carried $1 million worth of liability insurance. With permission granted, we worked on the shot in late morning, after rush hour, and before the lunch hour, to encounter the fewest passengers.)

In photographing artists with their work, the last thing I want to do is make a picture of the artist standing in front of, or beside, his or her painting or sculpture. To me, that all but defines boring. (Which is probably why my portrait of another neon artist, David Yocum, shows David's head filling the frame, one of his sculptures reflected in his eyeglasses.)

In Connie's case, I knew immediately that I wanted to use the Metro's great vaulted ceiling to frame both the artist and her work. Knowing that the station was lit by fluorescent light, I made a creative decision to shoot

the portrait with daylight-balanced film without filtration so that the ceiling would go green—or precisely the color we try to avoid when shooting under fluorescence normally.

By the same token, I didn't want Connie to look bilious, so it was fairly easy to figure that I would aim a daylight-balanced strobe light at her to render her naturally. In addition, I wanted her to wear white, to make her stand out in the picture, and anything less than daylight-balanced illumination would make her white outfit look weird.

There's a third light source at work here, though it may not be that noticeable at first. Which is cool, since subtlety is good every now and then. The modern, bright tungsten lights that shone from round portholes in the station's stairwells struck me. I wanted to position Connie so that her face would get a nice warm sidelight from the tungsten while her suit was lit by the daylight-balanced strobe.

The effect worked pretty well, I think.

Finally, to add a dramatic element to the shot—this was, after all, a subway station—I waited until a train pulled into (or out of) the station on Connie's left before I made my shots. I worked at roughly one-half to one-quarter of a second. The strobe light acted to freeze Connie fairly well. The fact that I was on a tripod meant that the vaulted ceiling—and Connie's sculpture, of course—would be rendered sharply. And the long shutter speed meant that the subway train would add a compelling blur of motion to an already-dramatic picture.

I did learn a couple of other interesting things too.

To be on the safe side, I shot this picture on both color slide and on color negative film, since I was unsure exactly how all my light source mixing would show up. It turns out that Kodak's Ektachrome 100-Plus Professional daylight-balanced transparency film gave me exactly what I thought I would get—green ceiling and all.

But ironically, the film that gave me the most accurate rendering of what I saw also provided the most disappointing images. This probably was the only time I didn't appreciate the extra emulsion layer in Fujicolor's Reala color negative film. My 2½ Reala contact sheets—with no special filtration by my lab—depicted a totally beige Metro station ceiling—or precisely what I did not want *this time.*

Of course, that extra layer has proven itself to be a godsend to me and other photographers who, at other times, have needed to tame the green fluorescent monster on location.

Using Camera Shake for Better Pix

01/26/01

Whenever I think of the photography of John Sexton, I think of beautiful black-and-white view camera vistas.

The photographs are stunning not only because they have been beautifully seen and superbly printed by one of the great photographers and printers of our time, but also because they are tack sharp, making full use of all the superb optics on John's assorted large-format cameras.

There is a measure of hyper-realism in Sexton's work—just as there is in that of many other great view camera landscape photographers, the best known of whom was Ansel Adams. This is because in most cases the zone of focus in their photographs goes from the near foreground to infinity, a trick our human eyes can't quite accomplish.

To achieve this, these photographers use the perspective controls on their view cameras to maximum advantage, and routinely work at close to pinhole apertures to insure minimal distortion of light rays as they pass through the lens, thereby maximizing image sharpness. (This is the same reason we squint to see things better—the smaller the "aperture" of our eye, the more things appear sharp.) In photography, especially in large format, working with such small apertures often requires shooters to work at seconds-long—and sometimes minutes-long—exposures. In turn, this means the photographers must work in almost monk-like silence and tranquillity, to minimize any possibility of camera shake during the exposure that could ruin the image and force the photographer to start all over again.

In other words, not your basic grab shot.

So when I received John Sexton's gorgeous new book *Places of Power* last year and set about the enjoyable task of reviewing it, I was struck (make that damn near struck dumb) by the following technical note accompanying his striking series of photographs made in power plants:

"Upon entering a coal-burning power plant one is quickly struck by

Slow shutter speed with flash combine for a dramatic portrait. Though the car is moving and the shutter speed is slow, the flash freezes my subject (our golden retriever Daily News) so that you can see every whisker, even as the outside world whizzes by in a blur.

the fact that there is coal dust everywhere. This is not because of lack of maintenance or cleaning; it is simply a side effect of moving nearly one million tons of coal through the plant annually. . . . Yet in the photographs everything looks so clean—almost sterile. The coal dust is camouflaged by the photographic process: since it is 'as black as coal' and doesn't reflect light, the dust disappears in the images."

That was fine as far as it went: a neat bit of photographic esoterica, pointing up photography's unnerving way of sometimes masking the truth before our eyes. But then came the clincher:

"As unexpected as the extremes of noise heat and dust was the considerable vibration I encountered. I still remember how anxious I was when I first set up my view camera in the turbine room. The entire building was shaking so much that the bubble level on the camera was quivering. *Fortunately, the camera, the turbine, and the building were vibrating in synchronization, and the negatives were tack sharp."* (Emphasis added.)

Now, I was familiar with the theory, but the final application blew me away: there it was before me—a sharp picture made with a camera that was shaking so violently at the time of exposure that it caused a bubble level to quiver.

But in fact, the same theory at work here is the one that lets us make sharp pictures when our cameras are anything but tripod-steady. Take panning.

Using Camera Shake for Better Pix

Following a fast-moving object or person with your camera might seem counter-intuitive to good picture-making technique, until you realize that your camera is moving at the same rate of speed as your subject. That's why people in a moving train appear to be stationary when viewed from a parallel train going in the same direction at the same speed. Obviously panning will blur your background to a fare-thee-well, but in most cases that's the effect you desire: enhancing the look of speed while your subject is rendered fairly sharply.

But let's say you want real sharpness. That's when you can use the same panning technique, only this time augmented by flash to freeze your subject even as your camera is moving.

The most bizarre thing about even the most basic flash unit is that the duration of the flash—the time its output is at maximum brightness—is incredibly short, far shorter than even your highest shutter speed setting. That means that you can, in effect, make two pictures at once. The first will be a slow shutter available light picture; the second—made at the same time—will be a high-speed flash picture with the flash acting almost as a second shutter, capable of freezing motion cold. The technique I'm describing is best used indoors or outside when the light is not at its most intense. For example, at an indoor track meet, let's say you want to capture a runner, but also give the feeling of speed as he or she goes past you. Working with flash, if you normally would shoot, say, at f /5.6 at $\frac{1}{60}$ or $\frac{1}{125}$ of a second, try setting your shutter speed way down to $\frac{1}{8}$ or $\frac{1}{15}$ of a second, then pan with the runner and make your picture as he or she goes by you. Note: For best results, you should use a camera that affords "rear curtain flash sync." This will insure that the blur of motion will be behind your sharply rendered subject, not in front—a much more natural-looking effect. In the accompanying picture of our late golden retriever, Daily News, in a moving car, I'm shooting flash at $\frac{1}{15}$ of a second. See how the background blurs and how sharp every whisker is on our girl's snout. Try it. You'll be surprised, I think, at how sharply the flash will capture your subject. Almost as surprised as John Sexton was when he made his pictures with a vibrating view camera.

SECTION V

Practically Speaking

Emergency Items for Your Camera Bag

11/13/92

There is a reason my camera bag is so heavy, and it's not just that it's loaded with cameras. Like many of my colleagues who make their living by making pictures, I have a thing about tools and gadgets I will never leave home without, because they have, at one time or another, helped me turn a good picture into a great one or, on a more practical level, have helped me make the picture in the first place.

Many of these tools, like a small bubble level or a Swiss Army knife, have little to do with photography itself. Others, like a couple of Morris Mini pint-size flash units, or a photographic gray card, are standard but comparatively inexpensive photographic tools.

I polled a number of my colleagues about their favorite gadgets and got a number of different responses, reflecting their different fields. Dency Kane of Manhattan, a fine art photographer whose commercial work centers around beautiful color "portraits" of gardens, came back at me immediately with "a polarizer." This filter, which limits the amount of light striking the film plane, is wonderful for reducing glare or reflections and is great for increasing intensity in color work. No wonder Kane swears by it.

By contrast, Tim Murphy of Burke, who, like my wife Judy and me, shoots everything from annual reports to weddings, recommends a Master Slave unit to help trigger remote flashes without having to "hard wire" them. One marvelous addition to the camera bag that does much the same thing but with much less hassle is the aforementioned Morris Minis. At first glance, they appear to be pocket tape measures; in fact, they are totally self-contained flash units—with built-in slaves. This means you can position one of these gizmos to the side of your subject, make a picture using your on-camera flash and automatically trigger the Mini to give you a far more professional-looking shot that is lit by not one, but two lights coming from different directions. They are so lightweight and

foolproof that the only problem I have had is in remembering to take them with me after a shoot.

But not all great tools are electronic. One came literally out of a cookie package. In fact, it was the cookie package. Years back, a colleague bragged about the great compact reflector he had. Sure enough, it folded down to a few inches square and seemed like a mini space blanket or something. In fact, it was a flattened, inside-out foil bag from a package of chocolate chip cookies. This one happened to be made by Keebler, but any package made of extra heavy foil will do. Opened up, it measured about a foot square and was great for reflecting light—sunshine or electronic flash—back onto a small subject.

And in that vein but on a much larger scale, I always keep a bedsheet packed with my studio flash units. Stretched between two poles, or even taped to a wall, it can reflect light like a champ—or at least as well as a collapsible reflector that can be as pricey as it is handy. But, unlike the reflector, the sheet also can be used as a diffusion medium through which to fire your flash units without the need for an expensive softbox. Years ago, when Judy and I didn't have nearly as many toys as we do now, we shot part of an annual report using that same bedsheet to bathe our subjects in soft, diffused strobe light. Our shots came out as well as, if not better than, those made by other photographers in other parts of the country who used much more "sophisticated" gear.

Sometimes a gadget proves its worth when you're in trouble. This happened to me recently when I noticed that the lens on my trusty Nikon FA seemed to be wobbling. Close inspection showed that the tiny screws holding the lens mount ring had loosened. Fortunately, I had a jeweler's screwdriver in my bag and was able to tighten the screws, stabilize my lens, and get back to work. Later, a friend who does a lot of air travel told me that he not only always travels with a set of tiny screwdrivers, he always tightens every screw that he can easily reach on his cameras when he lands. "Airplane vibration can loosen screws much more rapidly than you think," he says.

I place gaffer's tape, spring clamps, and a penlight into the same category as the screwdrivers: things you'll never need until you are desperate for them. Gaffer's tape (as opposed to duct tape) is a strong, very tacky fabric tape that can fasten a sheet to a wall (remember?), hold a second strobe light in place, or hold a lighting cable down to the floor to keep it from tripping people. And unlike duct tape, it removes easily.

Those little clamps, with the rubber-coated ends and handles, are standard gear in any studio for holding things in place, on light stands, tables, or anywhere. A few belong in your camera bag when you travel.

And I can't tell you how many times I have used my penlight in what I thought were well-lit rooms. Not only have I needed it to see my camera controls without going blind, I also have used it to help me root through the dark, crowded pockets of my camera bag for other gadgets

Also in those pockets are things like bedraggled pieces of colored cel-

lophane for use over a venerable Vivitar 283 (the workhorse of portable flash units). Working in color, a gelled strobe can make for an interesting highlight on your subject with minimal effort.

Then there's the bubble level and gray card. The level is a must when you are doing precise portraiture and want to keep your edges (on buildings, walls, etc.) running perfectly up and down or side to side. And you'd be amazed how difficult this is to eyeball. It's one reason why expensive cameras, like 4 × 5 and 8 × 10 view cameras or the super-pricey Hasselblad Super Wide C/M, have bubble levels built in.

A gray card is really necessary to help in exposure calculation. Exposure meters aren't calibrated to read white or black, but are set up to read an 18 percent gray field. Pointing the camera at the gray card and metering accordingly helps tell you if your meter is working properly.

Digging down even deeper into the camera bag, I was not surprised to find a dozen fresh penlight batteries, and a few fresh nine volts as well. (I'm paranoid about running out.) There's also the requisite cable release for really slow-shutter photos, as well as a couple of long PC cords to help me place a Vivitar 283 wherever I want it and still be able to fire it. (The one disadvantage of slave-driven strobes such as the Morris Minis is that they must "see" the triggering flash in order to work.)

The one item I haven't yet explained is the Swiss Army knife. Well, of course, it can be used to cut off pieces of tape and stuff like that, but I like to think that, after a shoot, it's the perfect photographic tool with which to cut the cheese, peel the apple, and open the wine.

Bon aperture!

Shooting Safely: Eye Protection

04/16/93

The message was on my answering machine. The caller did not leave his name.

"Uh, Frank, I have some information that you may want to publish in your column. . . . Basically, yesterday I went to an ophthalmologist—this was my second ophthalmologist—and he confirmed an earlier diagnosis that I have scars on both my retinas, and the reason for those scars is the numerous sunrises and sunsets that I have photographed over the years. . . .

"Basically what has happened is that the sun, especially [when I'm] using a lens like a 300mm lens, has burnt holes in, or scarred, the retina. . . . I think for your readers it would be informative for them to know first, not to look at the sun—obviously we hear about that with total-eclipse advice—but also, when they're doing sunrises and sunsets, especially those misty sunrises, the effect [on the eyes] can be quite dramatic, especially when they're looking through their viewfinder with a telephoto lens."

A sobering message, to be sure. And I could only sympathize with the anonymous fellow photographer who left it. The fact is that the act of making photographs can, in a number of ways, be hazardous to your health. But there's no reason you can't avoid those hazards as you become more involved with the hobby that you love.

Clearly the most dangerous hazard in photography is anything that can threaten your eyesight, such as photographing the sun without adequate precautions and safeguards. "Caution!" declares the Nikon School Handbook, "Never look at the sun directly through any kind of optical light gathering instrument (telescope, binoculars or camera), or even with the naked eye, without adequate and safe filter protection!

"The invisible ultraviolet and infrared radiation can cause partial or permanent eye damage and blindness before the viewer can become

immediately aware of it. The intensity and heat of the incoming focused sun's rays must be reduced by an amount of 99.9 to 99.99 percent before the image can be safely viewed."

Besides damage to your eyes, sun photography also can damage your camera as it focuses—and intensifies—the sun's rays. The direct image of the sun can, for example, burn through a cloth focal plane shutter, and the heat generated in the lens barrel can actually soften the glues used to keep lens elements in precise alignment. For this reason, Nikon recommends keeping your lens cover in place between exposures.

A very heavy neutral density filter, like an almost opaque grade 5, is one way to lessen the effect of the sun's rays, but it is not eye protection. One way to focus on the sun is obliquely, by placing a card an inch or so behind the camera viewfinder when the camera is pointed at the sun. "When the lens is pointed correctly, the sun's image will appear as a bright disk on the card," Nikon recommends.

Obviously, the occasional sunrise or sunset is nothing to worry about, but repeatedly shooting the sun is dangerous. The more you do it, the more precautions you should take. You want another recommendation? Find something else to photograph.

The other physical tolls that photography can take often relate to lugging around your equipment, and the effect can be as gradual and insidious as looking at the sun over the years—though not as dangerous.

Ever hear of "photographer's hip"? Probably not, but that's how our internist described my wife Judy's and my complaint of dull, deep and chronic hip pain from lugging camera bags around to hundreds of events and weddings over the years. The malady comes from misalignment of the body caused by the heavy bags and shows up on the side of the body opposite that on which the camera bag is carried. That's one way Judy and I knew our pain was photography related. She carries her bag on her right shoulder and her left hip hurts. I carry mine on the left and the right hip hurts.

The remedy: Don't carry such heavy bags, or use a handcart.

News shooters routinely carry several cameras at a time, sometimes loaded with different films or carrying different lenses. The most convenient way of carrying, say, three cameras at once is to put all three around your neck with straps of graduated lengths. But the very real danger here is the risk of pinched nerves in the neck that, in the worst cases, can require delicate surgery to correct.

Solution: Carry only one camera around the neck and the others on your shoulders.

My pal Tim Murphy reports that when he's photographing a hearing on Capitol Hill, it is becoming common to see photographers sitting on tiny benches in front of the witness table, or simply on their bottoms, rather than kneeling on one knee. This lessens the chances of developing water on the knee or other ailments from frequent contact with the

ground. It's also one reason you'll see lots of sports shooters wearing hard rubber kneepads when they're working the sidelines.

Every winter, there's some story of a kid who has to be gently pried loose from a banister, flagpole, or other outdoor metal object after he has been dared to lick the thing in subfreezing weather. Don't laugh. It's one reason outdoor shooters often tape the backs of their cameras with masking or gaffer's tape—to prevent a similar thing happening when they put their gear to their faces in the cold.

Photography should be fun. The problem is that sometimes it is so much fun that we forget to be prudent. We all should practice safe shots.

Shooting Fireworks

07/02/93

I don't know anyone who doesn't love a fireworks display, especially the eye-popping and ear-splitting extravaganza thrown every Independence Day on the Mall. Besides being a wonderful excuse for flag-waving and patriotic hoopla, the July Fourth light show is tailor-made for dramatic photographs.

I have to confess, however, that photographing fireworks is not my forte. I'd much rather watch them than shoot them. So, if I ever hoped to write the Definitive-How-To-Photograph-Fireworks-Column, I knew I had to hook up with someone who has been capturing those magnificent starbursts for years—and making it look easy.

Patricia Fisher is a freelance photographer who, with her husband Wayne, runs Fisher Photography in Washington. Together they have supplied magazines and other clients with all kinds of stock images of the nation's capital—from portraits of cabinet members to shots of tourists traipsing through our monuments and museums—to July Fourth fireworks displays.

Over a relaxed dinner recently at their home, Pat and Wayne presented a quick primer on shooting fireworks, including lens and film selection, great vantage points, and how to stay on the good side of the folks around you while you try to get a better shot than any of the quarter million other souls who have come to the Mall with their cameras.

As with any other photography, making good fireworks shots is a matter of preparation and of knowing your subject—in this case the pyrotechnical equivalent of incoming mortar rounds (". . . bombs bursting in air," remember?).

"Probably the most important thing for a good fireworks shot is basing your exposure [to capture] ground detail," Pat said. And sure enough, as I looked over the scores of slides Pat and Wayne had made over the years, I saw that virtually all their images showed enough detail in the dark

Taking a leaf out of Pat and Wayne Fisher's book, I made this black-and-white shot of evening fireworks in the tiny town of Cutler on the coast of Maine during the town's very first pyrotechnic Fourth of July. An open shutter, a medium-wide aperture, and a good vantage point were all I needed. The water and the workboats add a nice identifying touch—and who says great fireworks shots always have to be in color?

areas to give the viewer a sense of place and perspective along with the spectacular bursts of fireworks.

Pat said she uses a spot meter to calculate exposure, but over the years has tended to rely on relatively slow slide film (like Fujichrome 50) and an aperture of f/5.6 or 6.7 for "fairly long" exposures of fifteen seconds or more. She also uses a cable release to hold open her shutter, the better to minimize camera movement. Once, when shooting a special fireworks display at the University of Virginia, Pat said she employed a thirty-second exposure to bring up the detail in the University's famed rotunda figuring prominently in the foreground. It was a calculated risk, since the resultant images showed some color shift caused by reciprocity failure, as well as

some burnout in the brightest areas of the starbursts. But she was able to correct for this when she had duplicate slides made of the best images.

Obviously, such long exposures demand a tripod, but using one can easily block the view of those behind you. The solution? "I generally do not extend my tripod fully. I tend to sit down and shoot up." (She prefers a small but sturdy Gitzo tripod with a Leitz ballhead.)

This good neighbor policy extends to the Fishers' choosing one spot and sticking to it. "We tend to stake out a spot roughly an hour before the show starts," Pat said. "We don't move around because people are going to hate you if you try to do that once the fireworks begin."

When shooting fireworks, it also is best to stick to one lens. The Fishers have found that fairly short focal lengths work best—between 50mm and 100mm—so that the shot can have enough room for ground detail as well as mutiple bursts of fireworks. Covering the lens with a card in between bursts can minimize extraneous detail like puffs of smoke, though Pat noted that, when in a position that allows you to listen to the musical accompaniment, you often can anticipate when multiple bursts will occur—and leave your lens open accordingly.

Are there any special Washington vantage points the Fishers prefer? Well, yes and no. One of their favorites is the Capitol steps overlooking the Mall. "That position allows you to get that ground detail," Pat noted, pointing to one shot that showed detail in the crowd, including people cavorting in the Washington Monument Reflecting Pool. Long exposures that include such crowd scenes also let you record ever so slightly the hundreds of pops from flash units being used by amateurs who somehow think their teeny-weeny flashes are going to make any difference whatsoever. They do—on Pat and Wayne's pictures.

Another obvious choice is the Mall area near the Washington Monument. But get there early—and keep your tripod low.

One prime location, but one open only to those with special permission, is the roof of the Lincoln Memorial. One July Fourth, however, Wayne was positioned there only to find he was shooting on one of the coldest and wettest Independence Days on record. Not only that, the wind blew smoke in Wayne's face through most of the soggy show.

Final tips: "Shoot the early fireworks. By the end of the show, there is so much gunpowder in the air that everything is washed out." And never worry about how much film to bring. Says Pat: "I've never had to change film because you never get more than thirty-six exposures."

Better Printing

01/07/94

They say Newton was lounging under a tree when an apple bonked him on the head and inspired him to discover the laws of physics.

I recently had an inspiration that led to a discovery as well. Only I wasn't lounging under a tree; I was in the darkroom. The more I'm in the darkroom printing my personal work, the more exacting I become as to the tones of the final print. This is inevitable. The better one becomes at something, the less satisfied one becomes with work that in earlier times would have seemed just fine. Though I strive to produce black-and-white negatives that have enough medium tonal range to eliminate the need for great manipulation in the darkroom, that doesn't always happen, especially when I am shooting by available light.

I remembered this recently as I was printing a negative I'd made two years before of the artist James O'Neal of Lubec, Maine. Jim's Wyeth-like egg tempera landscapes routinely sell out at his gallery shows, and I wanted to include him in my portfolio of Down East portraits. He works out of a rustic studio that he built by himself on a hilltop on North Lubec Road. The space is a large unfinished room with a cathedral ceiling and a storeroom built into the side. He was preparing for a show the day I arrived to photograph him, and the walls were hung with canvases in various states of completion. There was a large, sturdy easel in the center of it all, a comfortable chair, and a nearby table full of paints, brushes, and rags. But there were no lights to speak of. Jim didn't need any, for that cathedral ceiling was supported on the high end by a huge wall of glass that let in great gobs of north light. It was the perfect artist's space: isolated, tranquil, and flooded with light. It also was a perfect place to make a portrait. I was taken immediately with the way the light played on the work space, on the easel and its blank canvas, and of course on Jim's bearded face as he sat near the easel and told me about his work. I made a few Polaroids, some with flash to open up the shadows, and quickly determined that this was

Portrait of Maine artist Jim O'Neal required some artful dodging—and aluminum foil was the perfect tool for it.

one case where less was more: The flash was intrusive and disturbed the tranquility of the light already there. I made the shot—or shots. I did two dozen environmental portraits of Jim sitting by his easel, then some tighter views of Jim as he talked animatedly, gesturing with his arms and hands.

In the darkroom two years later, the initial test prints were good, but it was clear that I would have to manipulate the print if I were to re-create the look of the light that day. I would have to burn in the right side of the print, the side from which the light was coming, in order to bring out the detail that my eye had seen.

All of which is no big deal. Dodging and burning in are among the things you learn when you start out in the darkroom. (Quick aside to those who haven't yet started: Dodging means blocking transmitted light from the enlarger to the printing surface; burning in means roughly the opposite—allowing additional transmitted light to hit part of a print.

Because we are dealing with a negative, or reversed, image, allowing more light onto a print will darken the area selected; less light will lighten it. Within reasonable parameters, this allows for a fair amount of fine tuning, especially in black-and-white printing.)

The area I wanted to burn in was irregular in shape—following the line of Jim's bent leg as well as the outline of a small side window. So holding a conventional straight-edged piece of cardboard over the printing surface to channel the light where I wanted it to go wasn't going to work. Normally, I would have placed a piece of cardboard in the printing easel, traced with a pencil the area I needed to burn in, then painstakingly cut along the line to create a custom printing tool. I also might have used my hand to dodge and burn in, but in this case, I simply could not bend my fingers into the shape I needed. Likewise, my store-bought set of dodging tools—different plastic shapes held by a thin metal wand—were just not up to this job.

That's when the apple fell on my head: Aluminum foil.

Okay, so it wasn't the key to quantum physics or the cure for cancer, but boy, did it work like a charm, and boy, was I chagrined that I hadn't thought of it earlier (like, say, twenty-five years ago).

I found that, using a heavy piece of foil, I could hold it over the easel when the image was transmitted and form the foil into exactly the shape I needed to block or admit just the right amount of light. If I got it wrong, all I had to do was reshape the foil. Because the foil was one piece (as opposed to my fingers, for example), I was able to make four 11" × 14" prints with no variation at all.

One of my longtime wish list fantasies has been for some kind of light sensitometer that will record dodging and burning information as it reaches the printing surface, lock it in memory, then retransmit it at will, allowing you to create endless numbers of prints with no further manipulation. (To make this work probably would involve not only all kinds of computer programming, but rear projection from under the easel surface and who knows what else. Any geniuses out there wanna make a million? Be my guest—but I want a cut.)

I'll bet because I've been so hung up on this invention, it took me twenty-five years to make this historic breakthrough with Reynolds Wrap. But, hey, who knows how long Newton was actually under that tree?

Photography
in the Garden

09/02/94

Probably because I'm a native New Yorker (raised in the Bronx and on the subway) I never had much of an appreciation for nature. Nature meant animals, bugs, and sleeping on dirt. Nature meant there was no place to get something to eat.

When I was a Cub Scout, I passed the tree-climbing requirement by scrambling up a chain-link fence. (This is true, I swear.) Later, when I was a Boy Scout, I figured I'd learn about outdoor living by following the example of my troop leader, who kept our campfire going by throwing cupfuls of lighter fluid on it.

You can see why I'm not what you'd call an outdoor kinda guy.

But things change, and one of those changes was marrying Judy, who turned me on to the beauty of a garden and taught me to appreciate that one constructs a garden as one would a sculpture—with balance, form, and grace. And it stands to reason that a beautiful garden deserves beautiful photographs.

Good garden photography is more than closeups of flowers, although that certainly might be part of a picture story. It is architectural photography without the architecture, portraiture without people. When a garden photograph works, it creates a sense of depth, warmth, and place. It pleases your eye with harmony and symmetry. The eye is not distracted by one bright color or light, but rather delights in discovering tiny details not immediately apparent. Good garden photography is good photography, period.

In the Washington area, there are myriad gardens in which to relax and make pictures. The lovely outdoor garden at the foot of Capitol Hill, for example, across from the enclosed Botanical Gardens, is a little gem that can be enjoyed in ten minutes, or doted on for hours. In Georgetown there is Dumbarton Oaks, a sprawling and beautiful oasis in the heart of the city. In Wheaton, Brookside Gardens offers not only well-tended plants and

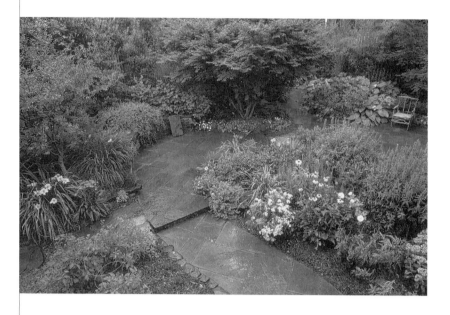

Harsh noontime light may be the worst time to photograph in the garden. Gray overcast often can lead to much richer color saturation. In the first image, of Judy's gorgeous garden behind our home, I hosed down our winding slate bath to lend specular highlights. In the second image, at our friends' garden in Chincoteague, Virginia, the gorgeous late-afternoon sky is as much an element as the flowers. © Frank Van Riper

flowers, but rolling hills, ponds filled with geese and fish, as well as a serene Japanese garden complete with an open-sided pagoda. Head along the Potomac to Mount Vernon, and you will run into River Farm and the magnificent, historical grounds of the American Horticultural Society.

But perhaps the grandfather of them all is the National Arboretum in northeast Washington, where the picture possibilities seem endless. Judy and I gave ourselves a day off there last spring and just wandered a fraction of its four hundred acres. It was the first time for me, and I was floored by what I saw. But first a few hints about photographing all this beauty:

- I'll bet more than 90 percent of all garden photography is done in color, yet one of the most beautiful garden books I ever saw was in black-and-white and documented the genteel ruins of the ancient gardens of Italy. So don't feel bound to shoot everything in color.
- Just as we wait for the magic light immediately after dawn and just before sundown for our landscapes, so, too, one might wait for such light when photographing gardens on sunny days. Still, one of the nicest things about garden shooting is that beautiful pictures can be made—maybe even should be made—in the shadows or when it's overcast. Soft light adds depth and texture to leaves and also allows colors to look rich and vibrant. The corollary is that garden photography should not be tried on glary days or when the sun is high. In this regard, a polarizing filter also is a good tool to keep handy. A filter that rotates can block the sun's rays from various angles, cut down on reflections on water and window glass, and generally give the impression of richer color saturation.
- Never underestimate the power and beauty of rain, especially immediately after a shower. Raindrops glistening on flowers and trees add sparkle to pictures and lushness to the scene. (It's not for nothing that many professional garden shooters hose down walks and pathways as well as the leaves and trees before photographing.)
- Sure, shoot lots of flowers, but don't forget the other details like beautiful bark patterns or unusual leaves on rare specimen trees. And of course don't miss the forest for the trees: Step back from looking at one tree or flower and see if you can incorporate it into a larger composition.

For me, two of the most amazing things about the arboretum (aside from the fact that admission is free and it is open seven days a week) are the huge bonsai garden and the towering original columns from the U.S. Capitol.

The bonsai garden simply has to be seen to be believed. I was accustomed to seeing tiny bonsais on people's end tables, but some of the arboretum's specimens are three and four feet tall and just as wide. They are awesome to look at and beautifully displayed in open-air settings.

On a much larger scale, the Capitol columns, standing majestic in an open green field, have been arranged so that one might imagine how they originally stood. They offer a wealth of pictures, and I can't wait to return with my view camera.

Unlike some places, notably the Capitol grounds, photographers and their equipment are welcome. A spokeswoman noted, for example, that tripods are always permitted.

"We just ask that you not step in the flower beds," she said.

Foiled Again

05/19/95

In photography, a good print often is as much the result of careful dark-room work as it is the result of precise exposure calculation.

When shooting fast-moving subjects or changing events, especially by available light, we often have to shoot first and accept the consequences of a less-than-perfect negative. Sometimes underexposed, or "thin," negatives can be punched up by high-contrast filtration during printing or, in extreme cases, via chemical intensification of the negative itself. Many times, though, a good print cannot be achieved without further manipulation via dodging and burning in.

Dodging and burning refer to ways of controlling the light transmitted by the enlarger through the negative onto light-sensitive photographic paper. When we dodge we block light from certain dark areas of our picture to keep them from going too densely dark to render detail. (Remember: In photographic printing, both black-and-white and color, we are dealing with optical opposites—more light on a print will make things dark; less light will render them lighter.)

Burning in is simply the opposite of dodging. We mask off most of the print area (often using our hands) to create a much smaller area of the print that will receive a longer burst of enlarger light than that given the rest of the picture. This area will thus be darker than it would have been without manipulation.

Though the hand is a great darkroom tool, it is not perfect, especially when you have to dodge or burn in an odd-shaped part of your picture that is surrounded by well-exposed areas needing no manipulation at all. That's when you should create your own printing tools designed for each individual picture.

Recently, during a day-long darkroom session, I hit on a new way to, in effect, dodge and burn in at the same time. It worked perfectly and required no additional effort.

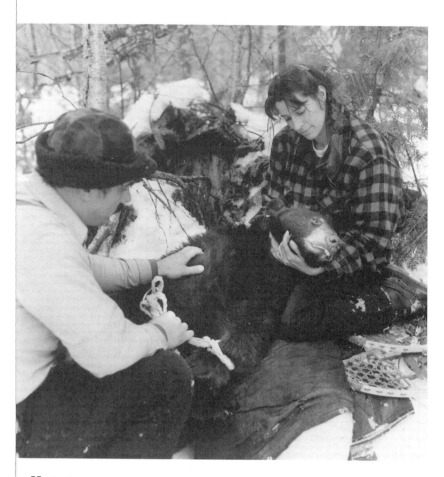

My "Pietà in the Maine Woods" was improved in the darkroom by my combined dodging/burning-in tool that helped me bring out detail in the sleeping bear's fur, without looking artificial. The original unmanipulated print was far too dark.

Creating darkroom tools for dodging and burning in takes little more than lightweight cardboard, a pencil, scissors, and a few books or boxes. When dodging, a thin piece of stiff wire also may be necessary—like a cake tester, for example.

First, place at least six inches of boxes or books on your enlarging easel, topped by the cardboard. Then turn the lights out and the enlarger on. You'll see a miniature version of your picture projected onto the cardboard. In the center of the cardboard, trace the area to be dodged or burned in. Carefully cut out the shape you have drawn and you're ready to manipulate.

If the area of your print needs to be burned in (darkened), use the cardboard (now minus the shape you have cut out) as a burning tool. You'll find that this miniature version of your selected area will allow you

to hold the cardboard at a comfortable height over your easel when printing and let you see exactly if you are letting in light where you want it. You can adjust the size of the opening by moving the cardboard up and down till it exactly matches the areas to be darkened. (Note: When dodging or burning in, always shake the tool slightly to "feather" the edges of the manipulation to make it less noticeable.)

Dodging is more complicated—but only slightly. To lighten an area, hold the cardboard shape you have cut out over the easel to block light from the selected area. If the area you want is in the middle of your print, however, holding the cutout with your hand won't do, because your hand and arm also will block light and thereby lighten areas that don't need it. Tape the cut-out to that trusty cake tester, however, and you'll be all set. The wire will not block light (remember to shake it slightly) and your affected area will magically lighten just where you need it.

Recently, while making a print from my recent bear-tagging adventure in Maine, I discovered that the anesthetized black bear in my picture was little more than a dark blob in the un-dodged print. I made my dodging tool as described above and was immediately able to render more detail in the mama bear's black fur. But her lighter face was showing up too light. That's when I had my idea.

With a pocketknife I punched random small holes in the dodging tool where the bear's face would be. It worked like a charm—the bear's body took the full dodge, while her face now got a mixture of blocked and transmitted light. I was dodging and burning in at the same time.

I have touted aluminum foil as a great dodging tool for its ability to be easily shaped. Now I've added a new technique to my repertoire.

Murphy's Photo Laws

A plumber once told my stepson Bill that there really are only three immutable laws in that profession: (1) Payday is on Friday; (2) Poop always flows downhill; (3) Hot is on the left; cold is on the right.

Which got me to thinking about photography's laws, each of them as set in stone as the above, and each a variation on Murphy's Law: anything that can go wrong will. The prudent shooter will bear them in mind to avoid disaster—and to come back with pictures.

Batteries fail most when you need them most. With the possible exception of large-format photographers—whose cameras are all-mechanical throwbacks to an earlier era—we all depend on batteries in one form or another to make pictures. I go through scores of AAs to power the motor drives on my Nikons. My exposure meters run on batteries. In addition, when doing event or wedding work, I rely on a heavy high voltage pack on my belt to power my flash. Have they ever failed me? You betcha. Just this spring, for example, near the end of a ten-hour wedding, as the bride and groom made ready to cut the cake, I looked down at the indicator lights on my high voltage pack and was dismayed to see all the lights going out every time I made a shot. I would have been standing there—all dressed up with nothing to shoot—if I hadn't had a fully charged spare in my camera bag. Crisis avoided. Moral: Before any important shoot, make sure your batteries are fresh. And always carry spares. Always.

A dropped lens will seek the hardest surface on which to land. I dropped a lens once. The sound of it hitting the marble floor on which I was standing will stay with me the rest of my life. It was magical how the lens, a 24mm Nikkor f/2.8, was transformed from a precision optical instrument into a paperweight in a fraction of a second. And only minutes earlier, I had been standing outdoors, on nice soft grass. Fortunately, I was able to use my wife Judy's 28mm wide-angle lens as a backup.

Still, that's not the worst dropped lens story I've ever heard. At that

ten-hour wedding, an uncle of the bride told me about the trip he made to the Southwest and how he dropped a lens into a canyon. Not just any lens, mind you, but a 30mm fish-eye lens for his Hasselblad. Oh yes, the camera went, too. He could see it on the canyon floor and did what any self-respecting photographer would do: He went down after it. Two hours later, he had retrieved all the pieces. The lens was fine—except for the smashed front element. Hasselblad is sending him a new one, for a mere $1,000.

Specs on new film are fiction. Only someone who believes in Santa or the Easter Bunny will shoot a new film without testing it first. When Fuji unveiled its super-saturated, ultrafine grain Velvia film several years ago, to go head-to-head with Kodachrome 64 and other great Kodak emulsions, the manufacturer insisted the film should be shot at ISO 50. So how come nearly every one of my slide-shooting colleagues rates it at 32? Testing, that's why. And when Fuji later unveiled Provia (ISO 100), the same thing happened. It's a great film, but I find that, in 35mm, I get the best results and the most accurate exposures, when I rate the film at 64. Ironically, the same film in medium format seems to perform best at its stated speed of 100. Go figure. Or better: Go test.

Taking just one shot of anything is asking for it. If film is the least expensive bit of gear we own, why do some of us parcel it out as if each frame were made of gold? Use it lavishly. At a wedding, I always make three of every group shot. Why? Because someone's eyes are going to be closed, that's why. Not only that, but labs have been known to bend, spindle, and otherwise mutilate film, so multiple shooting lengthens the odds against heartache. See a great landscape? Even if you are dead certain of your exposure, bracket like mad and make multiples of each exposure. I guarantee you will get several keepers and be surprised how different exposures will render wonderful variations on a theme. Not only that, but making "dupes in camera" is a far better way to make copies of a great shot than having duplicates made by your lab. (Except for very expensive reproduction dupes, commercially made duplicates almost always lose something in translation—be it in additional contrast or added grain.) And if you do think your precious slides or negatives never will be lost or scratched, maybe you do believe in the Easter Bunny. Think redundancy.

Photography is like college tuition. The cost of it always rises. But then you knew that already.

Surviving a Flood

08/29/97

It was one of those late-spring days Washington is known for, when every weather forecast includes the words "late-afternoon thunderstorms."

My wife Judy and I were shooting a wedding in a downtown ballroom, not far from our home, when the rains began with a vengeance shortly after the ceremony. By the time the guests left that night, it was coming down in sheets. But by then, I wasn't thinking about our clients; I was thinking about our basement.

Our darkroom is in a converted garage downstairs, and more than once during torrential thunderstorms, I've come home to find three inches of brackish water down there.

Fortunately, there was no damage in the darkroom itself—I store everything off the floor—but this storm was so intense that it left water in the rest of the basement as well, soaking, among other things, a cardboard box we'd inadvertently left on the floor, a box that bore the mundane, but heartbreaking, words, "family snaps."

There, in a damp, stuck-together mess, was more than a decade of memories in prints and negatives: some of the last photos of Judy's parents, pictures of our kids, pictures at gallery receptions and book-signings—and, of course, our wedding pictures.

I was angry and embarrassed. Angry that I hadn't cleaned out the sump pump after the winter to enable it to work. But I was even more embarrassed that I, a professional photographer, had fallen victim to the kind of disaster I previously had thought only happened to amateurs.

But some good did come of this soggy mess. All of our snaps and all of our negatives are fine now. And if the same thing happens to you, you can save your memories as well. Here's how:

The first thing to remember is that you should work fast. A wet, stuck-together mess is much easier to rescue than a dry stuck-together mess. The second thing to remember (and this can be a comforting thought as well)

is that your prints and negatives were "born" in water (photographic chemicals, actually) and therefore are used to being wet. If water helped create this catastrophe, it can help undo it as well.

The first thing I did was to fill one of my 16" × 20" darkroom trays with warm running water, using a darkroom siphon to keep the water circulating. I then put everything—prints as well as negatives—into the tray and let them have a good, cleansing bath. This box of pictures contained literally hundreds of 4" × 6" prints, as well as negatives in plastic archival sleeves. Many prints were stuck to each other, but, once in the water, came apart fairly easily. The important thing is to be patient. You run hardly any risk of damaging your prints in the water and even if they have dried together, a warm water bath should separate them.

Our negatives posed more of a problem, ironically because of the archival sleeves. Once wet, the sleeves tended to bond to the negatives, and if allowed to dry onto the negatives, could damage the emulsion, ruining them. I made sure the negatives and sleeves were thoroughly soaked, then gingerly coaxed each negative strip out of its sleeve. (Note: If the negs are really stuck, you might try a few drops of Kodak Photo-Flo solution, or some other similar liquid. Photo-Flo, among other things, is a water softener, and it helps in the streak-free drying of film strips because is makes water sheet and flow more smoothly.)

It was boring. It was aggravating. But it worked. Slowly each photograph emerged, and within less than an hour's time I had several hundred soggy, yet intact, pictures accompanied by their negatives. (This approach will work with photos and negatives that have been accidently immersed in other liquids—soda for example—especially if done right away.) Drying the pictures required several of my nylon mesh drying screens, set out on darkroom tables and elsewhere so that the prints and negs could air dry. Since virtually all snapshot prints are made on RC (resin-coated) paper, they tend to dry flat, with no need to place a screen over them. Given the size of the job, this was a blessing. (If you don't have a drying screen, just position the photos face up on a clean surface.) Normally, I would squeegee my prints to remove most of the water. But with hundreds of prints, I simply couldn't. I set them out to dry, soaking wet, and they turned out fine.

Alternatively, you might try blotting your prints with a photo-blotter roll—or even a succession of linen handkerchiefs. Matte-surface prints tend to be hardier than glossy—and less likely to show drying marks. Air-drying tends to be best, though.

Follow these steps and you'll save your snaps. Better yet, clean out the sump pump.

Harry Hamburg: Honing Skills

01/02/98

During a typical day covering Washington for the *New York Daily News*, photographer Harry Hamburg will shoot a job on Capitol Hill, hustle down to the White House to photograph the President with some visiting dignitary, and then may start a feature assignment involving a member of the New York congressional delegation.

If his beeper doesn't go off, somewhere in between he can grab lunch. Most times when he's working like this Hamburg will be in a crowd of other photographers, or held behind a rope on the White House South Lawn, or crammed into the well of a hearing room, waiting for a prominent witness to do something that will make a good picture.

Hamburg's very good—he has won the coveted "Insider's Washington" category in the White House News Photographers Association's annual competition—so it's not unusual for him also to be assigned to cover major sports stories as well as other fast-breaking events in and around Washington.

This kind of photography defines speed—speed in making the shot and, as important, speed in getting it into the paper. Because of this, Hamburg uses digital equipment almost exclusively now. His basic rig these days is a digital version of the Canon EOS-1. It allows him to transmit images instantly over phone lines, with no need to develop film, edit negatives, or, heaven forbid, wait for prints to be made. Over lunch recently, Hamburg whipped out his laptop computer and called up the pictures of Bill Clinton that he had made—and transmitted with captions—just minutes earlier.

"I think I've shot film maybe once in the last year and a half," he said.

Still, being part of the pack, even a distinguished pack of Washington reporters and shooters, can get old, despite the rough-and-tumble camaraderie of fellow journalists.

That's why, when he had a chance to set out on his own—albeit for just a long weekend in Europe—Hamburg left all the digital gear at home and went back to his roots. All he carried was an ancient Leica, one 50mm lens, and black-and-white film. No digital backs, no dedicated speed lights, no color.

The results are as beautiful as they are instructive.

"I had been in London for a few days for a surprise birthday party and decided that the new train to Lille was just the ticket for the weekend," Hamburg said. Lille ("a poor person's Paris") is in the north of France, a stone's throw from the Belgian border, and is one of the stops of the new high-speed Eurostar train that runs under the English Channel between London and Paris. "With its Flemish architecture, pleasant people, and relatively low prices," Hamburg noted, "it was a cheap, convenient getaway."

Working without the pressure of a deadline or a specific story, Hamburg was free to follow his eye. In looking at the photographs he produced—most of them wonderfully evocative images of people totally unaware of the photographer's presence—I couldn't help thinking of some of Cartier-Bresson's gentler work, so lovely are the moments he caught.

I thought, too, of Broadway and Hollywood actors returning to a small stage to hone their skills. Photography is a mental as well as physical game, and this little sojourn was a way for Hamburg to flex his visual muscles after months of working in a crowd under tightly controlled conditions.

Working in available light (using Kodak's great new T400CN black-and-white film), Hamburg did not have to worry about being in the range of his flash unit. He also was able to take advantage of black-and-white's excellent exposure latitude. The "normal" 50mm lens freed him from having to worry about the different focal lengths of his zoom lens. When he had to "zoom," he zoomed with his feet.

All Hamburg had to concentrate on was making pictures that pleased him.

And in the process he made images that please us—and teach us as well.

Hamburg Helper: Snap Tips

Keep it simple. If you're using one point-and-shoot camera, stick with a good all-purpose print film, like Fujicolor 400. Alternatively, 800-speed film will also let you shoot in low-light situations without flash or even a tripod in some cases. Another advantage is that these films (as well as those of lower ISOs) tend to be unaffected by airport security X-rays for carry-on baggage. Important: In Western Europe, these X-ray machines tend to be fairly benign, but machines in the former Eastern Bloc and other Third World countries can pose problems with their varying intensity.

In situations such as these, you might even consider having film processed on site, if possible. Even if the prints are made poorly, at least

you will have processed negatives that will not be affected by additional security zapping as you travel from point to point.

Stick to one great lens. If you're beyond the point-and-shoot stage, consider bringing only one lens with you. Hamburg loves his Tamron 28mm-200mm zoom, with a variable maximum aperture of f/3.5 to f/5.6. Of course, on Hamburg's trip to France he did just fine with his trusty "normal" 50mm lens and zooming with his feet.

People make any shot. "When traveling to different places," Hamburg notes, "the architecture and the buildings are great, but people are always going to be the most interesting subject. After all, you can buy a postcard of the Eiffel Tower." Better, he says, to make the Eiffel Tower a background element of your shot, focusing on someone, say, throwing a Frisbee to a dog. "Much better picture, believe me."

Night time's the right time. "Don't be stuck with shooting only during the day. Some of the best stuff can be made at night—especially if you're loaded with 800-speed film." In addition, Hamburg notes that rainy weather can afford some beautiful shots, of rich color saturation, provided you take steps to protect your camera and lens from the wet.

Be prepared. Sometimes the best shots just happen right in front of you—and you've got to be ready. Two modern-day ways to be ready for anything are: setting your camera on Program, or setting your camera to the widest lens opening on Aperture Priority. In the latter case, the wider aperture will allow for the higher shutter speed, that in turn will minimize camera shake.

Patience and Preparation Equal Good Pictures

09/11/98

Over dinner many years ago in small bistro on the Left Bank of Paris, Mike Wallace and I were comparing interviewing techniques when he told me the story of his first interview with Yasser Arafat.

In truth, I happened to have been in Paris on vacation, visiting my friends Neil and Carol. Neil was involved in a book project with Mike at the time and, since Wallace happened to be in Paris also, we all went out to dinner together. (I knew Wallace only slightly from the days we both covered Watergate.)

Over dinner, Wallace relayed how apprehensive he had been at the Arafat interview, the first the PLO chairman was to give to American television at a time when he was regularly being denounced as a terrorist, not accepted as a political leader. Back then, Wallace noted, Arafat favored mirror-lens sunglasses that only added to his ominous visage.

But right before the camera rolled, Wallace recalled, Arafat took off his sunglasses, turned them toward him, and smoothed his hair.

Yasser was getting ready for his close-up.

"Then I knew we had him!" Mike said. The interview went fine.

Wallace's comments about Arafat's willingness to be on camera—and CBS's efforts to land him as a subject—came to mind recently when a friend asked how I managed to make some of the photographs in my forthcoming book, *Down East Maine: A World Apart.* The book includes shots of people lost in prayer at a tent revival meeting and kids sitting nervously at their desks on the first day of school, as well as a location portrait of mega-author Stephen King.

None of these photographs just happened. They and many others in the book were the result of lots of planning and preparation—just as Wallace and CBS had to do lots of groundwork before being able to interview the PLO chief.

There's more to making a photograph than sticking a camera between

There is no way I could have made this picture—one of my all-time favorites—if I had not first become a nonthreatening presence by letting people know what I was doing, and by asking permission to photograph at their revival meeting. Once you are not seen as a threat, you, almost literally, become invisible. Obviously, for pictures like this, preparation pays.

you and your subject. There are times when you have to emerge from behind the lens, engage your subject, and only then make the picture. Sure, there's the simple courtesy of asking permission to shoot. But there's more to it than that. Asking potential subjects whether you can photograph them also means you find them interesting and worth recording on film. It tells your subject that he or she is a person of value and substance, or is doing something interesting and worthwhile. It makes for lots better pictures in the long run.

Too often, amateurs think that the longer their telephoto lens, the better they'll be able to capture someone unaware—that, in effect, they'll be able to capture an intimate moment without having to be intimate themselves.

Sometimes this "I Spy" technique may work, but most times it doesn't. Successful people photography, whether portraiture or documentary, is really a collaboration between photographer and subject. Your input can be as strong as dictating what your subject wears or how he or she poses, or it can be as subtle as merely being a nonthreatening presence.

Either way, once you become a person to the subject you are shooting—and not an impersonal, single-lens cyclops—your pictures will improve. "Oh, you don't want to take my picture," a potential subject might say, but if you genuinely care about making the photograph—care enough to gently persist and explain what you are about—I guarantee you'll be accepted more often than you'll be refused.

There are times, too, when asking permission can save you from later hassles, especially if you plan to offer your pictures for sale or publication. Though you generally do not have to get signed model releases from subjects when you are photographing in a public place, a safe middle ground is always to announce your presence beforehand.

For example: At the revival meeting shoot, I asked the pastor for permission to address the congregation as the tent meeting commenced.

"Good evening," I said, "My name is Frank Van Riper. I am a professional photographer and I am working on a book about Down East Maine." I then said that I had gotten permission from the pastor to photograph the meeting, but that people who did not want to be photographed had only to raise their hands and I would make sure they were not in any photographs. By making my presence known, by talking to my subjects before I began shooting, I became not only a nonthreatening presence, I became no presence at all. People forgot all about me, and I was able to make some truly remarkable photographs. I can only imagine my reception if I had marched tight-lipped into the meeting, brandishing a camera and a press card, and tried to take pictures.

Good Manners Revisited

10/09/98

When I wrote about politely making oneself known to people before making their picture—a way of tacitly getting permission to shoot—my wife and partner, Judy, caught me up short. "I bet you get a lot of letters asking, 'What about Cartier-Bresson?'" she said.

I did get letters, but none mentioned this giant of photojournalism, arguably the best known photojournalist of his time, whose ability to capture what he called "the decisive moment" silently and unobtrusively has produced some of the twentieth century's greatest images. Still, Judy's point is worth exploring.

Henri Cartier-Bresson was born in France in 1908 and trained as an artist. He gravitated to photography—and its ability to stop time—likening the process to the rapidly produced monotypes of fellow French artist Degas. "I discovered—thanks to that rapid and unobtrusive apparatus, the Leica—this method of drawing that carves and shapes reality in an instant," he once wrote.

Cartier-Bresson was as stealthy as he was observant. "A velvet hand . . . a hawk's eye" was his own description of how he worked. He never carried his camera over his shoulder, preferring to carry it in his hand or nestled in the crook of his arm, always ready to shoot. He covered the beautiful brushed chrome of his Leica M-3 with black tape, to make it less conspicuous. He never used flash ("impolite . . . like coming to a concert with a pistol in your hand"). He almost always shot in black-and-white; his favorite lens was a 50mm f/2 Summicron, on occasion a medium-wide 35mm f/2 or a 90mm f/2.8. He never owned, much less used, a telephoto lens.

I doubt if Cartier-Bresson ever asked anyone for permission to shoot. I doubt, too, whether most of his subjects even knew they were being photographed, so great was his method "of working without intrusion, silently, almost on tiptoe," in the words of photo historian Beaumont Newhall.

Once, Newhall wrote, the photographer was lunching with friends at

a restaurant when "he suddenly pushed back his chair, put his camera to his eye, snapped the shutter, and sat down—without even interrupting the table conversation. He had seen, while talking, a famous painter. Days later, we saw the photograph he had taken. It seemed, in its direct simplicity and in its penetration, the product of a formal portrait sitting."

Though on the surface Cartier-Bresson's method of working seems the opposite of what I recommended, the end result, I submit, can be the same. Like Cartier-Bresson, I hope to be a nonthreatening presence— actually no presence at all—to my subjects. Only in my case, I try to achieve this by putting my subjects at ease, be it through eye contact and a simple gesture toward my camera, or by approaching a subject and asking whether I can make his or her picture. In the best cases, the subject soon forgets I am there.

An e-mail from reader Jim Keefe describing the photographs he made in Ireland two years ago helps illustrates this point. On a sunny day in Dublin, Keefe wrote, he encountered a little girl, as beautiful as she was "dirty and ragged," begging in the street. When Keefe raised his big 80–200mm lens to his eye, the girl became alarmed, and her mother, herself begging a short distance away, told the photographer through hand gestures that she did not want him to photograph the girl.

"I walked across to [the] mother [and] gently explained to her I just thought she had a beautiful daughter and that I just wanted some nice memories to take back home with me." The mother relented, "and now whenever I look at the slides of the little girl, I recall the incident fondly."

A more telling incident occurred afterward, when Keefe spied "two elderly Irish gentlemen sitting on chairs outside a very colorful pub drinking their afternoon pints and reading the Sunday paper. What a scene!"

But when Keefe zoomed in on them from across the street, one of the men saw him and raised his paper to cover his face. Keefe lowered his camera; the man lowered the paper. "I again raised my camera to my eye, and once again [the man] raised the newspaper to cover his face."

"I had to talk to this guy," Keefe wrote. It turned out the camera-shy Irishman once had been photographed and the picture "ended up somewhere that he hoped it wouldn't. I didn't push the issue, but sat and talked to them for a few minutes, offering to buy them a pint."

As the three men chatted, the atmosphere warmed. "I had gone beyond being a stranger to them, and had shown a genuine interest in them and who they were as people. They let me take about half a roll, now using my 20mm [lens] rather than the non-intimate 80–200."

The pictures, Keefe said, are "quite personal" and reflect "a wonderful few minutes together" with his subjects.

Which way of working is better? Who can say? Cartier-Bresson was a catlike, visual genius whose skills let him never intrude on his subjects. For the rest of us, perhaps we can approach that level by doing something as simple as crossing the street.

Pictures During
Performances

05/28/99

One of the most exciting yet challenging forms of commercial photography is shooting stage productions.

Whether it be for a Broadway-bound show working out its final kinks at the Kennedy Center or a local theater group performing at a community library, photography done during a traditional "photo call" often helps form the public's impression of a theatrical production. These pictures, after all, are the ones used for billboards, posters, or programs. Under certain circumstances, they also can be used to illustrate newspaper or magazine reviews.

Amateurs called on to do such photography for small theater groups—usually at little more compensation than a couple of free tickets—too often think that bright stage lights are all a photographer needs to make good pictures, and that such lighting, combined with a front-row seat, will allow him or her to sit back and capture the onstage action with little more than a tripod and some fast film.

But, as with so many things, it's not that simple.

Though capturing onstage action on the fly can be done (most often by press photographers making pictures during a final dress rehearsal so that a publication has pictures to run with a first-night review done a few days later), doing it right requires a sports photographer's reflexes to capture action at its peak and an artist's eye to compose the scene quickly and well—not mention thousands of dollars worth of high-speed telephoto glass to get a decent exposure. And for all that, virtually every shot made this way has a disturbing shot-from-below quality since most final-dress photography is made from the orchestra seats, looking up at the stage.

Which is why most of the really good stage photography you see in playbills and on posters is the result of careful collaboration between photographer and performer—and almost never occurs during an actual performance.

Theatrical stage production pictures rarely can rely only on stage lighting, regardless of how bright this lighting appears. This shot, from a "Wizard of Oz" production at Gallaudet University's Model Secondary School for the Deaf, employs three big studio strobe units to light everyone well and hold background detail. Pictures were made during a special "photo call" during a dress rehearsal. © Goodman/Van Riper

For the past eight years or so, my wife Judy and I have regularly shot stage productions, most often for Gallaudet University's nationally renowned performing arts program in its Model Secondary School for the Deaf. Working with Tim McCarty, MSSD's former artistic director, we have made everything from rehearsal hall pictures in available-light 35mm black-and-white to formal, studio-lit onstage portraits in medium-format transparency color.

The steps we go through to do the latter—first for MSSD and now for McCarty's new venture, the Quest Foundation (making theater accessible to all, regardless of disability)—are applicable to all forms of theater photography. And if the steps involved require more work than shooting from your seat and hoping for the best, the results are worth it.

Several years ago, for example, Tim hired Judy and me to shoot the

final dress rehearsal of the MSSD production of *The Wizard of Oz*—a great opportunity since, as was the case with most MSSD productions back then, the costumes and sets were elaborate and very colorful.

The first thing we did, however, was to sit through virtually an entire performance without making one picture. That was so Judy, Tim, and I could figure out what representative scenes we wanted to picture—and what changes, if any, we might want to make in staging, to improve the photograph.

Usually, in situations like this we came up with half a dozen or so picture possibilities. After talking them over with Tim, we figured out the sequence we would need to allow for the least disruption when it came to costume changes.

With the dress rehearsal over, now came the "photo call," when Judy and I—not Tim the director—called the shots, literally and figuratively. In almost all cases, the best pictures needed additional light to supplement that used in performance. In fact, I quickly found out that the softboxes and shoot-through umbrellas I routinely used to diffuse my strobe lights, were ineffectual.

We needed direct light and plenty of it.

This was because stage lighting itself tends to be fairly direct, so what we sought to do was mimic this look, only with more intensity, via powerful studio strobe units

In most cases, we would use two or three studio strobe heads, fired directly at the subjects and/or the background. To bring up the background, I usually would shoot at a slower-than-might-be-expected shutter speed: $1/15$ of a second, sometimes even slower. Despite this slow speed, our photographs always were tack sharp for three reasons.

First, we always worked on a tripod to hold the camera, most often a Hasselblad 500C/M or a Hassy Super Wide C/M, perfectly still.

Second, the direct strobe light, with its incredibly short duration, acted to freeze our subjects, acting almost as a second camera shutter.

And third, since this was a photo call and Judy and I could control things, we always asked our subjects to stand real, real still.

In shooting theatrical productions, I tend to rely on daylight-balanced transparency film like Kodak E100SW or E100VS. This is because my strobes are balanced for daylight and, even if the tungsten-balanced stage lights register a little warm during the slower exposures, the effect often is pleasing as a background element.

Street-Smart Guide to Avoid Camera Theft

07/14/00

"Look," I told Judy, pointing to the license plate of the car in front of us. "It says Mazel Tov." (Actually, the tag on the car said "Masltov.")

"I thought you said 'Hasselblad,'" my wife replied.

"You know," I opined. " I could get us a plate saying 'Hasselblad'—or 'Haslbld.' Wouldn't that be cool?"

"Only if you want our cameras stolen from the trunk," Judy said.

Sadly, my wife and professional partner was right. Broadcasting one's affinity for an expensive camera on one's license plate is an excellent way to invite theft, or worse: armed robbery. In fact, that was just what I had told my stepson Dan when years ago he presented us with a handsome metal plaque bearing our logo, "Goodman/Van Riper Photography," saying he hoped we would affix it near our front door.

No sense advertising that our house contains the pricey and hockable tools of the photographer's trade, I told Dan. (The plaque now adorns the door of our home office.) You get the idea. With vacation time here, many of us will be traveling with our cameras and that, unfortunately, increases the risk of theft.

As of today (and I am touching wood as I write this) I never have suffered the theft of any of my camera equipment, though I have traveled with my gear all over the country and the world. Part of this is dumb luck, to be sure. But part of it, too, derives from the caution born of being a native New Yorker, whose Bronx upbringing nurtured a certain street wisdom about holding onto one's stuff.

As you get ready to hit the road to make pictures, keep in mind some of these pointers, from a fellow photographer—and Yankee fan:

- Never leave your camera—ever. Think of your Nikon or Canon as you would an infant or toddler. Out and about you would never leave a young child's side, even for a second, lest the little one suddenly tum-

ble off a chair or run into the street. So, too, an instant is all it takes for someone to grab an unwatched camera from a table or a car.

- And speaking of cars . . . They really offer little protection. Any crook can tell you how easy they are to break into. So doesn't it stand to reason that you should never leave your camera in one? Granted, sometimes you must, especially if your gear includes a heavy camera bag that you'd love to be free of, if only for a short while. Here let me repeat one of our cardinal rules: Judy and I never, ever make a stop and then stow our gear in the trunk or in the back of the car. Even if it means making a separate stop, away from our ultimate destination, we always make sure our equipment is safely out of sight before we stop the car—and lock it, of course, with our trusty Club on the steering wheel.

A New Yorker's paranoia? Maybe. But once a colleague relayed how all her camera equipment was stolen from her locked car trunk in downtown Washington, D.C. She had been shepherding her visiting parents around town when, sure enough, she stopped the car for lunch and locked her cameras safely (she thought) in her trunk. But a thief had been watching, too. The trunk was jimmied and empty when the photographer and her parents returned from their meal.

Today, if Judy and I grab a bite after a job, we always make sure to at least bring our exposed film with us, along with our cameras. Most times, though, we bring our main camera bag, too, since it now is a Tamrac Rolling Strong Box that's much easier to lug around than a hernia-inducing shoulder bag.

I haven't tried this yet, but I will, especially the next time Judy and I go abroad. Lowepro, another great camera bag and accessory maker, now offers "Pacsafe" that can secure a medium-size camera bag in slash-proof stainless steel mesh that can be locked to a stationary object like a bedpost or closet pole. This is one of those ideas that seems obvious—except no one has come up with it till now. The beauty part is that this excellent bit of security rolls up into a convenient carrying case when not in use. Granted, such a device won't stop a determined thief, but it will deter the casual "larcenist" looking for an easy score. (It's the same reason I always use my Club on my Ford Explorer, even when going to the drugstore or grabbing a coffee. I worked too hard to get that gorgeous gas-guzzler to let someone make off with it easily. You should feel the same way about your cameras.)

Okay, let's say the worst happens and someone does rip off your camera, or tripod, or whatever. Always file a police report, even if you're abroad and there is little real chance of a serious follow-up. Notorious sweethearts that insurance companies are (don't get me started), they often will insist on a copy of an official report of a theft before they'll even consider paying dime one on your claim.

But that's cool, because before your trip you did make sure all your insurance premiums were paid up and that your equipment rider was up-to-date, right? Right?

SECTION VI

Equipment: The Good, the Bad, the Basic, the Classic

Filters and Hot Sauce: Use Each Sparingly

11/06/92

I thumbed through a manufacturer's catalog of camera filters recently. The catalog ran more than 100 pages and I'd make a safe bet that fully three-quarters of the filters displayed would produce pictures so kitschy, so clichéd, so downright awful, that only the photographer's mother would like them. But this manufacturer has been in business for years—and I have quite a few of his products.

So what gives? A filter, like jalapeno hot sauce, is best used sparingly, but many novice shooters make the mistake of thinking that sticking a lot of extra glass in front of their lens somehow is cool, or creative . . . or something. In fact, when going over the filters I have used over the years, I can come up with maybe half a dozen that I would recommend without hesitation. Others were one-shot wonders that were great for the limited application for which I needed them.

In general, filters do one of several things. They can add or change color in color photographs. They can block some colors from registering, and thereby increase contrast, on black-and-white film. They can alter the reality of the picture in any number of (often hokey) ways. They can soften the image. They can compensate for the film you are using to give you a well-exposed picture under less-than-ideal circumstances.

By the way, one of the first lessons I learned about filters was to always use one that has virtually no effect at all on the photograph. The UV, or haze, filter ostensibly helps make scenic pictures with lots of sky clearer. Maybe so. But every shooter I know uses it simply to protect his or her front lens element. Every time I buy a new lens, I buy a new UV filter to go on the front.

One of the most useful filters when working in the sun is the polarizer. By only allowing light at certain angles to register on the film, the polarizer can suppress unwanted reflections from windows and shiny sur-

faces, keep water from looking totally mirrorlike, and also darken the sky to a much richer blue.

We have the late Edwin Land (father of the Polaroid camera) to thank for the polarizer. He invented the process during World War II as a way to make light from car headlights almost invisible from above—a big boon if the United States ever had to go to widespread blackouts during enemy air attack. Nowadays, of course, the polarizer's potentially life-saving history is all but forgotten in the pursuit of better pictures. (One note: Whereas other filters are often a single piece of glass that screws over the lens and stays there, a polarizer screws on, then rotates. This allows you to see exactly what effect it is having before you make your picture. The first time I saw a polarizing filter perform this magic, I was fascinated.)

Color compensation filters come in all types, but two of the most useful are the blue 80B or 80A filters that balance daylight film for the warmth of tungsten—incandescent—light, and the orange 85B that enables tungsten film to be used in daylight. The effect is not totally accurate, but especially when using daylight film under tungsten light, it creates a far more natural looking picture.

Fluorescent light may be the greatest thing that ever happened to offices, but it is hell on color film. Everything looks bilious and green. To compensate there is the reddish-pink FL filter. Other manufacturers call similar filters by their more familiar name (to photographers, anyway) of 30 Magenta. This filter adds the right amount of complementary red to the greenish cast of the overhead light to cancel everything out and render a nearly normal image.

But what about black-and-white? Can color filters help here? And how! Ansel Adams never left home without a pack of filters for the lenses of his view camera, the better to reproduce the dramatic skies that helped make so many of his images so memorable. Generally black-and-white filters tend to be in the yellow-to-red-to-orange range, each one able to reduce certain colors while accentuating others. An orange filter, for example, will reduce blue and green colors and yield more contrasty skies than will yellow, or even green, filters. I know a newspaper shooter who never has time for any gimmicks or gizmos but who always travels with an orange filter in case he needs to punch up a horizon in black-and-white.

Finally, two other filters might earn a place in your camera bag: the diffusion filter and the warming filter. The first is one of my wife Judy's favorites when we shoot weddings. She always reminds me that women "of a certain age" don't like to be rendered in tack-sharp focus. So on goes the diffusion filter when shooting grandma. And, to be honest, the filter does add a pleasing soft effect in almost any picture, regardless of subject. (These filters come in varying degrees of fuzziness; you might ask to see examples of their diffusion before you buy.)

The warming filter is a hardy perennial. Often called the 81A, it adds a hint of warmth to a color image and seems to give light-skinned subjects

the glow of a slight suntan. A lot of color portraitists use the warming filter all the time; its results are pleasant and subtle.

With nearly all the above filters, you should always be aware that any time you place a piece of colored glass in front of your lens, you are letting less light onto the film and will have to compensate exposure accordingly. A through-the-lens exposure meter will usually take into account the "filter factor" and automatically adjust your exposure. But on manual cameras, remember to read the manufacturer's guide on how many stops to open up to make up for the loss of light on the film.

Okay, so I've told you what filters I like. What about the others? It is strictly personal, but I hate gimmicky filters such as star bursts, multi-imagers, "speed" filters (to render a totally phony-looking blur on the back of a stationary car), heart-shaped or keyhole filters, double-exposure filters, and any number of others.

Of course, you're free to use whatever filters you want. Just don't use them on any pictures you show me.

The Diana/Holga Mystique

07/30/93

Somewhere in China is a factory that turns out one of the most laughably awful excuses for a camera I've ever seen. In fact, to call this thing a camera at all is to exaggerate. Replica of a camera might be better. Parody of a camera, better still.

This thing is a molded plastic box with a fixed shutter (well, actually a coiled spring attached to a piece of metal that blinks), a lens (sort of), and a hole to sight through. That's it. No prism, no autofocus, no motor drive. No glass, actually. The lens is plastic.

The Holga camera is the current incarnation of a line of cheap toys that began years ago with a similarly made camera called the Diana. It costs about $15 and though it looks like a cheap 35mm camera, it takes medium-format (120mm) film.

What is amazing about this camera is that it takes pictures at all. What is even more amazing is that, given the right conditions, it can produce pictures that are simply wonderful.

A few years ago, my friend Tom Kochel, a commercial and fine art shooter, displayed at one of Washington's finest photography galleries a set of prints he had made on his old Diana camera. It was not an April Fool's gag, either. Kochel's work, at the Jones Troyer Fitzpatrick Gallery, was gorgeous. And just recently, another friend, Craig Sterling, a fine art photographer whose black-and-white prints go for big bucks, had me over to take a look at his most recent work, made not with the Hasselblad he usually totes, but with the Holga he carried around during his honeymoon in Italy. More gorgeous work.

These two photographers each approached the Diana/Holga from different perspectives. Kochel, whose work usually includes annual reports and similar photography, was looking for a camera that was the antithesis of the medium- and large-format gear (and accompanying elaborate lighting setups) that he used in the studio and on location. As he put it, "I

The Holga is one of several toy cameras that, in the right hands, can produce gorgeous images. Washington photographer Craig Sterling, known for his precise architectural imagery, played with the Holga during a trip to Italy and came back with this beautiful, if unintentional, two-image panorama of the Arc of Septimus Severius. © Craig J. Sterling

was solving technical problems all the time and getting away from 'taking pictures.'"

Sterling, whose landscapes and cityscapes call to mind the work of Ansel Adams and Brett Weston, wanted to see what would happen if he did not, for once, produce a negative that was tack sharp from edge to edge. He consciously sought to make a creative tool out of the Holga's abysmally poor optics. Of the numerous images he produced in Italy, his photograph of the Arch of Septimius Severus in Rome perhaps best illustrates what a lousy camera in talented hands can do. The massive and much photographed triumphal arch looms in Sterling's picture in a somber panorama, the edges of the print going to a feathery blur, only the center remaining in focus. The arch is huge—in fact, it is too huge.

"Actually it's two negatives, side by side," Sterling said. "The film advance is awful!"

Sure enough, on closer inspection, one can see two separate photographs, made from slightly different perspectives, combining to make one arresting image. Sterling noticed on his contact sheet that there was virtually no separation between two of his negatives, so he printed them as one.

Obviously, using a Holga or a Diana sometimes takes more than skill. It takes patience and luck. Patience because the camera is anything but light tight. In fact, the first thing any Holga veteran will tell you is to load your camera in darkness, then tape it shut with black tape, the better to seal up the always present light leaks. Sterling went one step further: He taped shut the little red window on the back of the camera that showed you what exposure you were on. (He'd lift up the tape only when advancing the film.)

Sterling learned the hard way that unloading the Holga can be an adventure, too. After experiencing fogging on a roll that he thought had been fine, he realized that the film advance was so bad it did not wind the film tightly around the takeup spool, greatly increasing the risk of fogging. The solution: First, he always unloaded his camera in a film-changing bag, then, while still working in the bag, put the spools of exposed film into a light-tight, 4" × 5" sheet film box. (It holds half a dozen rolls very nicely.) Only when he got back to his darkroom did he remove the film from the box for development.

Incidentally, what few technical specs there are are these: a fixed shutter speed of (about) $\frac{1}{100}$ of a second and a fixed aperture of f/5.6 (sort of). Both Sterling and Kochel used Tri-X, a good workhorse film with plenty of latitude.

The bottom line for both these photographers was that when you use a camera with such limitations, all that really matters is your eye and your brain. No automatic gizmos are going to save you, because there aren't any. This is the camera to use with abandon, allowing serendipity and impulse to hold sway. In that sense, though it is little more than a toy, the Holga (or the Diana) is not a camera for children or amateurs, but for the adventuresome.

Holga cameras, which cost $15, can be ordered from the Maine Photographic ReSource in Rockport, Maine; call (800) 227-1541 or (207) 236-4788.

Tripods: "Can't Live with 'Em . . ."

08/06/93

They are the cumbersome overshoes of photography, the item that you must have when conditions warrant, yet don't like to carry around.

They are not especially pretty, and the better among them are very heavy and very expensive.

They easily can be left behind as too bothersome too carry, yet nothing, save the lens on your camera, can have more impact on the success or failure of your photograph.

They are big. They are bulky. They are tripods.

It did not surprise me that fully three-fourths of the people who took part in my reader survey said they owned at least one tripod. What I did not like hearing were the complaints from so many out there that they "didn't use them all that much," or that they found their tripods too much of a bother to use except under the most extreme circumstances (as when shooting, say, in near-pitch-dark under moonlight).

Obviously, tripods, and their one-legged brethren, monopods, are not something you would carry with you on a spur-of-the-moment photography excursion, or to family picnics and other such outings.

But serious photographers would no sooner go on a shoot without one than leave home without film. And serious photographers tend to use their tripods even in situations where most others would photograph handheld.

Tripods and monopods do more than provide a stable base. They also provide the means to carefully compose a shot and bracket exposures without having to worry that the one shot in which the exposure is just right is also the one in which the composition is ever so slightly wrong. They remove the twin bugaboos of camera shake and camera movement, so you can concentrate on your picture.

For years, manufacturers have tried to come up with tripods that are both stable and lightweight. Sadly, though I have seen many tripods that

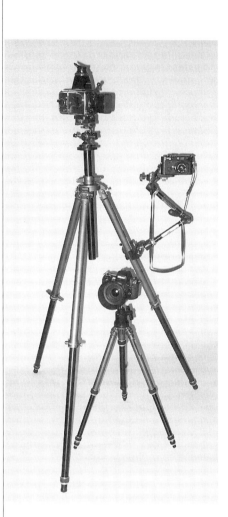

My means of support. The heaviest tripod I own is a big Gitzo that can easily hold a 4x5 view camera. Here, I've clamped a versatile Bogen Magic Arm onto it, to hold my Leica M6. The much smaller tripod also is a Gitzo and is a joy to travel with, especially overseas.

are stable and many that are lightweight, I have yet to see one that is both.

The problem with lightweight tripods is that, as good as they may be when unextended or extended halfway, they invariably become rickety when extended fully. A heavy camera—or more often a heavy 200mm or 300mm telephoto lens—will invariably cause a flimsy tripod to shake. The shake may be barely perceptible to you, but I guarantee it will be perceptible in your photograph as a nettlesome blur or softness in a shot you swore was tack sharp. Remember that the longer the focal length of the lens you use, the more it will magnify even the slighest motion during an exposure.

My personal preference in tripods is a small behemoth from France, the Gitzo model 341 Inter Pro Studex. Made of tubular steel and featuring three collapsing legs, the tripod extends to 6-feet-4. It is topped by a Gitzo ballhead, allowing for universal movement and rock-solid locking. Having lugged this thing to hundreds of assignments (in its own separate bag), I

assumed it weighed the better part of 15 pounds. To my surprise, when I actually weighed it recently, I found it weighed a mere eight pounds. The tripod and separate ballhead ran about $450.

Though several manufacturers, including Slik, Cullman, and Linhof, produce tripods as well, in the United States, the French Gitzos and the Italian-made Bogens seem to be the most widely used by professionals and serious amateurs. Zone VI in Vermont also offers two beautifully made wooden tripods, specially designed for its 4 × 5 and 8 ×10 field cameras.

Bogen and Gitzo each produce a wide range of tripods and monopods, the Bogens tending to be appreciably less expensive than the Gitzos. Bogen also produces a fairly good line of moderately priced tripods for amateur shooters, especially the 3001 series that has won high marks from consumer magazines. Prices vary, of course, but among the serious tripods, you can expect to pay at least $150 for a good one.

Narrowing the seemingly unbridgeable gap between stability and light weight are the new carbon fiber tripods, especially those made by Gitzo. These really have to be seen to be believed, and pros who have them love them. But be prepared to pay a good 50% premium for this strong lightweight material. I personally haven't been tempted—yet. When my wife and I went to Venice for a month to photograph for our next book, I brought with me my current lightweight fave: a small Gitzo G-126, topped by an equally compact Bogen 3262 universal ballhead. While the 126 will never match my heavy-as-lead Inter Pro Studex (who makes up these names?) for stability, it was plenty stable for my 35mm and medium-format cameras—and I was able to pack it in my suitcase. Total cost, about $350.

Unlike Gitzo, Bogen also offers an intriguing series of seemingly bizarre camera supports, each of which could prove its worth in gold under the right circumstances. There is the Car Window Pod, for example: a well-machined clamp that fastens instantly to any rolled-down car window.

My personal favorite, though, is the Bogen Magic Arm, an articulated arm that features a camera support on one end and a huge clamp on the other. A special handle at the "elbow" locks the whole business rigid once it is in the desired position. We found this tool invaluable several years back when we were hired to photograph the black-tie ball thrown each year by the Corcoran Gallery of Art.

To make an aerial view of the main dining area looking down from the gallery's second floor, we clamped the Magic Arm to a wooden railing overlooking the tables, locked it into place, then clamped on our Hasselblad Super Wide. The arm held the camera out over the scene, and we were able to make exposures of several seconds each.

You don't let a camera like a Super Wide float over a marble floor two stories up without a reliable support system. Granted, I held my breath during the shoot, but I'd do it again in a minute, so confident was I in this odd-looking gadget.

The Perfect Portable Location Lighting Kit

01/14/94

The only direct flight departed before dawn, so on a chilly morning Judy and I found ourselves at National Airport joining a handful of other insomniacs for the 6:50 flight to Bangor, Maine. This was to be a week of seasonal location portraiture for my book, *Down East Maine/A World Apart.*

I had spent each of the last four or five summers making literally hundreds of pictures of people, ranging from circus roustabouts to tent evangelists speaking in tongues, to farmers, fishermen, and the "father of chainsaw sculpture." But I had to mix in enough seasonal portraiture if I hoped to create an accurate picture of the independent and rugged folks who people the easternmost part of this small and beautiful state. I had a couple of appointments tentatively scheduled and hoped my luck would hold, as it had over the previous summers, to provide other photo opportunities as the week progressed.

By week's end I had more than a dozen rolls of exposed film and several keepers for the book. But I also came back with a better appreciation of what to pack—and not to pack—for a trip like this.

Location portraiture is something you love or hate. To do it right almost always means bringing along more gear than you could ever hope to use for that once-in-a-lifetime shot that would be perfect if only you had another strobe head to kick light into that far corner. It's one reason that masters of the medium, such as Arnold Newman, Annie Leibovitz, and Neil Selkirk, to name three, routinely travel with a retinue of gofers and gaffers to schlep lights, light stands, filters, gels, reflectors, and who knows what else. It was the reason I traveled with a carload of gear during the two years I worked on my book about the Eastern Shore and why, on our summers in Maine, I had a separate roof carrier on the Buick for camera gear so that Judy and I could fit our luggage down below—and leave at least a little room for our golden retriever—on the trip up and back.

But what if you don't have (or can't afford) a retinue of help, or more

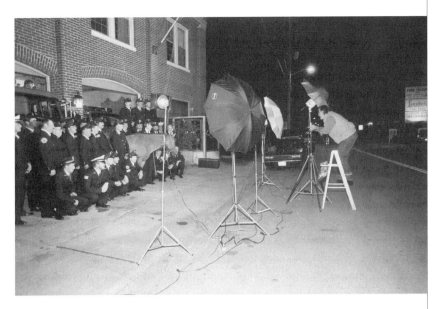

This is what you bring with you when you do not have to worry about everything fitting into the overhead or under the seat in front of you. But even with my minilighting kit, I was able to photograph this Lubec, Maine, sawmill operator effectively. One trick is to make good use of existing light to augment your strobes. author pic: © Judith Goodman; sawyer pic: © Frank Van Riper

important, are limited to your carry-on luggage and what few other pieces you can stow on a commercial flight? That's the dilemma I faced before Judy and I hopped a cab to the airport in November.

Unable to bring my usual complement of tungsten floodlights, studio strobes, and other lights, I had to come up with a much lighter outfit that not only would meet my creative needs, but fit into an overhead luggage compartment as well. The solution I came up with was two Armatar 100 flash units, two high-voltage battery packs, and a pair of Norman 2D diffusion reflectors, to approximate in a much smaller space the effect of umbrella-diffused light. The Armatars (made by Armato Photo Services of Long Island, now defunct, unfortunately) actually are Vivitar 283s retrofitted with a Lumedyne head and souped up internally to crank out a stop more power while at the same time giving you the option of bare-bulb operation.

Judy and I each use such a lighting setup on a camera bracket when we shoot events or weddings. This time, though, I had the option of using the lights off-camera, on separate stands, to create the effects I desired. And since the lights were battery-powered, I never had to worry about finding a convenient electrical outlet to power my strobes. (Important note: For this trip, I removed the automatic light-measuring thyristors from the flash units and substituted Vivitar Vari-Power Modules. This put the units' light output totally in my hands and also let me power up or power down the strobe units merely by turning the Vari-Power's dial, and not by moving the flash units.)

The only other lighting units I carried were ultraportable Morris Mini strobe units—no larger than a tape measure and internally slaved to go off whenever they sensed the output of the Armatars. These came in handy as accent lights or hair lights.

The whole business fit snugly into the gray plastic Doskocil case I had bought specially for the trip. An obvious knockoff of the highly regarded Pelican case, the Doskocil, though clearly not the equal of the Pelican, suited me just fine—and for roughly half the price. If I made my living lugging gear to exotic locales, there'd be no question about using Pelicans or the even more rugged Halliburton or Anvil cases. But the Doskocil—whose foam rubber interior you custom fit to your gear—performed like a champ, and I strongly recommend it.

For convenience, I checked through my bag of light stands as well as my tripod, but kept my camera bag with me, under the seat, and the Doskocil in the overhead.

Final report? I still wished I had my umbrellas and more powerful studio strobes, but the Armatars performed very well under trying circumstances—in a pitch-black sawmill, for example, and in a cramped meat locker. Outdoors, I often shot by available light, with one Armatar to open up shadows and add a little kick to the negative.

If I had it to do over again—and I'm sure I will—I'd add only one more light to my repertoire: a simple (unmodified) 283 and a bounce card. Sometimes, especially in photography, less can be more.

Keep It Simple(r), Stupid

ASMP, *Focus*, Summer 1995

I had a revelation recently about why a lot of new cameras leave me, if not exactly cold, then decidedly cool.

It's not that they are laden with bells and whistles it'd take an engineer to fathom. Some of these features are ingenious and, without doubt, make picture-taking easier. Rather, my gripe against a lot of the new cameras coming out these days is that they don't feel like cameras anymore. In fact, they look and feel more like my flimsy VCR remote than like a mighty machine for making images.

It used to be a camera was a hefty, solidly built, machined miracle whose body, gears, lenses, and springs offered a reassuring look at the best that Japanese, German, Swedish (and, every so often American) industrial design could offer. Now it seems as if everything is cut from the same cloth—or, more precisely, extruded into the same high-impact plastic mold.

The first time I held a Leica M2, or pressed the shutter release of my old Nikon F, or loaded a Hasselblad 500C/M, I knew I was in the presence of greatness; each of these wonderful cameras being separate and confident in their own quirky identities. Back then (in the early sixties) no one toting a Nikon would be mistaken for someone toting, say, a Heiland Pentax. The tanklike contours of the Beseler Topcon were easily discernible from those of the similarly clunky Alpa 6.

And the sound! The silken breath of a Leica's shutter was that of a lover's kiss—gentle and exciting all at once. The rolling double-pump of a Nikon F2 at 1/30 of a second was a basso profundo that vibrated in the belly. Add a motor drive and you were talking five pounds of kick-ass camera that hung from your shoulder, not only with authority, but with attitude. (In fairness, it also hung there pretty heavily after a day's shooting.)

Today? I'm sorry, but with the exception of the gloriously old-fashioned Leica rangefinder and the wonderfully retrograde Nikon 35Ti and

Contax G1, it's as if the rugged and individual good looks of the typical 35mm camera have been sacrificed on an altar of uniformity and ergonomic polycarbonate—the stuff they make car bumpers (and most new camera bodies) out of. They all look the same: the same rounded corners, the same dull black bodies, the same maddening array of buttons—the same everything. Even their vaunted lightness—a relief after years of carrying dumbbell-like Nikons—comes at a price. Those polycarbonate bodies are meant to bounce back after taking a hit—much like your car bumper. Only, behind your car bumper is the steel of your car body. Far more vulnerable behind your lightweight camera body are the delicate computer circuit boards that drive your camera's on-board electronics.

Today's 35mm cameras, wondrous though they are electronically, do seem a bit too much of a good thing for pro as well as amateur. In my experience, as both a journalist and commercial photographer, the only people I've ever seen use most of the bells and whistles on their high-tech SLRs have been news photographers, who usually have but one chance to make a picture and usually only a few seconds to spare. Anything that helps them make a picture under those conditions is great—and worth it. For anyone else, cameras like the gizmo-laden Canon A2e, with eye-controlled focus and myriad functions requiring all kinds of memorization and dial-spinning, may simply be too confusing. Remember: people hire us because *we're* supposed to know this stuff—not because our equipment is smarter than we are. And while I'm at it, let's not forget that Cartier-Bresson, Robert Frank, and Diane Arbus—not to mention Julia Margaret Cameron, Atget, and Edward S. Curtis—never had autofocus, program mode, or multi-pattern metering.

Not surprisingly, then, we are seeing a whole new level of mid-range SLRs, designed to be simpler and far more user-friendly than their predecessors. The new and excellent Nikon N70, for example, or the Pentax PZ-1P or Minolta Maxxum 600si—these are the kinds of cameras that are certain to fill the niche between the point-and-shoot happy-snaps and the allegedly more sophisticated "professional" SLR's. The Maxxum even touts "a step backward that's a lead forward"—"big, bold, beautiful buttons and dials" instead of "electronic fussiness." (What a concept!)

A prediction: sooner or later the higher-end SLRs are going to incorporate a built-in pop-up strobe. (Yeah, I know it's the mark of an amateur, but given the choice between making the picture and wishing I had a 283 handy, I'll take the pop-up. And, working on location with slaved moonlights, for example, wouldn't it be nice to trigger those babies with the on-camera flash and not worry about being hard-wired?)

Of course, for those whose eyes glaze over at electronic trendiness, there always will be the Nikon FM2N. Manual cameras like these wind up in the camera bags of: (1) Students learning photography's basics and (2) Pros who want a backup body when (inevitably) their hyper-automated SLR's go down in flames during a location shoot.

Happily (until recently) most medium-format cameras never had to

compete in terms of lightness or trendiness, so they tended to be substantial, rugged, and delightfully free from superfluous electronics. But now even that is changing. Doesn't it say something about what really matters to working shooters that, in all the hoopla over Hasselblad's new hyper-electronic (and hyperexpensive) model, one of the features Hassy touts with equal fervor is a place (finally!) to store the damn dark slide?

Or that one of the hottest medium-format systems around now is Miyama's ultrasimple rangefinder?

Will the gizmo-laden camera ever disappear? Not as long as there are people out there who love Nintendo, CD-ROM, and virtual reality. But it's nice to see manufacturers every so often making room for those of us who once thought Nintendo was a new Italian restaurant, CD-ROM a way to invest your money, and virtual reality a contradiction in terms.

Diffusion: A Sharp Difference

09/01/95

A pair of nylons and a jar of petroleum jelly may not seem like photographic tools. But each can be used to advantage to make soft-focus pictures.

Soft-focus, it should be noted immediately, does not mean out-of-focus. A soft-focus picture is one in which a diffusion medium is placed between the camera lens and the subject to soften the final image, not blur it.

Softening an image, for example, will make facial lines as well as skin imperfections less noticeable. This is one reason many people prefer a bit of diffusion when having their portraits made. Age, however, is not the only determinant in using diffusion. Diffusion, for example, can enhance photographs of young children and brides as well. It's one reason we tend to shoot both sharp and softened portraits when we do a wedding—it's nice for the client to have a choice when going over the final pictures.

Today the easiest way to achieve diffusion is with a softening filter placed over your camera lens. Many manufacturers make diffusion filters, and there is a real difference in the kinds and degree of diffusion available.

For example, my wife Judy and I have used a number of different filters in our work, including two of our favorites, a Hoya Softener "A" and a Tiffen Soft/fx. They retail for about $30 each, but usually can be found for less. Each supplies just enough softness to render a pleasing picture while maintaining a large degree of overall sharpness. Diffusion filters achieve their effect in a number of ways. Some, like the highly regarded—and very expensive—Hasselblad series of soft filters, use a pattern of clear circles all over the filter. Others use a nearly invisible series of finely etched lines in concentric circles. Still others employ random clear patterns over the filter. Both Nikon and Hasselblad make superb soft filters, and there are many professionals who swear by them. But these filters generally run about three times the price of their competition, and I simply don't think they are worth it.

Two very different moods can be created with and without diffusion. The technique is mostly used with women and can add a flattering softness that should not be confused with lack of focus. (© Goodman/Van Riper)

Back in the glory days of Hollywood, it was not uncommon for directors of photography to stretch a piece of nylon stocking over the lens when the leading lady was getting her big close-up. (It worked very well, too—still does.) The great still-portraitists of the time, such as George Hurrell, likewise had a number of diffusion tricks up their sleeves.

I have used petroleum jelly for diffusion, but must warn you that I think it's a bad idea. I hate putting the gunk so close to my lens. However, done carefully, it can be a fairly useful creative tool, since the petroleum jelly can be placed wherever you want it, leaving some parts of your picture tack sharp.

The easiest way to do this is to have a special resin gel holder on your lens, of the type made by Cokin. Then you can use a piece of clear plastic or, preferably, glass that can be smeared with the petroleum jelly and placed in the holder safely away from the front element of your lens.

A setup like this, for instance, can let you create a soft oval around a bride and groom, or other subject, especially if the background is not lovely. Special oval diffusion filters also are available. They are more expensive, but are a lot less messy.

When using diffusion, be aware that it not only will soften your image, but lessen contrast, too. I've never found the effect so marked as to make me change my exposure setting, but they almost certainly will change your darkroom filtration when you are printing and you should be prepared for it when reviewing the results of your shoot. The net effect, when comparing filtered and unfiltered photos of the same subject, is that the filtered ones will appear lighter because of the lessened contrast.

Perhaps the worst way to choose a diffusion filter is to hold the filter up to your eye. Much better is to bring your camera to the store and place the filter on your lens. That way you will be looking through your camera's "eye" as well as your own and get a better idea of what the particular diffusion effect will be. Note, too, that diffusion filters come in degrees of softness (we prefer the least soft) and that most good camera stores at least will have manufacturers' brochures illustrating the effects with actual pictures.

A final note: Let's say you already have made a picture that you wish had been diffused. If you do your own printing, you can cheat and hold the diffusion filter under your enlarging lens while printing. The result will be similar to what you would have gotten had you remembered the soft filter in the first place.

Delta 3200: A Superb See-in-the-Dark B&W Film

07/23/99

For years I have been enamored of chromogenic black-and-white film because of its remarkable exposure latitude and incredibly fine grain. In fact, when I recently had a custom lab make four 3' x 3' mural prints for a museum show, the prints' clarity and sharpness astounded me. As regular readers know, I started this love affair with chromogenics (i.e., black-and-white film developed in C-41 color print chemistry) when I started using Ilford's XP-2, then was wooed away by Kodak's superior chromogenic emulsion, T400CN.

But it's never a good idea to stick with just one film—after all, not all situations call for the same interpretation. And every so often I longed to create some of the gritty black-and-white images of my youth, when the only black-and-white films I knew of were Tri-X and Plus-X, with an occasional Verichrome Pan thrown in for good measure.

Recently, for example, I have been going back to a tried and true formula: punishing Tri-X by pushing it two stops and shooting this normally 400 speed film at 1600. Since Tri-X is a more contrasty film than either XP-2 or T400CN anyway, you are bound to get a look much different from the silky smoothness of the chromogenics when you push this workhorse film.

Over the past several years, we have seen a number of ostensibly super-high-speed films appear, that nonetheless seem embarrassed by their ability to render grainy images in next to no light. For example, when Kodak unveiled its top speed T-Max film, TMZ 3200, the literature kept going on about how the film would produce remarkably sharp and tight-grained pictures when shot at 800. And in the past few months, Ilford has promoted its own 3200 black-and-white film, Delta 3200, by showing gorgeous pictures of canyons in the Southwest. The images were great, all right, but they were made at nothing near the film's nominal stratospheric ISO.

Ilford's Delta 3200 can all but see in the dark, and give you a pleasantly grainy look that doesn't sacrifice sharpness. Here, Judy catches a newly married couple in Venice outside the Sala di Matrimoni (for civil ceremonies). On a very overcast day, she was able to shoot fast enough to freeze a direct rice hit on the groom's head. © Judith Goodman

To which I say: What's the point?

If I want grain-free prints, I'll either shoot with XP-2 or T400CN, or with any number of other first-rate, slower speed, black-and-white emulsions, all in the ISO 100–400 range. If the only purpose of these 3200-speed films is to give me yet another way to do landscapes, why bother?

But if I want to free myself from having to always travel with a flash or if I really want to emphasize—not minimize—grain for artistic effect, then these are the tools to use, especially the Delta film.

Ilford has produced a superb high-speed film here, one that beats out both pushed Tri-X and TMZ. I have used the film in both 35mm and in medium format and have been dazzled by its punch. This is a film that loves contrast and grain, yet doesn't block up highlights or hide shadow detail.

Consider this example: It was at a wedding and, since the client shared our love of black-and-white, we had some fun. A shot of a sax player alternating between two horns was made not only with Delta 3200 (rated at 3200, by the way), but also with a fish-eye lens to add to the image's weirdness. This one happened to have been a flash shot, but the film produced excellent contrast by available light as well. And I loved the pronounced grain.

A few weeks later, at another wedding—this time the bride was a fellow photographer—I used the Delta film in my medium-format Mamiya 6 and used this camera only under available light, which wasn't a heck of a lot. Again I was delighted with the results I got: punchy, contrasty prints, with rich blacks and whiter whites, even when bride and groom were lit by candlelight. (I should note that I was less impressed with the available light results I got from my 35mm pushed Tri-X.)

What all this tells me is that the Delta 3200 has the potential for being an all-around film and not just a late-night parlor trick of an emulsion. Shooting with it at lower speeds seems to tighten up the grain remarkably, and using it at its advertised top speed delivers on all counts, if what you seek is grit and grain. Granted, one advantage of the wide-latitude chromogenic films is that they can be shot anywhere from ISO 100 to 800 on the same roll with no change in developing time.

But, judging from the results I got, the Delta 3200 is worth the effort of keeping tabs on which rolls were shot at which ISO.

Hasselblad: The Perfect System

11/10/00

It takes a while to feel you've found the perfect camera system, but I honesty believe I have.

Sure, I have used 35mm for decades and I love my Leicas and my Nikons almost as much as I love my two cats. My new F100 is an extension of my hand. My Leica M6 may be the quietest, best made camera I've ever encountered. The F5, which I love but can't afford, may be the finest SLR ever made. My Nikkor lenses are fast, sharp, and easy to use. And I know that my colleagues who use other high-end 35mm systems feel the same about their gear. But 35mm is not the perfect camera system.

I also have used large format, marveling at the size of the negative it produces, and marveling, too, at how this admittedly bulky system forces me to slow down and actually think about the picture I am about to make. The lenses for large format are legendary and the cameras themselves, especially the wooden 4 × 5 and 5 × 7 field cameras, often seem more like works of art than camera gear—again, wonderful; but, again, not perfect. For me, the perfect system—the one that combines the best of both photographic worlds—is the one in the middle. The system that is appropriately named Medium Format. Medium format combines the portability and ease of use of 35mm with the image quality of large format. And as far as I am concerned, Hasselblad makes the finest medium-format system on the planet.

A long time ago, as I was borrowing some pricey bit of equipment from Nikon Professional Services in Washington, Scott Andrews, the head of the office, asked me why I kept raving about my Swedish-made Hasselblads.

"After all," Scott said, "it's just a box."

"Ah, but what a box," I replied, with Zen-like calm and detachment.

In truth, if I regard Hasselblad as the perfect camera system, then the

all-manual 501C/M may be the quintessence of rugged, dependable, trouble-free photography gear.

Think of it as a Volvo that runs on film.

A totally modular system, the medium-format Hassy breaks down into its component parts with startling ease—so that it does look, in Scott Andrews' term, just like a box. The viewfinder comes off, the lens comes off, the film back comes off, leaving you with an all-metal chamber with a matte-black interior, whose main purpose is to provide a way for you to crank your film to the next exposure.

This modular construction means you can customize your picture-taking with ease, changing viewing screens, focusing hoods, film formats, films and—obviously—lenses. No other system in any format affords such easy adaptability. For example, though I love my Mamiya 6 medium-format rangefinder camera, it does not allow me to change focusing screens or, more importantly, to make Polaroid test shots with anything approaching the ease of Hasselblad.

But if a chameleonlike ability to change were all Hasselblad offered, I wouldn't be raving about this camera, or the rest of the Hassy line.

Simply put, in medium format, Hasselblad rules. I have used my three Hassy bodies for more than a decade and a half. Save for routine maintenance—and one time when I experienced a camera jam after working the better part of an afternoon in a swarm of sawdust at a duck decoy plant—these cameras have been virtually trouble-free. This is a ruggedness born of dogged testing and quality control. The boxy Hassy actually began as an improvement upon a captured Luftwaffe aerial camera, designed to help Sweden maintain its armed neutrality during World War II. Back then Victor Hasselblad was an ambitious photography retailer in his early 30s, who had left his family's importing business to pursue photography manufacturing. Asked if he could build a camera equal to the captured Luftwaffe camera, Hasselblad famously replied: "No, but I can build a better one."

But it wasn't easy. The first Hasselblads were beautiful to look at but very delicate—not surprising since their innards were designed by watchmakers, unused to the mechanical strain a camera must endure. Modification begat improvement until finally, in 1952, the camera came into its own. *Modern Photography* magazine field-tested the then-new Hasselblad 1000F and reported spectacular results. *Modern*'s testers ran five hundred rolls of film through the camera—even deliberately dropped it twice—without the Hassy breaking or going out of alignment. A legend was born.

The Hasselblad line of lenses includes some of the finest glass on earth, made by venerable Zeiss Optical. My current trio of lenses includes the 80mm f/2.8 Planar (normal,) 50mm f/4 Distagon (medium wide) and 150mm f/4 Sonnar portrait lens. There are many more, but at something like $1,500 a pop, I'm fine for now. (For specialized uses, I also have the phenomenal—and phenomenally expensive—Super Wide C/M.)

Though the Hasselblad is traditionally a square format system—in fact, it all but pioneered 2¼" × 2¼" square format—any Hassy easily can be turned into a 645 camera simply by slapping on a 645 film magazine. This will give you a slightly smaller, rectangular image and therefore fifteen exposures on a traditional roll of 120 film instead of the usual twelve. Still, most Hassy users prefer square format, and I am among them. It has become fashionable among some these days to deride square format as, well, "square," but I find a certain formality to square that works well for most of the work I do. It is perfect for portraiture, less wonderful for landscape, but superb for product work. And, as someone who has shot his share of album covers, Hassy is made for CDs and, before that, LPs.

I said earlier I viewed this as the perfect system. Sure, I love 35mm for its flexibility and speed. No one can take away my Nikons or Leicas, and nobody ever said you would break speed records working with the agreeably clunky 501C/M, or any of its more electronically sophisticated brethren. But there simply is no getting around the fact that square format film offers some triple the area of its 35mm counterpart. This gorgeously huge negative or transparency lends itself to proportionately huge enlargement.

Finally, with the 501C/M, there is another element of reliability that goes beyond mere ruggedness or smart design. This is an all-manual camera (i.e., no batteries anywhere). You determine the exposure (with your separate exposure meter). You set the shutter speed; you set the aperture. Then, after you have made the shot, you crank the film to recock the shutter.

I don't mind any of this—in fact, I love the fact that I never have to worry whether my camera's batteries are fresh, as I do with every other system I own.

And if none of this has convinced you that this is a great system, consider this: In 1962 astronaut and amateur photographer Wally Schirra was disappointed by the quality of photographs being taken in space. He bought a Hasselblad in Houston and had it modified by NASA technicians so that spacesuit-clad photographers could operate it. The pictures this camera made blew the doors off anything taken previously, and NASA has been sending Hassys aloft ever since.

It was a Hasselblad, operated by Neil Armstrong, that made the first photographs on the surface of the moon.

SECTION VII

Reviews

David Hockney, Revolutionary

04/23/93

In the comfortably cavernous screening room of the National Gallery's East Wing a few weeks ago, I watched a short documentary about an anarchist.

Not a bomb-throwing anarchist, or a bellicose sloganeer. In fact this revolutionary is a pleasant, rather mild-mannered fellow who smokes cigarettes, wears horn-rimmed glasses, and favors bowties and striped shirts. But David Hockney, a transplanted Briton now living in California, has shaken up the photography establishment just as surely as if he had thrown a bomb into a meeting of the Royal Photographic Society.

Hockney is an artist, a painter whose works on canvas have brought him world renown. His theatrical set designs are both whimsical and glorious, pregnant with vibrant color. The first time I saw Hockney at work was on a video in which he used one of the first "paintbox"-type computer palettes to create a wondrous series of images that changed, transmogrified, and grew each time he set stylus "brush" to glass "canvas."

But like most artists, Hockney grew restless with what he was doing and gravitated toward something new. For him, the something new was photography.

"Photography is not really a good medium for an artist," Hockney declared. He found it nice, but not all that significant, that photography could capture a moment in a fraction of a second. He noted that it takes several moments—say, four or five seconds—simply to take in the image that a photographer has made in $\frac{1}{250}$ of a second. A painting, he maintained, actually displays far more of the "pace and time" of a scene—and in some ways is thus more accurate because it reflects, even subconsciously, the different information the artist has received from the subject over the period of time it took to create the work.

Two other factors affected Hockney as he cast about for ways to use his battered camera. One was the idea of depicting movement, or the passage of time, on a flat, static surface. The other was more mundane, but

equally genuine: the desire to somehow retain the excitement that we all feel when we tear open a package of snapshots—"the same enthusiasm of anyone looking at batches of new prints."

Thus were born "Joiners."

To call Hockney's Joiners "photo-collage" is not quite right. To be sure, his early work, in which he pieced together Polaroid snapshots to create a larger portrait or picture within a square or rectangular border, did resemble collage, much as did the early work of photographer Neil Slavin. But Hockney balked at the borders.

He sought to create a sense of space, or of motion, by using snapshots—the same 4" × 6"s you get from places like MotoPhoto or Colorfax—to build much larger scenes, some extending over several feet in length and width. The idea is not new: Photographers have made panorama views with conventional cameras for years, simply by rotating their tripod-mounted cameras along the same axis to create longer images. But often all that did was create a landscape; Hockney wanted people in his pictures—and he wanted them in action.

The simple act of someone walking down a flight of stairs to bring you a cup of tea, of two friends talking animatedly in a living room—these became the subjects of Hockney's Joiners. And forget about regular picture borders. Hockney pasted his pictures in logical order, but left out extraneous details, creating wonderfully ragged and exciting edges. The photograph suddenly was freed from having to be simply a slice of time; it became a smorgasbord of images that the brain easily assimilated into a coherent visual narrative. Hockney thus depicted both motion and the passage of time on a single flat surface. If this was the antithesis of Cartier-Bresson's "decisive moment," so what? It simply was a new incarnation of photography.

It is remarkable, for example, to see Joiners of people engrossed in a Scrabble game—with several pictures of the same face caught in different expressions and pasted in juxtaposition with one another and feel that you are watching a film when, in fact, you are looking at a single flat surface.

In the documentary *Hockney the Photographer* that was shown at the East Building last month, we also saw the whimsy that informs so much of this artist's work.

Hockney created "Fredda Bringing Ann and Me a Cup of Tea" for the benefit of the documentary film crew, so we see him actually snapping away and creating this multiple image. We even see him dropping his rolls of film off at the local one-hour lab, only to find out later that the lab has ruined some of his film. Fortunately, there is enough to work with and Hockney decides to include the note of apology from the lab ("Mr. Hockney: I'm very sorry, very sorry, about the two rolls of film. . . .") into the finished collage.

This was all over a decade ago, and, typically, Hockney has since moved away from Joiners. The last time I saw him was on a recent PBS special. He was playing with fax machines.

Harry Callahan, an Introduction

04/21/95

"I was no good in school," Harry Callahan said last month to an apprecia-tive, respectful audience at Washington's Corcoran Gallery. "My father was a farmer. If I'm a good photographer, it's because I'm naive."

His images, made over the course of the past eighty-three years, include some of black-and-white photography's enduring icons: his closed-eyed portrait of his wife Eleanor, his multiple-image views of his native Detroit, his silhouettes of trees in winter, and his stunning, mini-malist views of sand, sea, and sky during a Cape Cod summer.

Each photograph, along with an equally strong portfolio of color work, shows the deft hand of an artist in full command of his craft and his powers. Yet Callahan is probably the last person to wax eloquent about his work.

But that is an eloquence in itself, for rarely has an artist been so will-ing to pay tribute to the gentle hands of whimsy and chance in guiding his work, to acknowledge his debt to the simple joy of making photographs.

"Everything I've done, I've done intuitively," Callahan said.

And who can doubt him?

It may seem odd that someone who has spent so much of his life teaching (first at the Chicago School of Design, then as chairman of the Department of Photography at the Rhode Island School of Design) does not easily rattle off f-stops, film/developer combinations, or focal lengths, especially to an audience of photographers who would lap up every morsel. "I have to deal with students over a long time," he said, conceding that "I'm not one of those workshop guys" who can cram a career's worth of insight into a frantic week or two. "I'm more a role model than a teacher," he said.

The contrast is great between the simple eloquence of Callahan and what the National Gallery's curator of photographs Sarah Greenough calls "the cult of personality" that attends so many of today's photographic

superstars. Callahan is a refreshing breeze in a world too often filled with self-important self-promoters and critics who measure their influence in column inches of dubious artspeak.

Callahan is on to a simple truth: that to be a photographer, one must photograph. No amount of book-learning, no checklist of seminars attended, can substitute for the simple act of making pictures. Experience, he seems to say, is the best teacher of all. And for all that, there are no guarantees that one will produce art, much less become an artist. Only the journey matters.

In the darkened Corcoran auditorium, the screen is filled with another early nude of Eleanor, this one with her back to the camera, the light from what appears to be an attic window gently modeling her curves.

"It's a goofy photograph," Callahan says, "a twenty-second exposure." He says the picture does not take well to great enlargement, since Eleanor's head moved slightly during the exposure. "It's just a case of doing goofy things," he says almost dismissively, even if every photographer in the room that night, myself included, would give an arm to have made such a picture.

He revels in the process of photographing, bending rules to suit his whim. Once, decades ago, he decided to photograph sunlit water. He jiggled the camera to produce shimmering light patterns, that, in turn, produced gorgeous prints. He made random pictures of people walking urban streets, then rolled the film back into his camera to repeat the process. The result was a striking series of city still lifes, image upon image.

Callahan's street portraits rival the best of Garry Winogrand, Henri Cartier-Bresson, or Lee Friedlander, yet many were random snaps, made either with a wide-angle lens held at knee level or a telephoto lens set to a fixed focusing distance.

He is delighted to divulge how a particular photo happened, in marked contrast to a number of his much younger colleagues, who would sooner die than admit they were the fortunate heirs of happy accident.

That, ultimately, is what makes Callahan a great and legendary photographer. "I don't know what's gonna happen," he says when, even now, he wanders the fields of Providence, Rhode Island, where he and Eleanor make their home. Next year, the National Gallery will give him a major retrospective—and anyone who appreciates the way that photography can uniquely combine the beautiful and the unexpected should be there to see what happens.

Dorothea Lange's Ireland

Dorothea Lange (1895–1965) was more than a superb photographer. She was an outspoken humanist whose feeling for the dispossessed and down-trodden illuminated her black-and-white pictures with the light of genius. She was one of the small band of U.S. government photographers who documented the plight of America's rural poor for the Farm Security Administration during the Great Depression. Her immortal 1936 image of a migrant mother's careworn face, her two children leaning against her in shared despair, is a heartbreaking masterpiece.

But if Lange is best known for her bleak photographs of people defeated by poverty, she is largely unknown for the work she did in Ireland in the 1950s, documenting people equally beset by hardship and, yet mar-velously—even miraculously—unbowed by it.

On the eve of St. Patrick's Day, *Dorothea Lange's Ireland* (Elliott & Clark, $29.95) reveals a side of this complicated artist, as well as a body of work, barely seen in the past. It is a beautiful book, and its genesis was part detective story, part blind luck.

Gerry Mullins, a native of Dublin, is a young freelance journalist liv-ing in San Francisco, where his day job is in the financial warrens of Charles Schwab & Co. Two years ago, hoping to sell a story to a small Irish American paper, Mullins thought there might be an Irish angle in an exhi-bition of Lange's migrant worker photos then on display at San Francisco's Museum of Modern Art.

Though there was nothing he could use in the MoMA show, the exhibit's curator gave Mullins a clue to a much bigger story.

The curator told Mullins that she thought Lange had been to Ireland and suggested that he visit the Oakland Museum, the repository of Lange's huge store of negatives and prints.

"I went there expecting to find a roll of film she had snapped at Shannon Airport on her way to someplace important," Mullins said, with

a laugh during a phone interview. Instead, he tumbled upon a monumental trove of 2,400 images, all made by Lange in Ireland in 1954 during an impassioned six weeks of photography, accompanied by her son, writer Daniel Dixon.

Even in the small research prints provided by the museum, Mullins knew he had uncovered something precious. How precious is marked by the fact that only 21 of Lange's 2,400 Irish images ever has seen print—in a nine-page pictorial spread in the old *Life* magazine, titled "Irish Country People," in the issue of March 21, 1955. (An Aperture publishing retrospective of Lange's work, "Dorothea Lange—Photographs of a Lifetime," published in 1982 and just reissued, contains but five of her Irish photos.)

That was Lange's last spread in *Life*. Though the magazine spread was large by today's standards, the volatile Lange resented that it contained so little of what she ranked among the best work of her life. She resented, too, that the magazine had run virtually none of her son's text. She never returned to Ireland and died of cancer nine years later.

Mullins's discovery in 1994 sent him on a transatlantic odyssey. He had mailed pictures to his parents in County Clare, where most of Lange's pictures had been made, asking if they could identify any of the forty-year-old photos. He then went to Ireland himself and "began stopping old people on the street," trying to put names to faces.

"It always was in the back of my mind to do a book," Mullins said, and after several false starts for lack of funds, he finally hooked up with Carolyn Clark of Elliott & Clark publishing. Within months, Mullins and Clark had culled Lange's huge Irish archive into a manageable collection of about one hundred photos.

The resulting book is one Lange doubtless would have treasured. Her pictures—beautifully reproduced and elegantly presented—depict a way of life that largely has changed, yet a people who are remarkably the same. There even is a startling admission.

One of the most memorable photos in the 1955 *Life* essay was of farmer Paddy Flanagan, grinning gap-toothed as he hefts two huge sheep.

But the picture isn't Lange's.

In a fond essay that accompanies Mullins's biography of Lange, Daniel Dixon recalls that, during their Irish sojourn, his mother would sometimes give him a camera. "That photograph (of Flanagan) has since been published and republished, and always as my mother's work. But I remember aiming the camera at that leer and those two woebegone sheep, and it pleases me to think that for one instance, I might have been as good a photographer as Dorothea Lange."

Understanding
Indians

10/25/96

"Indians have to be explained and accounted for," writes Paul Chaat Smith. Smith, a Native American writer, curator, and cultural critic, notes that his Comanche ancestors, though "some of the finest people you'd ever want to meet," also could be "world-class barbarians, a people who for 150 years really did all that murdering and kidnapping and raping and looting, against Mexicans, Apaches, Utes, Pawnees, Pueblos, Americans, Poncas, Tonkawas—well, yes, pretty much anyone in our time zone.

"Compared to us, the Sioux were a bunch of Girl Scouts."

It is a measure of Smith's insight—not to mention his integrity—that his introductory essay to a remarkable new book of photographs, of Indians by Indians, makes a point not to gloss over the bad while accenting the good. He also makes the point that the best, most honest, most compelling photographs of a culture or race are those made by the members of that culture themselves.

The book, *Strong Hearts*, accompanies the recently opened exhibition of the same name at the Smithsonian's International Gallery at the S. Dillon Ripley Center. The photographs in this collection require no excuses or allowances, itself a form of intellectual condescension. This is, after all, contemporary photography, made by fellow American photographers, representing their life, their culture, and their condition. There is some superb work here—from still life to documentary, from portraiture to abstraction—and though some of it may not be pretty, in the manner of a souvenir postcard, all of it is honest and genuine.

Documentary photography is fascinating. It is a path that I have followed for nearly a decade, first on the Chesapeake and now in rural Maine. And because of that I am sensitive to the criticism of Smith and the other writers and poets in *Strong Hearts* that it is a form of photography too often done badly. Smith likens many non-native photographers to big game hunters on safari, only whose Range Rovers and Grand Cherokees

house Nikons and Leicas, not high-powered rifles. Content to photograph a grizzled elder or a colorful gathering of nations before heading quickly home, these photographers, Smith says, "blow right past us, without a clue."

But the thirty-four Native American shooters whose work is presented here don't miss much. "Their images show us our families, at their Sunday afternoon best and predawn, post-bar-closing worst. . . .

"We see our grandparents, foolish in parade cars and ridiculous in war bonnets, laughing in a way you never see them laugh in pictures taken by non-Indians." There are families parked in front of color TVs, men and women at humdrum work, and down-at-heel "street chiefs" carrying surplus food from the welfare center.

It is gritty, ironic, poignant, and occasionally funny work, made by Indian photographers who, as Smith observes, "have strayed off the reservation."

But having said that, is it fair to assume that a photographer, artist, or writer who is not part of a particular culture can never document that culture fairly? I don't think so. In fact, a case can be made that someone thrown into new surroundings can see and document things that have been ignored or taken for granted—or even forgotten—by local people. (Henri Cartier-Bresson's work in China, for example, or Bruce Davidson's portrait of tenement and gang life on one block in New York City.)

What distinguishes documentary photography from tourist snapshots is an understanding of the subject that only can come from total immersion or, failing that, serious study and research. Anything less and you conjure up the ironic images of Indian photographer Zig Jackson of white photographers with their cameras inches from the faces of Indians in native dress at a clan gathering. "Indian Photographing Tourist Photographing Indian" is the name of his series. Somehow you know that most of these tourists got back into their campers and headed home, their knowledge of the culture they encountered limited to a few images on a roll of Kodacolor.

The images in *Strong Hearts* are the ones these snapshooters never saw—or even cared to look at.

STRONG HEARTS: Native American Visions and Voices (Aperture, New York), $35.

George Tames: Choosing His Shots

12/27/96

There is a heartbreaking photograph in *Images of the President,* the small but beautiful retrospective of the work of the late *New York Times* photographer George Tames, now on display at the National Portrait Gallery.

The poignant image is not what many regard as Tames's most famous picture—of a stoop-shouldered JFK taken from behind as he stands over a table in the Oval Office a few days after his inauguration in 1961. Tames called that shot "The Loneliest Job in the World," and though it may have evoked the feeling of isolation that is said to be part of the presidency, the simple fact—as Tames always admitted—was that Kennedy, who liked to read standing up because of his bad back, simply was scanning the newspapers during a break in his busy postinauguration schedule, when the photographer happened by and made the fortuitous shot.

No, the photograph that evokes pain and pathos is one Tames made at the White House more than a half century ago, on Aug. 18, 1944. In that picture, a smiling Vice President Harry Truman is shown having lunch with President Franklin D. Roosevelt. Both men are smiling for Tames and looking straight into the camera. But you know that only Truman's smile is genuine. Roosevelt, his face lined with fatigue and only eight months away from death by massive cerebral hemorrhage, obviously is enfeebled. To reporters afterward, Truman insisted that FDR was fine and that rumors to the contrary were flat wrong. But to a friend he confided in disbelief that the president "is just going to pieces."

Much is written about the truth-telling power of photography. But the camera equivocates as much as it verifies. A trick of angle and perspective can change a picture's message as easily as a writer's choice of words can alter a story's meaning or thrust.

Tames was never into such games. If ever there was a straight shooter, it was George. Respected by his fellow photographers as well as by the politicians he covered, Tames brought pictorial grace to the good gray

New York Times for more than forty years. When he died in 1994, we lost something special. In my case, I also lost a friend.

So it is a bittersweet task to review what, given the venue, probably is the most prestigious exhibition to date of Tames's work. *Images of the President* grew out of a generous gift of one hundred of Tames's prints, presented to the Portrait Gallery by his widow, Frances O. Tames, shortly after her husband's death. Mary Panzer, curator of photographs, culled the images that make up the exhibition and wrote the excellent commentary contained in the free trifold brochure accompanying the show. There is not one bad picture here. Of particular note is a wonderful shot of Dwight D. Eisenhower—with incandescent grin, hands upthrust in a sea of supporters—as he arrives at the 1952 GOP convention. Or a strangely compelling, almost sinister portrait of a young Lyndon B. Johnson, just a junior congressman from Texas then, in a too-big suit and flashy tie, yet whose steely predator's gaze bespeaks the powerful, flawed president he was to become.

Befitting his era, Tames worked almost exclusively in black-and-white, and mostly in 35mm. His favorite "gun" was a beat-up old Nikon F with an odd-looking sportsfinder that, he said, allowed him to compose better on the fly. Other shooters might roam the halls of Congress dangling three or four cameras at a time, but Tames seemed always to be most comfortable with only one. And he never burned film at the rapid rate of his motor-driven colleagues. He was content to wait and squeeze off a frame or two at just the right moment. When that happened, he once said, he was able to show in one picture "the whole thing, the feeling of a hearing, the feeling of an event."

The Tames show, elegantly hung, is tucked into a small upstairs gallery near the Hall of Presidents. His work hangs but a few yards away from George P. A. Healy's immortal portrait of a seated President Abraham Lincoln.

In all it's a fine show. Unfortunately though, it is not the best. What's my problem?

Simply this: Over the years I've seen too many of Tames's greatest hits to be satisfied with an exhibition that limits itself merely to the presidency.

Where, oh where, are those wonderful images from the yeasty, boiling world of Capitol Hill, where Tames loved to hang out? For example, this show features some fine available light images of LBJ giving the "treatment"—Johnson's special brand of hands-on, in-your-face-cajolery, to Sen. Theodore Green, when Johnson was Senate majority leader.

But I submit that a very similar yet far better image is one Tames made several years later, during the Vietnam war, showing young upstart antiwar Sen. Frank Church of Idaho locked in a face-to-face confrontation with one of the Senate's old lions, John Stennis of Mississippi. Unfortunately, because this show is limited to the men who made it to the White House, pictures like this don't make the cut. Nor do we see any of

Tames's elegant portraits from the Supreme Court, especially his beautiful window-lit image of then-Chief Justice Earl Warren.

If I have one small criticism of Panzer's thoughtful essay on Tames's work, it is with her contention that Tames "understood that his special access to senators, presidents, and committee chambers depended on his ability to keep much of what he heard and saw in confidence."

Certainly, Tames respected confidences—but he was no photographic eunuch. As one former *Times* staffer told me, more than once a major story resulted from, or was improved by, information Tames gleaned from indiscreet lawmakers who forgot that the fellow photographing them was a working journalist, with two ears as well as two eyes.

"These guys must think we're deaf," Tames once declared.

That's the man I knew.

The Artistic Ambition of Mathew Brady

10/17/97

"He was born into a world without photographs," the National Portrait Gallery's Mary Panzer says of Mathew Brady, the complicated nineteenth-century artist/entrepreneur who helped give the fledgling craft of photography a vision based, schizophrenically, on both fancy and fact. "By the time he died (in 1896)," Panzer continues, "photography had entered every crevice of American life."

Brady remains a cipher, even to historians, since he left almost no written record of himself in the form of letters or diaries. But from the recollections of colleagues—and the occasional newspaper interview—Mathew Brady, known to most as the camera man who recorded the Civil War, emerges as a "felicitously prehensile" promoter with an overwhelming desire to cozy up to and photograph the rich and famous of his age. Viewed only in this unflattering light, Brady—whose work now comprises a large and fascinating exhibition at the National Portrait Gallery—seems little more than the forebear of a mundane studio photographer, caring more about selling portraits to unsophisticated clients than about creating anything beyond the saccharine or clichéd.

But for all his commercialism—and Brady reveled in being a photo impresario—he also possessed visual genius. His "views," as many of his photographs, daguerreotypes, and ambrotypes were called, carry to this day the indefinable aura of fine art.

Typical of the intelligently mounted shows for which the Portrait Gallery is becoming known, you walk into the first-floor rooms of this exhibition and are transported back into Brady's own "National Portrait Gallery," the high-blown name he once gave to his own studio. The crimson walls, wooden display cases, and gilded frames—not to mention such actual Brady equipment as cameras and a posing stool—all work together to transport the viewer back in time. It is a gratifying bit of museumship, complementing the thorough and well hung show, organized by

Panzer, the Portrait Gallery's curator of photographs and author of the exhibition's superb catalogue.

If Brady the man is almost unknown to us, Brady the artist emerges here as a person of many parts. He helped define photographic portraiture in its infancy, and if, in the process, he blended techniques of painting and sculpture, not to mention a heroic and not strictly accurate depiction of people and events of his time, so be it.

Mathew Brady: Images as History, Photography as Art depicts Brady's huge range of work for the first time in more than a century and outlines, besides his gallery of notables, his ambitious quest to create a kind of visual history of America. Here, for example, reflecting a time before television—or even daily newspapers capable of printing photographs—is Brady's attempt to capture in one image the "Last Hours of Lincoln" and provide a grieving nation a visual touchstone on which to base its sorrow over the president's assassination.

How odd, or even ludicrous, such a commercial exercise would seem today. Working with painter Alonzo Chappel and publisher John Bachelder, Brady made individual studies of many of the people—family members, friends, members of Congress—who had trooped past the martyred president's bed during the nine hours he lay dying. Brady's individual attitudes of grief, many of which are on display, were then incorporated into a huge tableau by Chappel.

Does the painting depict reality? Of course not. Do the photos on which it is based accurately depict the grief each person felt? One must answer yes.

But it is the Civil War photographs—portraits of military leaders, as well as stark images of Union and Confederate dead—for which Brady is best known. Yet most of the grim battlefield pictures likely were made, not by Brady at all, but by his one-time employee Andrew Gardner. Brady was more at home photographing generals such as U. S. Grant and Robert E. Lee, or depicting Union soldiers in heroic postures under the harsh midday sun. Staid and static though such pictures might be, they often are not—again a testament to Brady's significant talent as a portraitist.

Successful portraiture is nearly always a collaboration between the sitter and the artist, with the artist keenly aware that he or she is responsible for everything in the frame. Brady's best work illustrates this spectacularly. His famous portrait of Grant standing outside his tent, leaning against a tree, his left arm on his hip, is a fascinating blend of informality and structure. There is a wooden folding chair incongruously to Grant's right—Had he just stood up?—that provides a welcome visual anchor to the myriad folds of the tent in the background. Grant's relaxed pose and piercing, though oddly gentle, stare create visual tension with the rigid, bark-crusted tree. Everything in the portrait works; it is a pleasure to the eye. Likewise, Brady's portrait of the "Officers of the Sixty-Ninth New York State Militia/Fort Corcoran, Va.," posing around a gargantuan cannon, is a textbook example of how heroic group portraiture is done.

Brady's studio portraiture also reflected his unique artistry and vision, the more so because it often involved exposures of more than one minute, during which time subjects had to remain immobile, their necks held rigid by a hidden brace. His subjects seem to emerge from the deep background, their faces carefully illuminated, often from only one dominant direction. This three-dimensional aspect—see his evocative portrait of Horace Greeley—was no accident and makes the more evenly lit work of his contemporaries seem flat and uninspired by comparison.

What set Brady apart, Panzer notes, was his desire "not simply [to] amass an accurate record. . . . He envisioned his work as part of a larger endeavor, in which he collaborated with artists to transform simple facts into vivid tableaux. . . . He saw photographs as part of the material from which historians and painters could construct their record."

The growing ability of the camera to record instantly—to capture the essence of an event in a fraction of a second—ultimately rendered much of what Brady did obsolete.

But never his vision.

Ansel Adams: Tracked by His Indelible Prints

11/14/97

Elegantly framed and tastefully hung on the gray gallery walls of the National Museum of American Art is what could be viewed as the last will and testament of Ansel Adams, photographer, musician, writer and, when he wanted to be, hell-raiser and keeper of his own flame.

They are the photographs that Adams, an American icon, personally chose as his legacy—the images by which he wanted to be remembered. If, in the process, he guided critics and historians away from the more mundane stuff—including his technically proficient but undistinguished commercial still lifes—who would deny him the luxury of trying to write the first draft of his personal history?

He was "St. Ansel" to many: to those who revere large-format black-and-white photography and the heroic portrayals of the American West that he produced during his eighty-two years; "St. Ansel," too, to the legions of young people he taught and spoke to, proselytizing for the comparatively young art form of photography—an art form that, like jazz and the American musical theater, seemed to be made for a young, rambunctious country that brooked no technical boundaries and reveled in the new.

The title of this simply beautiful show is *Ansel Adams, a Legacy: Masterworks From the Friends of Photography Collection.* It easily could have been called "Ansel's Greatest Hits" for all of the familiar and resonant images that are displayed here. But that would probably lead some to assume that they had seen all these images in previous shows, that lovely though "Moon and Half Dome" might be, life is too short to go over old ground.

Well, guess again. For while there are scores of photographs here that are familiar, there are scores more that are not. And even the images that we have enjoyed for decades are new in the sense that Adams reprinted them in the 1970s and 1980s, reflecting his mature taste as artist and master printer—often with strikingly different results.

Photography critic Andy Grundberg, who curated this show along with Merry Foresta, the museum's curator of photography, notes that the prints on display here are more "dramatic and theatrical" than those that Adams produced in earlier decades and that may be more ingrained on the public consciousness. He attributes this to a change in Adams's "visual acuity," maintaining that "in his mature years the photographer saw the world quite differently, in terms of his eyesight and metaphorically, in terms of his aspirations for his pictures."

Leaving aside the dubious notion that Adams produced these spellbinding prints because his vision was failing, it is true that some of his most famous images, including "Moon and Half Dome" (1960), "Winter Sunrise Sierra Nevada" (1944) and "Clearing Winter Storm" (1944) are more contrasty and punchy than those seen in books or in previous exhibitions of older prints.

"But that's just the point," one almost can hear Adams saying, nursing a Scotch while lecturing on his favorite subject. Reflecting his training as a classical pianist, Adams was fond of saying, "The negative [is] the score, the print the performance." These prints are Adams's final virtuoso performances, reflecting his tastes at the time, and they have their own good and bad points, depending on your sensibilities.

"Clearing Winter Storm," for example, does sacrifice shadow detail in some of the darker mountains in return for a much more dramatic white cloud at the center of the frame. In explaining the profound, almost mystical popularity of this image, Grundberg cogently notes in the exhibition brochure that this photograph was made in 1944, "just as optimism about the outcome of World War II was rising, and the tide on the battlefields was turning." It thus embodies "not only an essentially American landscape, but also a unique historical moment."

So too does "Winter Sunrise"—one of my own favorites—lose a fair amount of detail in the dark sweep of shadow that sits like a band across the middle of the frame. But the magic of the early morning highlights in the rugged craggy mountains remains, and the band of shadow now becomes a more arresting abstract form.

It is also worth noting Foresta's observation that the softer, less contrasty renditions of Adams's earlier prints reflected the artistic tastes of the period.

Though best known for his landscapes, Adams also was a brilliant portraitist, as masterly in recording the planes of a face as he was in recording the rugged face of a mountain. Consider his 1933 image of the Mexican painter Jose Clemente Orozco. The artist's massive head dominates the frame, his thick black-framed glasses and caterpillar of a moustache offering visual accompaniment to his penetrating gaze.

"I wanted to concentrate on his compelling expression," Adams told his longtime aide James Alinder in 1978, in comments published in an Aperture monograph on portraiture. "When you saw his whole head its power was lessened; but by moving into his amazing eyes, his intense

stare, the portrait became complete. [Orozco] said, 'Oh, that is good,' when I brought the camera close."

It is interesting to speculate whether someone as technically adept as Adams would, if he were alive and working today, experiment with digital cameras. Foresta maintains he most certainly would. But just as certainly, she—and I—believe he would stick to the magic and majesty of the black-and-white print, at least until the digital incarnation of the image were as beautiful—and archival—as the original.

Adams once told an interviewer, "I actually don't think of people, rocks, and trees as anything very different. . . . Of course, the people really mean much more than the rocks, but I seem to reach an intuitive response in either case.

"Photography is a form of awareness and communication. Suddenly you see it's right and you make the exposure."

Over and over and over again. In Adams's case, over a lifetime.

Mean Drunk
in a Dark Bar

04/23/99

The vintage black-and-white photograph shows a group of young men and women whose attention is caught by something out of the frame. Fresh-faced, dressed in casual clothes, they might be headed for an outing or a picnic, and listening intently to directions.

But then you notice that the thin bespectacled man on the left is wearing a military campaign hat and is carrying a gun. You realize, too, that the man-boy wearing shorts in the center of the group also is carrying a rifle, and that his is tipped with a bayonet.

Then, and only then (or at least it was that way for me), you see that the two nicely dressed young women at the right of the picture also are heavily armed. And that the necklace on one of them is not a necklace at all, but a clip of high-caliber bullets.

"Partisans Entering Pistoia, Italy, 1944" reads the legend on the back of the print, one of nearly a hundred striking—yet eerily mundane—images gleaned from photography dealer Jo Tartt Jr.'s huge collection of vintage war pictures, most of them relics from newspaper photo morgues and flea markets, and doubtless destined for the garbage until Tartt bought them.

The photographs, a deceptively haphazard collection of dog-eared, occasionally discolored, sometimes grease-penciled artifacts of an age before computers (even, occasionally, before television), are on display at the Troyer Gallery in Northwest. "These pictures stand as a send-off to the High Priests of High Art and the Archangels of Archival," writes Tartt (himself an Episcopal priest and former rector) in a pair of handouts accompanying the show. Who cares whether or not this stuff is well-preserved, he says in effect, much less whether it's art?

What matters is impact. Sometimes, Tartt declares, "A really good photograph can confront you like a mean drunk in a dark bar."

Photography's ability to record the ambiguous as well as the definitive is reflected in this curious shot of partisans entering Pistoia, Italy, in 1944. On careful look, the image raises more questions than it answers.

And so these pictures do—and in the process raise questions about their power.

Many writers, myself included, have described the impact of everyday photographs, their ability to freeze, and therefore to cheat, time. One reason the so-called snapshot aesthetic arose at all is that any photograph—be it by Steichen or my late mother—has an inherent verisimilitude simply because it reflects something that existed in front of the camera when the image was made. The photographer is the only artist who cannot create an image from memory. For this reason, photography gets a not-always-deserved reputation for honesty—The Camera Doesn't Lie.

In fact the camera does not lie. But the people in front and in back of it might.

Thus wartime photographers on both sides take pictures of their people looking heroic, to bolster the morale of loved ones at home. The better of these photographers also record suffering and cruelty and, if those pictures clear the censors, they make it onto the front page as well.

With the picture of the well-dressed partisans, it is the image itself that creates ambiguity—and perhaps that was the anonymous photographer's intent. The people here are like extras in a crowd scene, never meant

to be closely scrutinized. Every woman visible in the picture is well-dressed and perfectly coiffed. All the men are clean-shaven. The grit and horror of war is nowhere in this image. I get no sense that these people have just emerged from house-to-house fighting, yet the weapons of destruction are there, in the partisans' clean hands.

Grant them their loyalty. But did any of these people ever fire those weapons before they were photographed with them? And what are they looking at?

"[This] exhibition is meant to be about photography and seeing, not about war," writes Tartt. "Neither polemic nor moral tone is intended."

And that, finally, is what makes photography such a simple yet complicated art form. Its power to deceive is as great as its power to move.

This conundrum is captured perfectly by Tartt and Troyer in two pictures deliberately hung one above the other. The bottom photo is of a nattily attired Irving Berlin seated at a piano, surrounded by a group of smiling men in uniform, the cast of the World War II musical *This Is the Army*.

Above this obviously staged public relations shot—in a hauntingly similar composition—is one from the same era that caught my breath and stopped my heart. (The mean drunk in the dark bar.) Instead of a line of smiling singer-soldiers, there is a line of American women straining against a dock railing, not against Irving Berlin's shiny piano.

All the women are in anguish; many are weeping. The caption tells us they are watching the caskets of 4,183 war dead being unloaded from an American transport ship as it arrives stateside. The photograph, a rare display of the horror of World War II literally coming home to America, mirrors scores of images we see every day from Kosovo. Yet the impact of the old picture is so much greater.

Those dead boys were ours.

Henri Cartier-Bresson and Brassai:

Two Different Ways to Greatness

10/29/99

It is fitting, if somewhat bittersweet, that the last major photographic exhibition at the National Portrait Gallery is a monumental celebration of the human face by Henri Cartier-Bresson.

Fitting, too, because this work can be compared with that of Cartier-Bresson's contemporary, the Hungarian-born photographer Brassai (Gyula Halasz) (1899–1984), whose retrospective of vintage prints is now on display at the National Gallery of Art.

To be sure, the Portrait Gallery is not going away; it merely is joining its sister institution, the National Museum of American Art, in a long-overdue overhaul that will last three years. Still, if you're going to shut down, even temporarily, what better way to do it than with a farewell offering from arguably the greatest photojournalist of all time?

For those of us who make pictures, the work of these two great shooters is instructive because each worked so differently to record the world around him. Brassai, born in 1899 in the Hungarian city of Brasso (hence his nom de guerre), came to love Paris in the years between the World Wars and recorded the night life of the city with a studied formality. Working with bulky, large-format cameras, he eschewed the new 35mm camera—which Cartier-Bresson, by contrast, embraced. Unlike Cartier-Bresson, who preferred always to work by available light, Brassai not only used a large, tripod-mounted camera, but often lit his scenes with powerful flashguns, the light raking across his subjects' bodies and faces. (Cartier-Bresson once huffed that using flash was "impolite, like coming to a concert with a pistol in your hand.")

Finally, the most telling difference: Brassai had no qualms about staging pictures, though, in fairness, he often would wait until his subjects forgot about his presence. Cartier-Bresson made his reputation as the master of the "decisive moment," that instant when all elements of gesture, com-

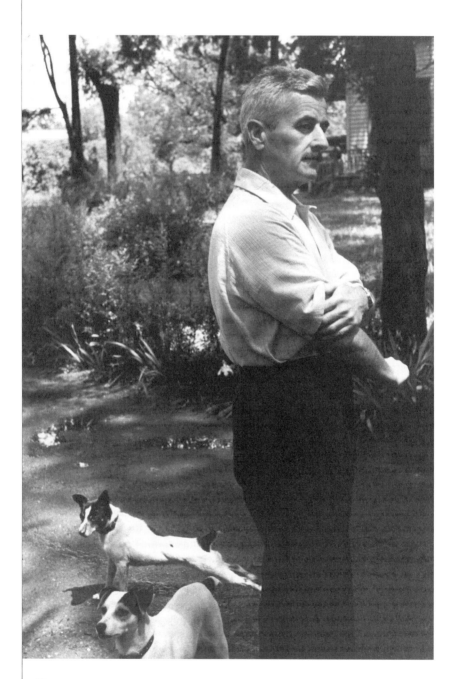

Cartier-Bresson's 1947 portrait of author William Faulkner defines the Decisive Moment, when all elements come together for a marvelous image. The exact parallel lines created by Faulkner's arm and the terrier's extended hind legs create a beautiful visual tension. © Henri Cartier-Bresson/Magnum

position, and lighting come together to create a transcendent image—a great photograph—then disappear, never to be re-created.

In viewing both these shows, I reinforced my conviction that where Cartier-Bresson's genius was in capturing people in telling poses, Brassaï's mastery was in providing a sense of place—especially of his beloved Paris. To be sure, a handful of Brassaï's portraits are wonderful—some of these, like his portrait of a chesty prostitute staring intently into Brassaï's lens during a game of snooker, have become icons. But, on balance, what moves me about Brassaï is his genius in capturing the nocturnal urban landscape, not his ability to record faces.

It is a genius that demands a tripod and a big negative. And perhaps it says something that, of the 113 images in the National Gallery's elegantly hung show, I was most smitten by the luminous study of Parisian paving stones that Brassaï himself chose for the cover of his 1933 book, *Paris at Night*.

To a location portraitist and documentarian like myself, Cartier-Bresson's photographs, especially the seventy portraits that the ninety-one-year-old personally selected for his first major exhibition in Washington, are stunning not just for their content but for their technique.

Almost without exception, every image in the exhibition is superb, though his photographs of Ernesto "Che" Guevara, the Cuban revolutionary, and of the Dalai Lama are perhaps the weakest of the lot.

But, Lord, what a lot!

Come to this show as if to a seminar. Study each image and see how the photographer caught the perfect expression, the perfect cast of the hand, the perfect composition. (Admire, too, the beauty of the new 16 × 20 prints, made under Cartier-Bresson's watchful eye in Paris especially for this show.)

Certainly, Cartier-Bresson possessed a measure of genius, but he also kept on working, like a superb athlete whose muscle memory allows for the effortless repetition of great and difficult actions. The eye, after all, is a muscle, too, and the most recent image in this show, of painter Lucien Freud, was made in 1997, when Cartier-Bresson was eighty-nine.

For me, Cartier-Bresson's 1947 portrait of the author William Faulkner defines what it means to capture the decisive moment. Faulkner, the chronicler of the tortured modern South, is turned, diffidently perhaps, from the photographer, the author's keen eye cloaked in afternoon shadow. Faulkner clutches at his elbow, stiffly holding out his right arm, in what, by itself, would be a fine portrait. But, at that precise moment, one of the author's terriers, on the ground beside him, stretches, and the animal's back creates a line exactly paralleling that of Faulkner's arm. The visual tension is exquisite, and Cartier-Bresson creates—once more—a superb image, with the casual grace of Derek Jeter gloving a hot grounder.

Dissecting the Stravinsky Portrait

04/21/00

Consider Arnold Newman's portrait of composer Igor Stravinsky and realize how many things are happening within the minimalist confines of the photograph's borders.

The picture is probably unlike any you have seen (or taken) of anyone at a piano. Though the famed conductor is but a small portion of the picture—and off in a corner at that—your eye goes immediately to Stravinsky and his piercing gaze, directed by the black shaft of the grand piano's support arm.

The great instrument's cover, devoid of all shadow detail, becomes a giant musical note, a symbol of Stravinsky's music.

Even the background adds to the subtle, yet strong, graphic nature of this portrait. The image might have worked had the background been only one shade of gray. But two shades create visual tension, separating Stravinsky from his instrument, while his arm connects him to it.

An eloquent work by the man some regard as the father of the environmental portrait and who, at age eighty-two, is still making pictures.

The Stravinsky portrait, one of more than 130 of Newman's works in the current retrospective at the Corcoran Gallery, long has been one of my favorites. Not just because of its content, but because of what it reveals about Newman's philosophy of composition—and, perhaps even more importantly, what it says about the photographer's ability to work on the fly in unfamiliar surroundings and to improve on his work in the darkroom.

The picture was made in 1946 in a New York Hotel suite; and Newman, then all of twenty-eight, was eager to depict Stravinsky in an atmosphere that subtly depicted the kind of anonymous surroundings that were so much a part of the renowned musician's traveling life.

As Newman recounted during the press preview of the Corcoran show, he was able to use the piano in the suite to best advantage. Where another photographer might have set up a backdrop of gray seamless paper as a

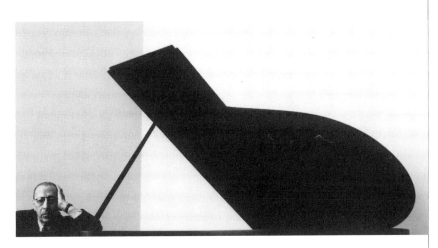

The now-legendary portraitist Arnold Newman was a mere twenty-eight years old when he made this classic image of composer Igor Stravinsky in 1946. Trained in fine arts and painting, Newman created a wonderfully abstract image in a New York hotel room. The two tones of the background are simply a corner of the room reflecting light differently. © Arnold Newman, from Arnold Newman/Breaking Ground, Corcoran Gallery of Art, Washington, D.C.

background, Newman wisely saw how the unadorned corner of the room created the impression of two different wall colors and posed Stravinsky accordingly. Working with a 4 × 5 view camera, Newman made twenty-six exposures. A sampling of contact prints from the session (reprinted in the 1974 book, *One Mind's Eye*) shows how the final image came about. Lighting for the shot appears to have been minimal. (Newman himself is understandably vague on the details of portrait sessions more than a half-century past, though he told his Corcoran questioners that his goal in most cases "is to try to make it look real." In fact, the photographer is famed for his crack that " 'Available light' is any light that's available.")

But if Newman had simply relied on what he got in the hotel room, the picture would not have become the icon it has. As he did with other great images (notably his tight crop on artist Pablo Picasso), Newman edited his work severely in the darkroom and cropped the picture to add an even more abstract quality to the final product. In fact, the finished portrait embodies perhaps only the central 50 percent of the negative. And the tactic works magnificently.

Newman once told an interviewer: "A preoccupation with abstraction, combined with an interest in the documentation of people in their natural surroundings, was the basis upon which I built my approach to portraiture. We must show the subject's relationship to his world either by fact or by graphic symbolism." And if the other 130 photographs in this show do not all measure up to the Stravinsky portrait, the vast majority of them do and make a compelling counterpoint to the uneven Annie Leibovitz show across the hall.

Edward Steichen: Diminished by His Success

01/12/01

This is what you must keep in mind when considering Edward Steichen:

- In 1900—*more than a century ago*—a breathtakingly ambitious, and very talented, Steichen, then aged twenty-one, went to New York to show his work to the legendary photographer Alfred Stieglitz. Stieglitz, with whom no one ever associated the words warmhearted or outgoing, liked what he saw in the young photographer/painter's work. Almost immediately he bought three of Steichen's photographs—for five dollars apiece.
- More than a generation later, during World War II, when many men his age would have been nearing retirement, Steichen accepted a commission as a Navy lieutenant commander, and over the next four years supervised all Navy photography, until he resigned his commission as a captain in 1946. (The starkly beautiful documentary photographs that Steichen himself produced during his wartime service stood in contrast to his ethereal, equally beautiful, still lifes and landscapes that had caught the eye of Stieglitz decades earlier.)

In between these two periods, Edward Steichen carved out a career as one of the most successful portrait photographers of his age, with studios in New York and Paris. He also enjoyed huge success in the then-new industry of advertising photography and became a star fashion photographer at *Conde Nast*.

In short, during his nearly ninety-four-year-life, Edward Steichen had not one but four, five, even six, separate careers. After the War for example, as director of photography at the Museum of Modern Art in New York, Steichen mounted what many have called the greatest photography exhibit of all time: the monumental *Family of Man* show, featuring 503 photographs from 273 photographers in 68 countries. (To be sure, the life-

affirming show, mounted at the height of the Cold War, was derided immediately by some critics as mawkish and superficial—and was savaged by some of Steichen's younger photographic colleagues. It says something about the staying power of this exhibition, however, that its catalog not only remains in print, but also is a bestseller, after nearly a half century.)

The current forty-year retrospective on Steichen at New York's Whitney Museum does a creditable job of encapsulating the work of a photographer whose different periods and aesthetics cover everything from misty gum bichromate prints to starkly lit glamour and celebrity shots. Walking through the museum's heavily hung halls, I could not help but think of Picasso, another restless, creative soul who seemed to abandon one way of working as soon as he mastered it. But in fairness, where Picasso is widely viewed as having been miraculously successful in virtually all of his "periods," Steichen's legacy is more clouded and problematic—some work clearly is better than some other. Yet much of what I have seen written about this show, and about Steichen in retrospect, by critics who have not spent much time—much less made their living—behind a lens, creates an off-putting air of sanctimony that seems to pillory Steichen for his own ambition and success, while sniffing that the work really isn't as good as Steichen's promotion of it.

Both premises are wrong.

To any of us willing to be judged by what we leave behind on film, even one immortal image is a divine gift. Steichen left behind scores.

"Heavy Roses, Voulangis, France," (1914) a sensual feast of floral abundance, may be the finest such photograph I ever have seen.

Likewise, Steichen's "Three Pears and an Apple" (1921) is an arresting image and subtle, elegant composition. (The soft outline of the fruit is the result of a *36-hour* exposure under dim, indirect illumination, during which time the film's emulsion expanded and contracted in the chill evening air.)

The photographer's 1920s portrait of journalist and author H.L. Mencken is a wonderful, almost abstract, composition of shapes and shadow. By the same token, Steichen's portrait of an insipid-looking Winston Churchill is lackluster compared to Yousef Karsh's later depiction of the angry English bulldog and wartime Prime Minister. (Karsh had grabbed away Churchill's cigar just before making the shot).

But, what the Churchill portrait lacked, Steichen's 1903 portrait of financier J. P. Morgan reflected in spades. Morgan, his red nose glowing like a beacon even in black-and-white, glares at the camera in what seems like barely controlled anger. Morgan leans forward, his left hand grasping the arm of his chair. But the arm of the chair is half-obscured in darkness, and what shows appears to be a menacing dagger.

A simply stunning, spot-on portrait of a robber baron.

And this is only a sampling. Never mind the classic, studio-lit portraits of Greta Garbo or Charlie Chaplin or Marlene Dietrich. The large-format, multi-image abstracts of then-novel New York skyscrapers.

Or his glorious and moody depiction of the Flatiron Building. Where is it written that an artist has to be a wonderful person, with the temperament of Gandhi or the soul of Bambi? Or, for that matter, that he or she should be devalued in the critical press for wanting to make a buck? Steichen could be overbearing and self-absorbed. That he was a promoter is beyond question. That he had a hell of a lot to promote also is obvious, at least to me.

And successful? Steichen knew great success from his twenties and parlayed that early fame into artistic success—and commercial wealth. Were he alive today and working at the height of his powers, he easily would be elbowing Annie Leibovitz, Greg Heisler, and Steven Meisel for jobs in the slick magazines, going head-to-head with Sabastiao Selgado and Mary Ellen Mark for the prime editorial jobs, and sharing center stage with Richard Avedon, Irving Penn and Sheila Metzner for damn near everything.

(Let it also be noted that among the foregoing photographers—all of whom are rightly viewed as masters—are a couple who might charitably be called strong personalities, accustomed to getting their own way and becoming monumental pains in the ass if they don't. Why is it that when these shooters have museum shows, the critics say nothing about their prickly personas? Could it be that these artists are not yet safely and silently dead?)

Edward Steichen's place in the pantheon of photography's greats is secure. However, it is his view of photography's purpose that seems to have rattled so many cages—and devalued his stock, at least temporarily. Exhibition curator Barbara Haskell notes that "Steichen came to believe that no qualitative distinction existed between fine (art) and commercial photography and that propaganda had been art's historical function."

Such an attitude—especially put so bluntly—inevitably put Steichen at odds with more effete artists who insisted that theirs was but a search for truth. (Note, too, that propaganda denotes persuasion, which in turns conjures up advertising, which in turn raises the old whorish notion of doing photography for money.)

Yet if, as I believe, the purpose of art is to make the viewer *feel*—anger, rage, sympathy, empathy, love, humor, desire, awe—then Steichen is dead right. One might question an artist's priorities or allegiances, but the same talent that causes us to marvel at the sublime symmetry of one artist's Grecian urn, helps us also to view a photograph by another artist and a) enlist in the army to fight the infidel, or b) run out and buy those cool-looking slacks.

Edward Steichen succeeded handily on both fronts. He won awards for his efforts to use photography to bolster the allied war effort. His advertising clients loved him.

It is entirely possible that if he had not been so successful so early or so universally, photography's cognoscenti might be more willing to applaud Steichen's myriad accomplishments today.

Great Photography Books: A Dinner Table Debate

02/09/01

On a chill winter's night recently—when Judy and I, miraculously, were not shooting a wedding—a group of friends gathered around our dinner table to talk photography.

There were four couples in attendance that night, and those of us who were not professional photographers had significant ties to the business, either professionally or personally.

The crowd joining Judy and me were: Judy and Peter Garfield, Peter being the well-known corporate and fine art shooter; Barbara Tyroler and her husband and partner David Cooper, (Barbara's a University of Maryland photography instructor and commercial photographer), and Linda and Richard Pelletier. Richard is the Washington area rep for Eastman Kodak Company's Professional Services Division.

As the last of the lamb shanks were picked clean and the final glasses of wine drained, I posed a dessert topic with the 100 percent selfish idea that I would turn what followed into a column.

"What are your favorite photography books of all time?" I asked. That stopped conversation pretty effectively—but only because everyone had begun to seriously mull the photography books that most had affected them over the years. And the results we came up with provide, I think, a good (if partial) primer for anyone seeking to learn about photography by looking at great pictures. (Note: I found it fascinating to compare this list with my own highly personal list of favorites that I published in this column more than eight years ago.

For one thing, the new list contained virtually all black-and-white photography; my 1992 listing contained four books out of twelve that were in color. In addition, the new list of nine all-time great photo books featured the work of only one woman, Diane Arbus. In 1992, Arbus was on the list also, but she was joined by Linda Butler.)

If the following dinner table listing of great books has a timeworn

feeling of Golden Oldies, it's because most of the books we chose—like the photographers who made them—have withstood passing fads and fancies. Each is a true classic. The newer ones have what all of us believe to be the stuff of greatness as well. In no particular order—this was, after all, a dinner party, and the wine was really, really good—we picked the following:

Moments Preserved by Irving Penn (Simon & Schuster, 1960). This book is out of print, as are many of the ones that follow, so it may best be seen in the fine arts section of a good library. Penn, as I have written before, is modern photography's Renaissance Man—capable of shooting anything and anyone, from cigarette butts to fashion models, in color and black-and-white. Trained also as an artist, Penn has been making gorgeous photographs for decades, and has a new book coming out this year. I would add my own additional vote for Penn's gorgeous book, *Passage* (Knopf/Callaway, 1991), which is a superbly printed retrospective of this great photographer's varied work.

American Photographs by Walker Evans, essay by Lincoln Kirstein (Museum of Modern Art, 1938). This out-of-print classic is the standard by which most collections of Evans's work are measured. Evans is one of my heroes, not only for his Depression-era documentary work, but for his beautifully seen landscape and architectural photography as well. Fans of this enigmatic and highly articulate photographer also should consider *Walker Evans First and Last* (Harper & Row, 1978) as well as two current and very different "biographies": *Unclassified/A Walker Evans Anthology* (Scalo, 2000), which accompanied the recent Evans show at the Metropolitan Museum of Art; and the superbly printed *Walker Evans: The Lost Work* (Arena Editions, 2000). *Unclassified* is extremely valuable for reproducing pages of Evans's own manuscripts, as well as contact sheets from some of his better-known work. *The Lost Work* is wonderful simply because it draws on so much Evans work that was unpublished, twinning it with sensitive, perceptive text from Evans scholars, Belinda Rathbone and Clark Worswick. And, typical of books from Arena Editions, the reproduction is magnificent.

Sudek by Josef Sudek, text by Sonja Bullaty (Clarkson Potter, 1978). Sudek, a Czech, was a superb documentarian in the tradition of Andre Kertesz and Cartier-Bresson. His photographs capture his native Czechoslovakia, especially the capital city of Prague, one of my favorite cities in the world.

Diane Arbus—An Aperture Monograph (25th Anniv. Ed., Aperture, 1997) One of the most famous books in modern photography history, it rightly cemented Arbus's place among the craft's giants. Though her black-and-white medium-format depictions of people on society's fringes once earned her the moniker "Wizard of Odds," Arbus's was a gentle, if unblinking, eye that never was cruel. She spawned numerous imitators. (Not as well known as her stark documentary work is her earlier magazine and fashion work, done with her then-husband and partner Allan Arbus. In the years following Diane's suicide in 1971 at age forty-eight, Allan pur-

sued an acting career and won fame on the hit comedy *M*A*S*H* as the pragmatic, sensitive army shrink, Dr. Stanley Friedman.) Their daughter Amy Arbus is now a first-rate fine art and editorial photographer. See also: Patricia Bosworth's sympathetic, well-researched *Diane Arbus: A Biography* (Knopf, 1984).

Arnold Newman and Philippe Halsman: As it happened, both photographers—each a legendary portraitist—had had recent museum retrospectives in Washington and the dinner table consensus was that the catalogs to both shows deserved inclusion here. That certainly is true of *Halsman: A Retrospective* (Bulfinch, 1998), but I am going to overrule the panel on the huge Newman catalog. Why? Because I think with a few exceptions—his color portraits of arms maker Alfried Krupp and master builder Robert Moses—Newman's work is much stronger in black-and-white. Therefore his earlier black-and-white book *One Mind's Eye* (Godine, 1974) is a better, and better-edited, selection of Newman's superb photography.

The Americans, by Robert Frank, introduction by Jack Kerouac (Scalo, 1998). A beautiful new edition of this classic and seminal work of photojournalism and documentary photography. The Swiss-born Frank's book of stark, gritty black-and-white images is simply a must-have for photographers hoping to capture the world around them. Frank's 1950s odyssey across the United States was paid for by a Guggenheim Foundation grant to reflect "a European eye look[ing] at the United States." Note to potential grant-seekers: Among Frank's big-ticket sponsors when he applied for his Guggenheim were Walker Evans and Edward Steichen.

Henri Cartier-Bresson (Any edition of his work). No other photographer has so consistently captured telling gesture, composition and detail in his photographs as has the legendary HC-B. He defines the "decisive moment," caught by what critic-historian Beaumont Newhall called "the velvet hand; the hawk's eye." Of all the editions of his work, one of my favorites is a small paperback, *Photographs By Cartier-Bresson* (Grossman, 1963).

Workers: An Archaeology of the Industrial Age by Sebastiao Salgado (Aperture, 1993). Salgado, the youngest member of this distinguished group, has spent years documenting the world's have-nots and wanderers. This book is his take on how manual laborers and others are being victimized in an ever-more mechanical, mercenary world. The black-and-white images are stunning.

So there you have the fruits of our dinner table debate. But I can't leave without adding three more titles that came to me after Judy and I had bade everyone farewell and done the dishes:

Roy DeCarava: A Retrospective (Museum of Modern Art, 1996). The only African-American on the list, DeCarava, long has been a favorite of mine for his evocative black-and-white pictures of his (and my) native New York of the 1950s and 1960s. His image "Ellington Session Break, 1954"—a serene, almost abstract, picture of two seated men in a rehearsal hall flanking a coat rack—is one I can look at forever.

Steam, Steel, and Stars: America's Last Steam Railroad, photographs by O. Winston Link (Abrams, 1987). This mad photographic genius and railroad buff documented the last days of America's steam engines in gloriously composed and painstakingly lit view camera tableaus that literally required hundreds of flashbulbs (that's right, bulbs) and miles of wire. God bless him, these are beautiful, bizarre pictures.

Yosemite and the Range of Light by Ansel Adams (New York Graphic Society, 1979). Imitated but rarely equaled, America's premier black-and-white landscape photographer combines technical mastery, superb composition, and unequaled printing skills in this collection of his most famous, most majestic, Yosemite images. Looking at these pictures is like going to church.

In the interest of completeness, here are the other books I mentioned in my personal all-time favorites column in '92:

- *Examples: The Making of 40 Photographs* by Ansel Adams
- *Vanishing Breed: Photographs of the Cowboy and the West* by William Albert Allard
- *Portraits* by Richard Avedon
- *Inner Light: The Shaker Legacy* by Linda Butler
- *Water's Edge* by Harry Callahan
- *Choose Me: Portraits of a Presidential Race* by Arthur Grace
- *Cape Light* by Joel Meyerowitz
- *Frontier New York* by Jan Staller

Stieglitz and New York: A Town to Match His Ego

04/06/01

Revered though he is as a giant of photography—brilliant practitioner, master printer, fierce defender of the medium as a fine art—Alfred Stieglitz was, by most accounts, an unlikable SOB.

Born to great wealth in 1864 in Hoboken, New Jersey, and doomed to spend his life without really ever having to support himself, Stieglitz was, in the words of biographer Benita Eisler, an artist who continually balanced the need to singly pursue his vision with that of "the narcissist who does not exist without others."

Alfred Stieglitz, Eisler says, "could not bear to be alone." He needed an audience to bully and cajole—just as he needed an audience to praise him.

He also was an awful businessman.

Set up in a photoengraving plant by his rich father, Stieglitz managed the neat trick of mixing contempt for his workers with "patronizing paternalism," at one point suggesting that his employees—proud craftsmen of considerable skill—accept reduced wages in slow times in exchange for future profit sharing. All this while Stieglitz himself was living at home on a generous allowance.

His subsequent relationship with the painter Georgia O'Keeffe, another strong-willed and not especially warm-spirited person, was troubled at best. Much younger than Stieglitz, O'Keeffe was keen to seek his support as an arbiter of modern artistic taste, even as she pursued other relationships (with both men and women) after she married the aging photographer, himself a philanderer.

In short, not the kind of people I tend to have over for dinner.

And yet, we owe a tremendous debt to Stieglitz, and to a lesser extent O'Keeffe, for their fierce devotion to their own art and to that of other modern artists. It is not too far off the mark to say that the photographer Alfred Stieglitz, single-handedly and with blazing perception, introduced Modern Art to America. He was, in the words of Sarah Greenough, cura-

National Gallery of Art installation re-creates the look of Alfred Stieglitz's New York galleries—which helped introduce modern art to America (© Robert Shelley/National Gallery of Art)

tor of photographs at the National Gallery, "the single most important figure in American art in the first half of the twentieth century."

So the current show at the National Gallery, *Modern Art and America: Alfred Stieglitz and his New York Galleries*, demonstrates: in paintings, drawings, photographs, and sculpture by artists like Picasso, Brancusi, Braque and Matisse—many of whose works were exhibited in this country *for the first time* by Stieglitz in his hole-in-the-wall gallery spaces in Manhattan over several decades.

"When Stieglitz opened the Little Galleries of the Photo-Secession at 291 Fifth Avenue in New York in 1905," Greenough notes, "he had the audacious belief that America, as the most modern nation in the world, could and should be the world's preeminent cultural force. And he was certain that New York, the city of ambition, the place where the hand of man—and the hand of modern man—was writ large, should be its center."

This is a show that invites leisurely perusal, in part because its display in the West Wing of the National Gallery is so engagingly spread out. The nearly 200 works of the exhibit are shown not only in smaller galleries, but also in the long wide galleries that usually serve simply to get you from point A to point B. Thus, the larger canvases of artists like O'Keeffe, John Marin, and Marsden Hartley have space to breathe—and to be viewed from afar. At the same time, much smaller works on paper—including the seminal early drawings of Rodin, Matisse, and Cézanne—are shown in much smaller surroundings that mimic the intimate spaces of the galleries Stieglitz created. (These early works were small for a reason: they were

small enough for Stieglitz and his agents to pack them carefully in trunks and, in effect, hand-carry them from overseas in their luggage.)

Charles Brock, co-organizer of the exhibition along with Greenough, notes that Stieglitz, who became enthralled by photography while studying in Germany in his youth, was "unique in his vision of the role that photography would play in modernism."

By photography's very nature—a totally new, "scientific" and, therefore, modern art form—it was fitting that it be tied to all other contemporary art that embraced the new or the unusual. "It is hard to imagine the shock" generated by some of the work Stieglitz exhibited, Brock noted as he walked through the exhibit, especially the delicate tiny nudes that adorned the walls of 291. At the same time, Stieglitz knew that these small provocative works, by their very nature and size, made for "a more coherent dialogue with [the] photography" that hung in juxtaposition with it. Looking at the abstract work of Picasso, or the cubist works of Braque, or the totemlike sculpture of Brancusi, one can understand the cross-fertilization one sees in the more abstract work of Paul Strand or in the photograms and other work of Man Ray.

The onset of World War I also helped America—and therefore, Stieglitz—assert dominance in the modern art world. From 1914 until the end of hostilities several years later, art, especially avant garde art in western Europe, was all but forgotten, as a generation of young men died in the killing fields of Ypres and Verdun. After the war, and until his death in 1946 at the age of eighty-two, Stieglitz continued to champion modernism, especially American modernism.

His status as an artist would have been assured merely by his genius as a photographer. (Go to this show if only to marvel at the stunning black-and-white prints he made.)

That he also helped birth an entire new art movement merely adds to his legend.

SECTION VIII

Interviews

Alan Markfield: Movie Stills Shooter

09/24/93

The only thing I hold against my friend Alan Markfield is all that time he spent alone with Sigourney Weaver.

Actually, Markfield wasn't alone with her all that much. Usually, there were a few score other folks nearby when he was photographing this striking and talented actress: grips, technicians, lighting people, other actors—you name it—on location in Indonesia during the filming of *The Year of Living Dangerously*.

But Markfield did send me a picture of Weaver—a relaxed portrait during one of her few days off during the making of that acclaimed film.

If you think the life of a Unit Stills Photographer—the official union designation for the job Markfield has been doing for some fifteen years now—is all rubbing elbows with movie stars, guess again. Oh, there's a lot of that, and Markfield can drop names with the best of them. But as I touched base with him recently before he headed off to Vancouver, British Columbia, for a three-month stint as unit shooter for the upcoming film *The Yellow Dog*, it became obvious that his job is a fascinating mix of drama and drudgery.

"Officially, you're part of the camera crew," said Markfield, who is a member of the International Association of Theatrical and Stage Employees. "Anytime the movie calls for a still photograph, it's usually yours."

For example, say you're watching a murder mystery and the star is reading a newspaper showing a picture of a dead body on the front page. "That means you took that picture a few days before, using an extra."

"Or, if you're at a movie and see in the background a framed picture of, say, the star and his 'wife'—that's yours again."

At the beginning of *Year of Living Dangerously*, there is a slow pan of gritty black-and-white news photos, shot by Billy Kwan, the tormented newsreel shooter (played by actress Linda Hunt—who won an Oscar for

Location stills shooter Alan Markfield (do I really have to say "left"?) on the set of the blockbuster kid flick, *Teenage Mutant Ninja Turtles.* Alan will travel with a ton of gear and stay on location months at a time. (Note: that's not New York City, but a fake Gotham, on a backlot in Wilmington, North Carolina.)

the role). Actually, they all were Markfield's photos, made specially for the film on location, in the weeks before shooting began.

"Your job is to create props (like Billy Kwan's portfolio), make a photographic record of the film, shoot portraits that might be used for advertising posters, as well as the stills that are supplied to newspapers and magazines across the country when the film debuts," Markfield said.

"Everybody thinks those stills are actual frames from the movie itself, but each frame, if used for a still, wouldn't reproduce well." And so the unit photographer is often just out of camera range, making his or her own photographic record for later use in any number of ways.

Like many unit photographers, Markfield has a background in hard news. "I've been doing this for fifteen years," he noted, "but before that I was doing wars and riots." In fact, he has been to most of the world's trouble spots, from Vietnam to Nicaragua to Iran. That training—to work quickly and effectively when all hell is breaking loose—seems to mesh well

with the controlled chaos of moviemaking. Markfield noted that shortly after his colleague Ken Regan wrapped up work as stills photographer on *The Pelican Brief*, he headed off to the Sudan for a news assignment. "Most of us who come from a freelance background try to return to news every now and then, in much the same way that an actor will return to Broadway to hone his skills."

Unlike news shooters, however, who have to pack light with a minimum of fancy gear, the better to stay mobile (and, in some cases, alive), unit photographers have to be prepared not only to deal with, but to create, varied lighting conditions. So, as I spoke with Markfield by phone, he was making final preparations for an assignment that already had seen him ship seven full cases of camera and lighting gear to Vancouver. Noting that no two photographers will agree on what's best for a job, Markfield said he has been shooting with Canon cameras and lenses for years and loves them. He'll take about ten camera bodies and twenty or so lenses, with a lot of redundancy in case of an equipment failure. Besides his automatic cameras like the Canon T-90 and A-1, Markfield said he never leaves home without his totally mechanical F-1s—the legendary Sherman tank of Canon's pro line that mirrors the take-no-prisoners ruggedness of the Nikon F2.

Most movie sets generate their own electricity to power lights and other gear, so Markfield doesn't really have to worry about batteries when firing his strobes. Still, for portability and dependability, he said he relies on the wonderfully modular portable lighting systems offered by Lumedyne, which can be run either with their own portable power packs or on direct AC, depending on the circumstances.

For all that, Markfield rarely uses flash when shooting during filming, preferring to "ride" the lighting created by the director of photography, or "DP."

"Some of these DPs are real princes of darkness," Markfield said, so a combination of fast glass like Canon's amazing 50mm f/1.0 and new, faster films like Kodak's 320 ISO Tungsten (EPJ) can produce tack-sharp pictures even under very low light.

He estimates that he shoots about ten rolls of film each day of production. On a three-month job such as the current one, that can translate into nearly a thousand rolls of film, each frame carefully catalogued and numbered by the special custom labs that cater to the film industry. He'll ship film regularly during production to make sure his equipment is working properly.

By the way, think directors mind having a photographer nearby clicking away with a motor drive when the film cameras are rolling? You bet they do. So Markfield uses one of three soundproof "blimp" housings whenever he is shooting during actual filming. Custom made for his T-90s and A-1s by Jacobsen Photographic Instruments in Los Angeles, these blimps cost upwards of a thousand dollars apiece and, as far as Markfield is concerned, they are worth every dime.

Fred Maroon Captures the Capitol

12/17/93

It is the most accessible government building in the world, many believe, and certainly among the most beautiful. It's domed design was first envisioned by George Washington at a time when there were no domed buildings anywhere in the young United States. As writer Suzy Maroon notes in the text that accompanies her husband Fred's monumental and beautiful profile of the U.S. Capitol Building: "Among the majestic buildings and recognized landmarks of the world, it would be hard to find one that had a less auspicious beginning. . . .

"A competition was held for its design, and the winning entry was the work of an amateur who sent in his design months after the competition's deadline had passed. No funds were appropriated for construction. It was to be built in a city that did not exist. And finally, in a well-intended but injudicious attempt to mollify him, the disappointed and jealous runner-up in the competition was put in charge of construction of his rival's building."

Thinking of this as I thumbed through Washington photographer Fred Maroon's latest book, *The United States Capitol* (Stewart, Tabori & Chang, $45), I also was struck by the difficulties Maroon had to overcome some two centuries later in trying to make a documentary photographic record of this great and public place. In the end, the political, jurisdictional, and just plain turf battles he had to fight in order to work in the Capitol Building were every bit as maddening and difficult as the technical hurdles he jumped every time he set up his lights, camera, and tripod.

But fourteen months of pressure, toil, and trouble have produced the most complete and beautiful photographic record ever made of the Capitol Building. Anyone who has spent time in the building will be amazed to see it reinterpreted through Maroon's architecture-trained eyes. Of course there are shots of places the public never sees: the cloakrooms, the private offices, and hideaways. But to my mind, Maroon's

Fred Maroon has covered Washington like a blanket, producing thousands of wonderful images, and a slew of award-winning books. Capturing the Capitol Building was rewarding, but it wasn't easy.

genius is most obvious in his renderings of the places we all walk through but never really see.

Part of the reason is lighting. Maroon used crates of lighting gear (mostly tungsten and quartz floodlights) to bring much of the Capitol's treasures out of the shadows. So adept was he at creating a look of natural daylight with his thousands of watts of artificial light that members of Congress occasionally found themselves asking Maroon where he had

made a particular shot—so different did the scene look from that which they raced past every day.

As Maroon explained to me over a cup of coffee at his Georgetown home, the obstacles for a professional shooter were enormous. "You saw the directive that just came down this week: You cannot photograph on the steps (of the Capitol) without special permission from the subject and a permit from the Sergeant-at-Arms."

"Obviously, it doesn't get any easier up there. They just don't have a clue what photography is all about. . . . In effect it was like trying to get a bill through Congress. All the (procedural) things were necessary. I had meetings with various committees in charge of this, that, and the other thing in the Capitol to get them on board.

"You had to stroke all over the Capitol those people you needed on your side so you could keep going forward. Everything ultimately had to be signed off in the contract," Maroon said.

Take everything you've heard about Capitol Hill being a law unto itself and double it for photography. Capitol cops seem to delight in making life difficult for the press, photographers especially. In fairness, the cops are just following orders, but as we'll see, some seem to have difficulty using the brains they were born with—not to mention manners.

Maroon's worst moment in the Capitol project probably came early one morning when he was just about to photograph the grand granite and marble staircase on the Senate wing's east side. He and his assistants had arrived before dawn, permission in hand, and had been greeted cordially by the police at the door.

"They were expecting us," Maroon said. "One of them even said, 'Which shot do you want to do first?'"

Six hours of constant work later, the lights were set up and Maroon was ready to shoot. Then a different cop, a sergeant who had just come on duty, showed up and confronted the group, according to Maroon.

"Nobody told me about this," the sergeant declared peremptorily, and ordered every light taken down.

"Look, isn't there someone we can call?" Maroon pleaded.

The police officer wouldn't budge. The lights, scaffolding, and light stands all came down, despite the official approvals Maroon had so laboriously obtained.

Amazingly, this coffee-table book of huge crisp color photography was shot entirely in 35mm (Maroon is a walking ad for Leicas—he has sworn by them for decades). Because the project required slides, Maroon shot entirely with transparency film, meaning his exposures not only had to be on the money, but correctly balanced for color temperature. Finding he often needed compensating filters to get the color just right, Maroon called on Pro Photo's Dick Baghdassarian, who fashioned a special gel holder for his Leicas.

But all the high-tech gear, pinpoint metering, and hours of setup would have meant nothing without Maroon himself behind the lens.

Wegman's Rays
of Light

10/15/93

Picture photographing a still life. Now picture photographing a still life outdoors, with the light changing constantly.

Now picture photographing a still life using a mammoth Polaroid camera that is costing you a thousand dollars a day to rent. Finally, figure all the above and factor in the fact that your still life has four legs and a wet nose: Your still life is a dog.

Welcome to William Wegman's world, an antic, gentle-spirited place that is peopled, or perhaps, puppled, by a collection of his and his friends' Weimaraners, including Fay Ray, Chundo, and Battina—sleek and elegant creatures with eyes like a Spanish martyr's and personalities liberally laced with ham.

Wegman, who is fifty this year, divides his time between his New York studio and his rustic cabin in Rangeley, Maine, where he likes to spend his summers. Two summers ago in Maine, he photographed "Little Red Riding Hood," the second in a series of children's books, published by Hyperion and continuing a method Wegman has used ever since his first Weimaraner, Man Ray, insinuated himself into Wegman's photography and became an underground legend for his amazing ability to radiate intelligence, feeling, and emotion between two floppy ears.

Wegman uses his dogs to create a photographic narrative that is at once whimsical and compelling. His latest work is a skewed retelling of classic children's tales in which the dogs assume the characters of Cinderella, Little Red Riding Hood, and all the attendant costars. By setting his pliant dogs on stools and draping them with clothing, the dogs can seem howlingly funny and lifelike.

The photographer's exhibit—*Fay's Fairy Tales: William Wegman's "Cinderella" and "Little Red Riding Hood"*—is at the Baltimore Museum of Art. When I spoke to Wegman by phone earlier this month, he had just returned from Milan, where a clothing store, of all places, had just opened

an exhibition of his work from the children's books. "But when you think about it, it's all about dressing up," Wegman said. As Wegman talked about his work from his Maine hideaway, it was clear he was not alone. Every so often one could hear the startled yelp of a Weimaraner or two, including Battina, Fay's daughter.

Then, suddenly, all hell broke loose.

"Uh-oh," Wegman said, "Someone's at the door, the dogs have heard it, I'm in my underwear, so I think I'll move to the other room."

I doubt this ever happened to David Frost when he was interviewing Nixon.

Calm restored, Wegman described how he gravitated to working with what is arguably the world's most unwieldy camera: the giant 20" x 24" custom-made Polaroid, of which only five exist. Not only does it cost $1,000 a day; each print pulled from the camera costs roughly $32. To put this into perspective, at times during the shooting of "Little Red Riding Hood," Wegman had to make more than thirty prints to get one keeper. And no, Polaroid wasn't picking up the tab.

But, Wegman said, the prints this giant camera produces can be amazing. "It really is [amazing]. And it's amazingly terrible when it's not working well. It gets your adrenaline going because it costs so much. . . . Everybody's got to pay attention."

The pressure to work against the clock is one reason some of the photography in "Little Red Riding Hood" is not the equal of that in "Cinderella." The latter was shot entirely in Wegman's New York studio, in which he was in total control of the light. But much of "Little Red" was shot outdoors, in Maine, in a two-week marathon during which it rained nearly every day. "We could get the big strobe lights pretty close to the model, but the landscapes and background sometimes went dark. That was sort of a problem," Wegman said.

Still, only a cad or a cat lover would not be charmed by the book.

In working with animals that also are your companions, there is the inevitable heartbreak that comes when a canine colleague dies. And that is what happened when Man Ray died in 1982. Wegman, who actually considers himself primarily a painter, was able to immerse himself once again in his painting after his dog's death—a kind of forced interlude that actually might have been a creative boon.

Nevertheless, finding Fay—and in her the same marvelous acting ability and desire to work that Man Ray had—started the cycle all over again.

And Fay begat Battina—as well as Chundo, who plays the Big Bad Wolf. So the line continues.

At last look, Wegman was thinking of next tackling "Rumpelstiltskin."

Frans Lanting's Okavango

01/21/94

"Here is an Africa I thought no longer existed," wrote photographer Frans Lanting when he first beheld the miracle that is Okavango.

An alternately desolate and lush delta in the heart of southern Africa in northern Botswana, Okavango "is just a thin sheet of water stretched over the Kalahari, but that layer of water covers eighty-five hundred square miles [and] astronauts looking down on the earth from outer space were captivated by its outline—an outstretched hand in the center of southern Africa, imprinted blue on the brown of the Kalahari."

It has "no mountains like Kilimanjaro looming over the land or spectacles like the congregation of a million wildebeest on the open plains of the Serengeti. What Botswana has is wildness."

It is a hefty leap of time, place, and circumstance from the African bush to a restaurant in downtown Washington, where Lanting and I meet for the first time to discuss his spectacular book, *Okavango, Africa's Last Eden* (Chronicle Books). The restaurant was chosen not so much for the food, as for the location, within a block of the *National Geographic*, where Lanting has been a regular contributor for years. A reserved man of forty-two, Lanting is a native of Rotterdam who began his career as an environmental economist but who wound up instead "a professional nomad" making his living with a camera.

People who spend so much time alone in the wild (one can't help but think of Jane Goodall) tend not to be extroverted; they are perfectly content with their own company and that of the animals. Yet Lanting's initial reserve starts to melt when I tell him his book reminds me of a musical composition, orchestrated to achieve highs and lows of texture and intensity. "In my mind I set this up as a symphony with six movements," he says with a smile. We are talking the same language after all. The rest of lunch is a breeze.

Lanting's *Okavango* succeeds spectacularly on every level. The wildlife

photography is superb—although one would expect no less from a *National Geographic* shooter. But the text, too, is first rate, reflecting Lanting's deep commitment and expertise as a naturalist as well as photographer. Then there is the physical presence of the book itself and the quality of the reproductions. Beautifully laid out and superbly printed, *Okavango* is a multilevel, multilayered feast. (And frankly, at $45, it's a steal.)

A small thing, perhaps, but one reason this book is so good is that Lanting knew well enough to get out of his Land Rover every chance he got. "In my work, I'm more a hard-core photojournalist who applies 'f/8 and be there,'" he said over his sandwich and iced tea, referring to the credo of the news photographer. "That photograph of the elephant's legs didn't just happen."

He was referring to an unusual shot of a small group of impalas thirstily drinking from a shallow pool of water. The delicate creatures take up the bottom third of the frame, but the entire rest of the picture is dominated in the foreground by the massive legs and dangling trunk of a bull elephant. The beast's huge head is out of frame, only a sharp white tusk peeking into the top of the picture. That the elephant's head cannot even fit into the picture makes him seem all the larger.

"The immediacy of the image comes from being right there," Lanting said. "Traditionally, most of wildlife photography is done from a metal box on wheels."

The results—especially when looking at the images all together—can be incredibly static, every picture made "from three to four feet off the ground," he explained.

"Some people have credited me with taking flash techniques more common in people and fashion photography and taking them into the bush," Lanting said, with both pride and justification. Two such images stand out for me. One is an eerily beautiful (and seemingly available-light) shot at dawn of two elephants standing at the edge of a watering hole. There's only enough golden light on the water to render them slightly more than silhouettes. But what makes the shot is a dove, wings splayed and totally lit, frozen between the elephants in midflight. Lanting tracked the bird with a Metz 60 strobe unit equipped with a fresnel screen to extend the range of the flash, then fired, essentially combining a background available-light shot with a foreground flash one.

The second shot is a wide-angle photo of a female ostrich sitting atop her eggs, the night sky ablaze behind her. She is lit by a warm-gelled softbox, and the effect is dramatic in the extreme.

"I approached her with great caution," Lanting said, "remembering the story of an ostrich slicing the belly of a hyena with one kick of its powerful clawed feet. My stomach never left the ground."

Neil Selkirk: Seeing and Shooting by Instinct

04/29/94

About a dozen years ago, a British-born photographer one year my junior taught a master class at the Maine Photographic Workshops and changed how I work, how I photograph, how I see.

Not bad for what was billed innocently enough as a course in location lighting.

But Neil Selkirk is nothing if not insidious. His open, guileless nature masks a prodigious talent and a drive to make pictures that trigger in us deep, almost primal, emotions.

Like Diane Arbus, under whom he studied, and Richard Avedon, whose work he reveres, Selkirk, forty-six, is above all a portraitist/observer. I place him, along with Avedon and Irving Penn, among the finest photographic portraitists working today.

Selkirk's approach to environmental portraiture is both simple and complicated. Given the time, he can devote hours studying and preparing his subject's environment. He is not averse to altering or cleaning up the background to highlight the person or persons he photographs. He will concentrate intently on perfecting the lighting and mood he wants to use and create. But when the subject shows up, Selkirk will do almost nothing except make the picture.

"The way they are is the way they should be rendered," he told me recently by phone from New York, where he lives and works. "To prepare [the subject] in any way is to sully the process."

This pristine approach to portraiture—and respect for what the subject brings, intentionally or not, to the final image—is in marked contrast to the work of other, better known, photographers like Annie Leibovitz, Herb Ritts, or Bruce Weber. These superstar stylists regularly go to great lengths to create unusual or bizarre environments in which to place their subjects and have them perform before the lens.

By contrast, a Selkirk portrait almost never looks mannered or pre-

The magazine assignment was to think "concealment" and New York photographer Neil Selkirk used his large bag of lighting tricks to make this striking portrait of director Robert Altman. The band of light across Altman's eyes is from a flash that was aimed into the car's rearview mirror, angled to reflect light onto the director's face. © Neil Selkirk

cious. Often his portraits look as if they just happened, as if this fortunate photographer simply encountered his subject doing something telling and happened to have a loaded Hasselblad in his hands. If not strict objectivity, then certainly spontaneity informs his work. That, and the belief that what makes a picture successful as much as the image itself are the emotions the image evokes in the viewer.

"The process of looking is more akin to smelling or tasting than it is to reading," Selkirk wrote recently, in commenting upon Avedon's work. "One's response is immediate and instinctual, more like a reflex which disposes with the conscious brain as being too cluttered and lacking in spontaneity.

"Thinking actually limits our ability to enjoy photographs, which derive their power from their ability to penetrate directly to the uncon-

scious. Down there in the unreachable, the images stimulate memory and make connections, which then pop forward into the conscious mind where they become accessible to you and me."

To illustrate, consider one of Selkirk's portraits, contained in his proposed book, *See No Evil.* It is a black-and-white portrait of the filmmaker Robert Altman. When assigned the portrait for a now-defunct magazine, Selkirk was told to think of the idea of "concealment." That one-word direction prompted Selkirk to place Altman behind the wheel of a car as dusk fell and have him simply look into the camera from the open driver's window.

Altman's round, whiskered face is in shadow, his head covered by a cap. But Selkirk angled the rearview mirror to throw light from a small strobe unit into Altman's eyes, creating a rectangular band of light—a reverse raccoon mask—that highlights the director's intense stare looming out of the darkness. To add to the effect, Selkirk shot handheld at a slow shutter speed, creating a barely perceptible blur over everything but Altman's flash-frozen stare.

All of which is not to say Selkirk hasn't done his share of workmanlike corporate or executive portraits and competent, though ultimately forgettable, annual report pictures, making factories look pretty. (One does, after all, have to make a living.) In fairness, though, to watch Selkirk create a mood where none exists is to watch a lighting wizard at work. I'll never forget during our class how he turned a harbor-side bar bathed in harsh, glaring morning light from picture windows on three sides into an intimate nighttime tableau, all apparently lit by candlelight.

But for his serious work, which is almost always in black-and-white and which invariably involves people, Selkirk said, "I think the only thing I prepare is everything except the subject."

And he prefers to work within "the limitations imposed by refusing to go any significant distance" to change the person being photographed.

Once, as he and his wife Susan viewed an exhibition of portraits by a world-renowned photographer, each was struck by the seeming artificiality of each pose. Something was missing in every image.

"Susan said it best," Selkirk declared. " 'If you tell 'em to move, you've missed the point.'"

Jeffrey Kliman's Blues in Black-and-White

09/27/96

Spend a few minutes with Jeffrey Kliman, a lanky, hyperactive Baltimorean and, even without seeing any of his work, you'll know he photographs jazz musicians.

For one thing, he talks in riffs, not sentences. For another, nobody with his kinetic temperament could shoot large-format landscapes of limpid streams and snowy mountains on a quiet morning.

He doesn't get up that early.

The smoky, funky world of jazz is Kliman's milieu, the 35mm camera his horn. In the middle of a crowded opening of his riveting jazz photographs, at Georgetown's Govinda Gallery, Kliman talked about his work and let loose a few—but by no means all—of his secrets for photographing musicians at work.

"You're not there as one big lens," he said. "You've got to respect the musicians, and the audience, so you can get invited back."

Photographing musicians in performance—be it in a tiny jazz club or a huge rock concert—is more than packing a camera and a long lens. Often, the most important work is done before the show, getting permission from the club, the artists' record label—even from the performers themselves—so that you can work unhindered and not find yourself out on the street, courtesy of a bouncer the size of a vending machine.

Jim Saah, a Washington-based documentary and editorial shooter, notes that in the Washington area's smaller rock clubs, permission to photograph often is left up to the band members themselves—and many bands on their way up are surprisingly amenable to photographers, even amateurs, provided they are discreet and don't draw attention to themselves.

"At some places, like the 9:30 club," Saah noted, "the club's policy is they don't care—it depends on what the band thinks."

Like Kliman, Saah loves to work in black-and-white, though for his

editorial assignments, he often has to shoot color. In that case, he relies on Fuji's great NHG 800 color negative film. "It has tremendous latitude," Saah said, adding that the film's T-grain structure (of the type found on such fine-grain black-and-white films as T-Max 100) renders images so tight you'd swear they were shot on 400 film.

Saah used to use T-Max 400 but now has switched back to the old workhorse Tri-X for his black-and-white shooting. When he does have to push the film, he never goes above 1600.

By contrast, Kliman loves T-Max 400 and hates to push the film anywhere it doesn't want to go. To capture detail and depth, he relies on Nikon's SB-24 flash units, set to the TTL (through-the-lens) mode, to provide just enough fill-in flash to render detail while riding the dramatic ambient light onstage. Kliman's photographs, virtually all shot in 35mm, have the immediacy of news photos, but news photos with soul and wit. At Govinda—where he shares the walls with the vintage, large-format jazz work of Herman Leonard—there is an arresting shot called "Audition" that captures the angst of three female singers showcasing their talent. On the left side of what seems to be a panoramic image are two of the women, their backs to the camera looking out the kitchen doors toward the stage where the third singer is performing. The right side of the frame shows the dark, smoky club, the singer at the mike.

But look closer and you see a black line dividing the image. It's actually two frames printed exactly as they appeared on the film. "I took the first picture in the kitchen and I didn't care much for it—it didn't tell the whole story," Kliman related, pointing to the framed image. "I remember walking through the kitchen door, into the club, saying, 'Excuse me, ladies,' and making the next shot in the club. But that picture wasn't great either—the right side of the frame was too dark.

"Then when I saw the two frames together, I said to myself, 'That's real time, just the way it happened,' and I had it printed that way."

If Kliman had one bit of advice to give a novice shooting musicians it would be: "Know the damn music!"

"Learn something about it beforehand, know the phrasing." Then, typically, he started humming a popular song, pausing at the end of each phrase. "Flash!" he said.

Then through another phrase. "Flash!" again.

"Most artists know what you're gonna do and will let you do it," Kliman said.

But, as the song says, it ain't what you do, it's how you do it.

Bruce Davidson and the Inner Portrait

In one sense, Bruce Davidson's 1964 portrait of playwright Samuel Beckett is a snapshot. It was, after all, taken on the spur of the moment, with a small 35mm camera, and without the use of flash or studio lights. The subject barely knew the photographer was there.

Then why does the image rivet us? What is there about this available light photo that compels our attention?

The answer is that this is not a snapshot. The answer is that this image incorporates the important elements of emotion and gesture to become not just a picture, but a photograph; not just a photograph, but a portrait.

"Within the matrix of life is always a moment that reveals," Davidson told me last week as we stood surrounded by more than a dozen of his framed "intimate portraits" now on display in the Chevy Chase studio of photography dealer Sandra Berler.

That concept, I believe, defines successful portraiture. No matter how technically flawless a portrait may be, if it lacks emotion it is hollow.

Davidson, whose color and black-and-white work has been acclaimed for decades, follows in the footsteps of the greatest photojournalist of his era, Henri Cartier-Bresson, who himself spoke eloquently of the "decisive moment" when all elements of composition, gesture, and emotion come together in a photograph to create a perfect artistic balance.

To create such work requires, besides technical skill, a willingness to submerge oneself to the image—as well as being ready to shoot quickly. For this kind of work it helps to have spent time covering news, which Davidson did for years, for the famed picture agency, Magnum.

I must confess my bias here. To me, there is a huge difference in emotional impact between the manufactured feelings of a professional model, trying to achieve a look of ironic detachment for the photographer, and a subject photographed during a moment of genuine feeling or intensity. (Why I prefer Richard Avedon's portraiture to his fashion work.)

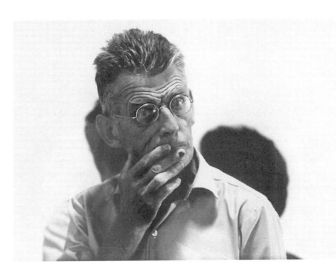

Davidson's early work was shot almost exclusively by available light with Leicas, and on Kodak's black-and-white workhorse film, Tri-X. (Davidson still swears by Tri-X today, though he tends to use square- and rectangular-image medium-format cameras, along with studio lights, when shooting his "conceptual," or more formal, portraits.)

On a technical level, it is interesting to note that in many of Davidson's portraits his subjects do not look directly into the camera. (Note: Beckett may be looking straight ahead, but in fact he is looking through, not at, the photographer. The acclaimed existential playwright, Davidson notes, is locked "in the privacy of his innermost thoughts" during rehearsals for *Waiting for Godot.*)

A later portrait, of scientist Linus Pauling in his research office, also shows the subject looking away. Much more animated than Beckett, both men nonetheless seem to be caught in a moment of intellectual ferment, the emotion of which helps make each portrait so successful.

Davidson also makes masterly use of a subject's environment, be it the clutter of a scientist's desk, or, as in Beckett's case, the austerity of a rehearsal hall in which the two shadowy figures behind him could represent *Godot*'s enigmatic players, Didi and Estragon. Likewise, a remarkable 1959 portrait of conductor Leonard Bernstein in a recording studio is made from a great height almost directly above the subject, as Bernstein lifts his arms ecstatically to conduct. Bernstein is off to the side, and dominating the frame are a series of undulating black lines on the studio's parquet floor that seem to personify the music Bernstein is conducting. Of course they are merely electrical cords, but, when combined with the look on Bernstein's face, the effect is magical. "My search is for an inner moment revealed in an expression, gesture, or attitude that gives insight into the persona," Davidson once wrote. "My portraits are as much an image of myself as they are of the subjects I photograph. Photography is the way I learn to see, sense, and reflect on the world."

David Burnett: Working Against the Crowd

07/31/98

Look at this image and marvel at how many things are happening—at how many elements are coming together precisely at the instant that photographer David Burnett releases the shutter of his Mamiya 7 on a crisp spring day at the 1996 Penn Relays.

Start with the sky. It creates a beautiful, intense backdrop to the action. A gray, washed out sky would have lessened the picture's intensity; a cloud-dappled one would have competed with the subject.

The 43mm wide-angle lens that Burnett uses for the shot causes perpendicular lines to converge dramatically so that they seem to lead the viewer directly to the athlete suspended so beautifully in midair. The officials gazing upward lead us to the athlete as well.

Then there is the athlete himself—frozen by the shutter, body tensed, yet seemingly relaxed. The young man is comfortable with his jump—and looks to be enjoying the ride down to the mat. And so we enjoy it, too.

Hell, even the pole cooperates by not falling across the plane of the athlete's body as the image is being made.

Boy, is this a great shot! It easily is one of the finest sports photographs I've ever seen.

I've been a fan of Dave Burnett's since we first met more than twenty-five years ago as we covered Washington—he with his cameras, me with my pen and notebook.

I'll bet you know his work, too, so ubiquitous has it been during this soon-to-be-fifty-two-year-old shooter's award-winning career. Perhaps his best-known sports image—and one that illustrates his penchant for breaking from the pack even at such photographic circuses as the Olympics—is his heartbreaking shot of distance runner Mary Decker, on the ground grimacing in anger and pain after tangling with rival Zola Budd during the 3,000-meter finals at the 1984 summer games in Los Angeles. The image has rightfully become a sports icon. Burnett was in the

Every element works in David Burnett's striking image of a pole-vaulter at the Penn Relays. Burnett is known for working outside the box and for trying new and creative ways to add punch to his pictures. (© David Burnett/Contact Press Images)

right place for it because he chose not to be with his fellow shooters near the finish line, but rather, stationed in the infield.

"I'm not really a sports photographer," Burnett told me recently, though many would disagree. In fact, Burnett has photographed news all over the world and has won awards from such prestigious outfits as the White House News Photographers Association and the American Society of Media Photographers.

"I had the good luck to be right where Mary Decker fell," he noted. "In pursuit of these pictures, I got so tired of being part of the pack." It was typical at each major Olympic event, he explained, for there to be as many as seventy-five photographers on the field—with several hundred cameras among them—motor-driving through so much Fujichrome and Ektachrome that it was difficult to hear. The experience taught Burnett something—about pulling back and slowing down. Lessons we all might heed.

Though much of his editorial news and sports shooting is done in 35mm color, handled through the Contact Press Images agency that he cofounded in 1976, it is clear that one of Burnett's favorite things is to shoot in medium-format black-and-white, most often with a Mamiya 7 or 645 camera, using the photojournalist's friend, Kodak Tri-X film.

His decision to work like this, he said, "really was a rebellion against longer lenses, faster films [and] in your face, in your face, in your face photography.

"Look at the pictures that were made in the 1930s and 1940s," Burnett declared. "You'll see some fabulous [work]." Back then, photographers working with bulky Speed Graphic cameras—basically hand-held view cameras—"had four seconds a frame [in which] to shoot; [they weren't shooting at] four frames a second." And virtually all worked in black-and-white, since there were no fast color films back then that could stop the action of breaking news or sports.

That more deliberate—and monochromatic—style appealed to Burnett, who once said of his work, "my photographs are usually pretty quiet. I hope that they have a subtlety or some second level to them that makes more than just a passing glance worthwhile. . . . The best pictures are those that happen naturally, without my influence."

On a practical level, Burnett notes that some sports, like baseball, do not lend themselves to medium-format photography—at least how he uses it. His preference appears to be track and field, as seen in a beautiful monograph of Burnett's work, *E-Motion/Grace and Poetry: The Spirit of the Sport*, published in Italy in 1996 as a catalog to an exhibition of his work in Milan last year. (Copies of *E-Motion* can be ordered through Contact Press Images, 116 East 27th St., New York, NY 10016. The cost is $25 and includes shipping.)

If, as David says, his photographs are "pretty quiet," they are at the same time equally eloquent. Looking at Burnett's work—and I often can tell it is his work before I see his credit line—I'm reminded of a really fine jazz musician, whose phrasing seems deceptively effortless, but in reality is the product of great talent, long experience, and exquisite taste.

Hell in a Viewfinder: Kosovo

09/08/00

Three weeks into his first assignment in Kosovo, Danish photojournalist Claus Bjorn Larsen was arrested and all of his film was confiscated.

"You could really feel the hate from the Serbian people," the thirty-six-year-old photographer said.

The initial setback didn't discourage him, though the devastation visited upon each side in the long conflict did.

"The Serbs only liked to have their story's side [told]," Larsen went on. "I was pro-Albanian. But then I saw what the Albanians [eventually] did to the Serbs, so I ended up being neutral."

At thirty-six, Larsen is a wiry young man with a round, open face. He exudes a kind of caring nonchalance that can typify a great war photographer. In this kind of work, cynicism is a hindrance, though skepticism helps, especially when hearing one side's one-sided version of what has happened or is about to happen next.

It may not fit the popular conception of a war correspondent, but empathy carries far more weight that a Hemingwayesque bravado. It creates a bond with your subjects that often produces trenchant, feeling quotes and sensitive, even beautiful, pictures in the middle of hell.

"Normally, children are really happy people," Larsen observed, looking at one of his prints of a desolate child, and mindful of his own little girl back home in Denmark. "But not here." In Kosovo, as in so many other war and famine zones, truth often is the first casualty, but the second casualty too often is childhood.

Larsen has been to Kosovo several times and is fortunate to work for Copenhagen's *Berlingske Tidende* newspaper. His mandate never was to try to cover spot news, in the manner of the wire services like the Associated Press and Reuters. Rather, his paper let him wander, without a writer in tow, and send back images that he felt were emblematic of the

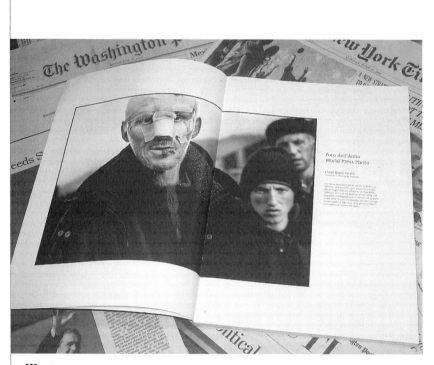

Working unobtrusively by available light with two battered Leicas, Danish photojournalist Claus Bjorn Larsen captured the horror of Kosovo, including this award-winning image that was seen around the world. © Claus Bjorn Larsen

conflict. These images were interspersed with the paper's other Kosovo coverage.

He worked almost exclusively in black-and-white and, wonder of wonders, his paper not only ran his stuff prominently, they printed it full frame, even including his black frame edges.

Such respect for his work gave him spectacular display and, combined with the first rate quality of his images, grabbed the world's attention. Last year, Claus walked off with some of international photojournalism's most prestigious awards, including the Visa D'Or from the annual Photography enclave in Perpignan, France, not to mention the World Press Photo "Photo of the Year" award for 2000.

The latter award, one of the most sought after in camera journalism, is one of which Larsen is especially proud. His photograph, of a wounded Kosovar Albanian refugee, his head swathed in bandages, his eyes fixed in a thousand-mile stare, was among 44,000 entries submitted by shooters around the world. "I tried to talk to him," Claus recalled of the day he made the picture, in April of 1999, "[but] he was in kind of a trance. I could see that he had very strong eyes."

"I took four or five frames, and then he just disappeared."

Given his own working methods, it is likely that Larsen himself is an equally fleeting presence.

He works only by available light, and almost always in black-and-white. His preferred camera is the Leica rangefinder, for its incredible optics and legendary durability. One of his favorite lenses is the 35mm f/1.4 Summilux, a pricey piece of glass that can damn near see in the dark. In the field, he most often works with only two lenses, a 24mm and a 50mm.

He is wedded to his Leica rangefinder, saying it allows him to work with both eyes open and to know immediately if he has nailed a shot (as opposed to enduring the split-second blackout we've all come to accept in SLR photography). To illustrate this, he pointed to another of his pictures, of a frantic breadline, dominated by a huge hand coming into the right of the frame.

"With the rangefinder, and with my eyes open, I could see the hand coming and knew exactly when to take the picture." There's another thing that Larsen did not mention, but which struck me because of the intimacy of his pictures. Working with a rangefinder camera forces you to get close to your subjects. (For example, the longest lens the Leica RF can take is a 135mm telephoto.) And getting up close to one's subject is a heck of a lot easier if your camera does not sound like a howitzer (the near-silent click of the Leica's shutter is legendary) and if you are not motor-driving your way through a series of flash pictures going off in your subject's face.

In fact, the more I spoke to Larsen, the more I admired his technique. A working photojournalist, he might be expected to travel the world lugging the latest in digital gear. But he says he will always use film because of the quality of image it delivers. (His favorite black-and-white? Kodak's great chromogenic T400CN.)

In Kosovo, he tended to shoot from the early morning until around 10:00 A.M.; then on most days from late afternoon till early evening. In between he would process his film, often having to filter the water he used to guard against impurities. Then the modern electronic world would take over. He would scan his negatives into his laptop, tweak the images in Photoshop (the equivalent of dodging and burning-in in the darkroom), and then transmit his stuff to Denmark. In most cases, Larsen didn't see real prints of his work till he got home. He tries hard not to look too much like a journalist, another reason he loves his Leicas. They are so small and unintimidating, he says, that people tend to forget about him.

Until they see his pictures.

Sheila Metzner's Platinum New York

12/15/00

Combine a love and a passion for a place with the peculiar properties of Polaroid PolaPan. Add to that the depth and patina of a platinum print, and you have—in addition to alliterative overload—the magic that photographer Sheila Metzner has achieved in her glorious new work, *New York City 2000*.

The large 22" × 18" platinum prints of New York landmarks that held me in their grip at the elegant John Stevenson Gallery in Manhattan, actually are a collaboration: between photographer Metzner and master platinum printer John Marcy of Florence, Massachusetts. The unlikely juxtaposition of techniques—using Polaroid's 35mm PolaPan instant positive slide film (which Metzner rightly calls as delicate as "butterfly wings") with the long and painstaking process of platinum printing, seems at first bizarre, even unnatural. But the results are some of the richest, deepest, most compelling platinum images I have ever seen.

Metzner concedes that she had reservations about following in the photographic footsteps of legends like Abbott, Bourke-White, and Stieglitz. But during what turned into a frenzied one-month personal project, she found that the buildings and bridges of her city had "a life of their own."

"From the very first bridge," Metzner said in a phone interview from Manhattan, "I was translating it in the camera. What I was going to get was not what I saw." Which, of course, explains how Metzner was able to make new all over again photography of such oft-shot sites as the Empire State Building, the Brooklyn Bridge, and the Chrysler Building, among others.

In one nighttime image the Empire State Building appears bathed in a smokelike umbra; in another, late-afternoon light rakes the building's front, creating brilliant linear highlights. "This is my New York. It glows," Metzner exulted in the program notes for her opening at the Stevenson Gallery last September. "I own the Brooklyn Bridge and the George

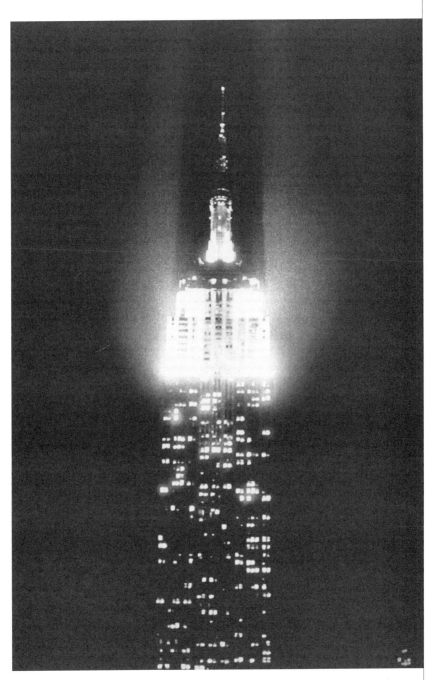

Empire State Building looks almost ablaze in Sheila Metzner's gorgeous platinum print, made from an original PolaPan 35mm slide. (© Sheila Metzner/Courtesy John Stevenson Gallery, NYC)

Washington Bridge," she declared. Then she added, lest anyone think she were getting too full of herself: "Ask my kids . . . They've been told that for years. Of course I pay my toll on the G.W. 'I don't want to make an issue of my ownership.' I prefer to remain 'invisible.'"

To call Metzner a woman of many parts is to understate. At sixty-one, she has mastered several careers, not least of which includes raising five children while climbing first the corporate advertising and then the commercial/fine art photography ladder. In fact, Metzner's biography has a kind of fairy-tale quality to it. When one of her early photographs caught the eye of the legendary curator John Szarkowski at the Museum of Modern Art, he included it in the landmark exhibition, *Mirrors and Windows: American Photography since 1960*. But if that weren't enough good luck for a relatively unknown shooter, the *New York Times* gave her photo full-page display in its *Sunday Magazine*. Later that year, Metzner's first solo show at the Daniel Wolf Gallery drew record crowds—and *that* show got another huge publicity hit, again in the good gray *Times*.

From there, her career flourished—aided, of course, by the fact that she was very, very good: a photographer who could shoot for the long haul, not a trendy one-shot wonder. Her commercial work has included fashion, editorial, advertising, book, and CD covers—even special assignment shooting for films. She also has directed television commercials and produced and directed her own short film on the artist Man Ray.

As I said: many parts.

But in the fine art world—and later, to a certain extent, in the advertising world—Metzner is best known for her beautifully composed, painterly color images, including still lifes, nudes, and others, produced for her by the Fresson family outside of Paris. The family's prints, which are named after them, are true pigment prints; made in a time-consuming four-color "process de charbon" that gives a pointillist quality to the finished product that wonderfully complements Metzner's vision.

These prints also are said to be the only truly archival color prints in the world.

Which may help explain why, for her black-and-white New York Project, Metzner was drawn to platinum prints, which John Stevenson calls "the most archival of any image(s) made on paper." In addition, platinum prints offer the viewer such a hugely expanded tonal range from black to white, compared to conventional silver prints, that the images literally seem three-dimensional because of their incredible depth and range. To best achieve this, Metzner chose to work in PolaPan—a quirky film at best, whose archival permanence is anyone's guess. It only comes in 35mm. You have to bracket exposures like crazy. And to process it requires a separate apparatus that looks like an old Kodak Day-Load film tank—all clicks and whirls and turnings of gears. But the end product, if all goes right, is a 35mm strip of thirty-six extremely delicate positive slides that offer up their own peculiarly beautiful tonal range. And so it went for a month.

Once the pictures were made and chosen, it fell to John Marcy to do his own magic. In an interview, Marcy reiterated the costly and time-consuming process. He noted that his rejection rate is roughly one third. (Note: that means one out of three of his prints is bad; most other platinum printers probably would be happy if one out of *ten* of their prints were *good*.)

Platinum printing is a contact printing process—i.e., negative in direct contact with sensitized paper, then subjected to ultraviolet light, and finally a chemical bath to bring up the image. But Metzner's original PolaPan images not only were tiny (35mm), they were positives. To create a 22" × 18" negative for contact printing, Marcy projected the PolaPan image onto a large sheet of continuous tone film in the darkroom, developed that film conventionally, then used the resulting negative to create a platinum print on 100 percent rag watercolor paper.

Described this way, the process inevitably loses some of its mystery. But as Metzner once said, "Photography [itself] in its most basic form is magic. . . . This image, caught in my trap, my box of darkness, can live. It is eternal, immortal." It is . . . magic.

SECTION IX

Photographic Memories

In the Family,
in the Frame

A few weeks ago, my cousin Eleanor hosted all of us once again at her home in Neptune, New Jersey, for what has come to be known in our family as Eating for Dollars or Operation Mangia.

This is the Italian side of my family, which means that Easter is observed by serving lasagne, accompanied by healthy helpings of meatballs, sausage, and rolled beef, washed down with lots of red wine and accompanied by appropriately loud conversation and laughter.

I don't know what impulse made me bring all my portrait gear up to New Jersey last Easter to make a family photograph immediately after dinner, when everyone was filled to bursting and contentedly lounging in Eleanor and George's newspaper-strewn living room.

Whatever the impulse, I'm glad I followed it, because this year, only a few months before Easter, my cousin Rose—Eleanor's sister—passed away, and the portrait would not have been the same without Rosie's smiling face. By the time Judy and I arrived this year, the family picture had been framed and hung on the wall, the moment frozen in time, the image captured forever.

We forget sometimes how powerful a tool a camera can be, or how important it is to record people and events important to us, and not to put off making a picture that one day we will cherish, lest we bitterly regret a lost opportunity. I remember several years ago making a portrait of my father during one of his trips from the Bronx to visit Judy and me in the years after my mother died. "Pop, come here," I said, "I want to test this new piece of equipment." It was a new softbox for my studio strobes, and I had my father stand against a gray wall as I adjusted the light and set up my Hasselblad. He wore one of his favorite checked flannel shirts and stood patiently with a bemused expression on his angular face as his son fiddled with different exposures and made the picture.

I didn't know it then, but it was the last portrait I ever would make of

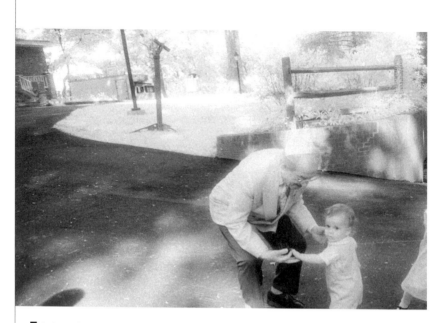

This beautiful picture of a grandfather dancing with his two grandchildren became a precious memento to the family after he died. © Judith Goodman

him. And when Pop died just a few years later, it was that image—a framed 11" × 14" portrait—that stood next to his closed coffin at the funeral home, a final tribute from his only son.

The camera, as much as the pen, the tape recorder, movie film, or the VCR, helps keep memories alive. Each time we press a shutter release we do the impossible—we stop time and capture something precious.

I'll never forget the photographs Judy made at a wedding a few years ago. In one shot, the bride's father is bending over, grasping the hands of his grandchildren, as they do an impromptu dance in the beautiful long shadows of late afternoon. In another shot the bride impulsively kisses her father on the cheek, as his eyes close in what could be joy or surprise.

When he died unexpectedly a few weeks later, those photographs, beautiful as they were, became even more precious to the bride and her family.

But remember: Timely pictures can be made anytime. In fact, that's the idea. Sure, we all take snapshots at important milestones: births, graduations, weddings. But the brick and mortar of everyday life is also the brick and mortar of memory. A suggestion: Think of the routine you and your wife or husband—or you and your best friend or coworkers—engage in every day. It might be making the morning coffee, gathering for the daily business conference—even putting out the trash at night. It may seem odd, even silly, to photograph these mundane events, but one day, when everything has changed, these snapshots will take on new life and meaning.

Such is the power of photography. Use it. Now.

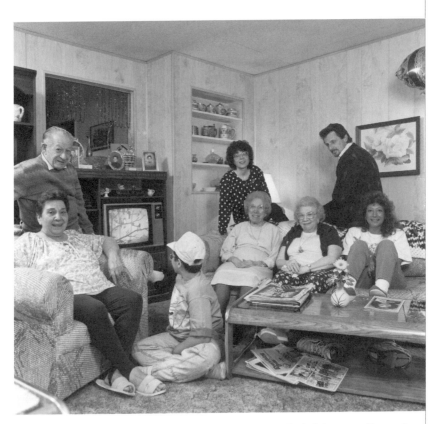

My Italian cousins after our annual Easter feast. When my cousin Rosie (left, on couch) passed away later that year, I was grateful I had brought along my camera and lights. © Frank Van Riper

War Photographer's Poignant Legacy

07/16/93

They were young once, caught up in the war we lost, or at least didn't win. And now, moving into middle age, the veterans stared at the pictures on the wall and could not let go. They stared, left the gallery, then came back to stare again.

When they finished looking at these images, of anonymous young men as they struggled to survive in Vietnam, many of the veterans sought out Kay Hawley and hugged her.

"Thank you for letting people know we were there, and that we're still here," the vets told Hawley, coordinator of the Schmucker Gallery at Gettysburg College in Pennsylvania, a ninety-minute drive from Washington. It has been that way ever since a small but emotionally charged exhibit of photographs opened there in June, made by a young combat photographer—and Gettysburg graduate—who was killed in action just weeks before he was to be rotated home and who willed his photographs and diaries to his alma mater.

If photography has the power to expose, to hurt, to sensationalize and to slant, it also has the power to heal, as these forty-odd photographs by the late Stephen H. Warner attest. They are not all great images—at age twenty-five Warner had not yet become a great photographer. But many of his photographs nonetheless have power and a poignant timelessness:

A young G.I., a shy smile on his face, engrossed in a letter from home, a can of beer at his feet. Another G.I., standing alone with his rifle in a ruined forest of burnt and broken trees, his eyes wide in the "thousand-mile stare" that marked those who had been in-country the longest. A group of soldiers, all painfully young, posing in front of the open hatch of a chopper. The picture is slightly out of focus, the print quality poor, but I can't forget it because it mirrors the attitude and gesture of other men, in other wars: that poignant mix of anxiety and bravado one sees in wartime photos from the Civil War to Sarajevo.

The late Stephen Warner had not yet become a great war photographer, but he was on his way to becoming one when he was killed in Vietnam, doing what he loved. The delight of a young G.I., reading a letter from home, is one of Warner's many photographic legacies. (GI pic: Estate of Stephen H. Warner/Special Collections, Gettysburg College Library)

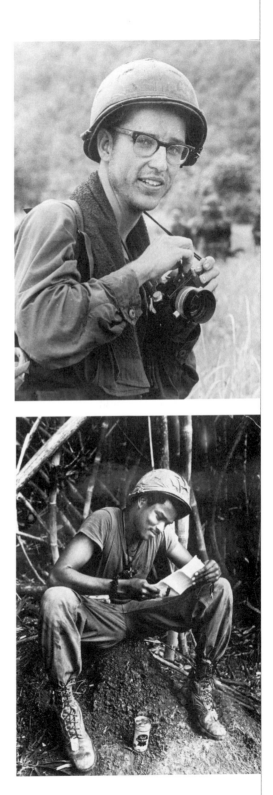

Stephen H. Warner: Words and Pictures From the Vietnam War, began as a classroom assignment, an exercise in "visual arts resource management," taught by gallery director Norman Annis to a handful of Gettysburg students. It grew into the first fine art exhibition at Gettysburg College organized with student involvement. The kids who helped mount this show were not even born when Warner was killed in an ambush near the Laotian border in 1971. To people like Maggie Slade, a twenty-one-year-old junior and codirector of the exhibition, Vietnam "was just something we read about in history books." But by the time she and her fellow students had finished wading through a quarter of the four thousand images Warner had made, and read his diaries and journals, they felt they knew him.

It is not my job to review this show. I want only to report on the effect it is having, and on the way it has brought closure to many of the veterans who have stared at Warner's pictures.

Shortly before the exhibition opened, David Hedrick, special collections librarian at Gettysburg and himself a Vietnam veteran, got a phone call. "I was Stephen's commanding officer," said the voice on the other end of the line. Living in the area, the man, a retired Army colonel, said he had read about the show in the local paper. The man told Hedrick how he had tried to dissuade Warner from making still another trip to the front, since it was policy for short-timers in the colonel's public relations unit to stay safely behind at Long Binh. "If I order you not to go, are you going anyway?" the colonel said he had asked Warner.

"I don't want to make promises I can't keep," the young photographer replied. And the colonel relented. He has carried the pain of Warner's death with him for more than two decades.

When the show opened, the colonel was there, reluctant at first to talk about his experience. But the presence of other veterans, who had their own stories of loss and anguish, made it easier for the man to accept what had happened, and to accept that Warner was doing what he loved when he died, following in the footsteps of men like the late Ernie Pyle, the great World War II correspondent, who had died covering what he called "the little soldier—the forgotten man."

"How in hell can you write about something like this without participating?" Warner had written his parents. "You can't."

On Feb. 8, 1971, he wrote: "I just happened to be up along the DMZ when this big push west began last week, and being bored I decided to go along for the ride. . . . Don't worry about me. I'm having a ball and believe it or not, the stuff I'm involved in isn't really that dangerous."

Six days later Warner was killed in action.

Unburied Treasure: UMBC's Amazing Photo Archive

06/18/93

No matter how beautifully it is made, a reproduction simply cannot compare with the original work of art.

In painting, this means being able to see and appreciate Van Gogh's frenzied brushwork, or marveling with our own eyes at what Rembrandt created with light and dark.

I remember spending the better part of an afternoon at the Van Gogh Museum in Amsterdam viewing his masterpieces with my glasses off, the better to view them close up.

On another trip, to Florence, nothing I had seen in art books or museum catalogs prepared me for what I saw as I walked down the main gallery of the Academy of Fine Arts to confront Michelangelo's magnificent *David* for the first time.

There is something about the physical presence of a work of art that increases our awareness of what the artist was about when he or she created it. This is true even in photography, as I discovered just a few weeks ago, not in Amsterdam or Florence, but in Catonsville, Maryland.

The Albin O. Kuhn Library and Gallery at the University of Maryland, Baltimore County, is one of the finest and most accessible repositories of fine art photography in the country, if not the world—and one of the least known to the general public. Where other institutions limit access to their collections to serious scholars and researchers, often requiring advance reservations and letters of reference, the Kuhn Library allows anyone, from the scholarly researcher to the merely curious, to peruse its treasures during library hours.

All that is required is curiosity, care—and white cotton gloves.

"Most museums have much stricter procedures for researchers to follow, and the reasons vary from institution to institution," noted Tom Beck, the Kuhn's curator of photography and the man who helped build the UMBC collection into a world-class archive. "One of the reasons [for their

limited public access] is that they are not set up for public service. But we are a library. It's what we are set up to do."

And how. Picture this: There I sat in the library's well lit and temperature-controlled research room, poring over a printout of the library's holdings with the relish of a five-year-old scanning a dessert menu. When I was done, librarian John Beck (no relation to Tom) literally took my order.

"How about some Diane Arbus, Harry Callahan, and James Vander Zee?" I asked, hoping not to seem too greedy.

"No problem," John laughed. "I'm used to it. I used to be a bartender."

Within minutes, John arrived with portfolios of these great photographers. And that's when the magic happened.

These were not limited-edition lithographs, or prints under glass. These were the real thing: original photographs, either personally made by the photographer or, as in the Arbus portfolio, printed by my friend and former teacher Neil Selkirk, with the permission of the late photographer's estate.

And I was holding them all in my own two (cotton-gloved) hands, peering intently at them for as long as I liked, comparing them, learning from them.

One of the best ways to learn the photographer's craft is simply to look at great photographs, and I really believe the effect is multiplied when you are able to look closely at original work. Of course, there is no field of brushstrokes to wander through. But looking at an original photograph is the same as gathering written primary source material. In one sense, it is as if you are talking to the photographer directly, without the filter of an interpreter, journalist, biographer, or printer. You can learn volumes about the artist's printing technique and use of light and shadow. You can see better than in any reproduction how he or she chose to compose a photograph or use a particular paper, or dodge or burn in certain areas of the print. Perhaps because I had assumed that masterfully done reproductions of photographs were virtually identical to the original, I was even more surprised to see how much more "information" was contained in the originals. The experience was simply overwhelming.

A dapper man with a neatly trimmed beard and a scholar's intensity, Tom Beck noted that since 1974, when UMBC made a conscious decision to establish a photography collection, the library has amassed "about a million and a half photographs." To put this in perspective, consider that the famed George Eastman House collection in Rochester has roughly a third as many cataloged photographs. In fairness, Beck said that size alone does not make a collection great. The National Gallery, he noted, has a considerably smaller collection as well, but a much "deeper" one in terms of its holdings of works by individual giants like Alfred Stieglitz, Ansel Adams, and Robert Frank.

Still, to anyone who takes this art form seriously, the UMBC collection is a local treasure that deserves our appreciation and support. They even supply the white cotton gloves.

Worst-Case
Scenarios

10/01/93

Think about it. Think about how many things have to go right for us to make a photograph.

The camera has to work, obviously, but the film has to be in good shape, too. Not sitting on some store's sunny shelf for three months where the humidity is hovering around 90 percent before we even load it.

The flash not only has to work (we at least can see whether it goes off), but it has to work in sync with the shutter. Then, if the film goes to a lab it has to be run through a processing machine that is a mass of rollers and gears and chemistry, any one of which can ruin the film in a heartbeat if something goes wrong.

Then, if we're shooting slides, the film has to go through an automated mounting machine that doesn't look at the images we've made, but at the spaces between each frame to decide where to slice the film with an irrevocable *thwack* from a sharp blade.

It's a miracle we get any pictures at all.

So is it any wonder, when photographers talk among themselves, the talk often turns to disasters? I don't know any photographers who haven't experienced at least one world class foul-up, either of their, or someone else's, making. And when the conversation does turn dark among my fellow shooters, at least there's the feeling that we're all in the same boat—human and very fallible.

So, the next time your pictures come back from the lab in shreds and tatters, think about these true horror stories and don't be so hard on yourself. You're in plenty of good company. With one exception, I've withheld or changed the names of the poor souls involved. They know who they are.

At a political convention "Ralph" had just come off the convention floor with a roll of film he was sure contained some winners for the next day's paper. Entering the darkroom, he loaded the roll into a developing

tank, poured in the developer, then left, only for a minute or so—a very bad move. In that minute, "Mikey," another photographer, entered the workroom and prepared to develop his film. In the darkroom, he opened the same developing tank and—ohmigosh!—there was Ralph's roll, now fogged beyond recognition. Mikey's mind raced. Then he acted. He took out the ruined film, threw it away, then replaced it with an unexposed roll from his bag. He left the darkroom and sat down to read the paper.

When Ralph returned, he greeted his colleague, then continued to develop what he thought was his roll and was amazed to see that the entire roll was blank.

"$#&$*!!," he observed, convinced that his camera had malfunctioned. Mikey was very solicitous, to be sure.

Moral: Never go to the bathroom when developing film.

"Fred" was in the right place at the right time. A magazine photographer on one of Jimmy Carter's foreign trips, he was watching the President dine at a candlelit official function when he saw a waiter come up behind Carter wielding a flyswatter to bat away the pesky insect lest it land in the chief executive's soup. A great picture, Fred thought and he quickly made the shot. Only the camera he raised to his eye was not the one loaded with high-speed Tungsten Ektachrome which would have been perfect, but the one loaded with daylight-balanced Kodachrome 64.

"I've got good news and bad news," Fred told his picture desk.

Moral: Try to have a picture desk—and lab—with a sense of humor. (Incidentally, the lab was able to push the bejabbers out of the Kodachrome and produce a very grainy, but passable, image.)

After a long cross-country plane ride, "John" raced to his darkroom to develop his film, so he could transmit his pictures in time for his paper's final deadline. His whole body ached with fatigue as he poured in the developer.

Only it wasn't developer. It was Hypo.

Moral: At times like these, have someone who is awake develop your film.

It is thirty years ago and I have this great idea for a five-column picture we will use to kick off the college basketball season in the school paper. Instead of the usual head shots of the starting five, I'm going to have the guys stand in a line in the gym and have each dribble a ball down the court for a great panorama picture. Just to be sure, I have the guys march back and forth a bunch of times, and shoot a whole roll of film.

We're on deadline, so the sports editor and I rush home to my darkroom to develop the film. Back then I was using a Day-Load tank and as I wind the film in, I am unaware that I have loaded it wrong and that every frame has rolled onto itself. Out of thirty-six exposures, I have maybe one half of one frame properly developed.

"Can you do something?" my sports editor implores. "I've already got the page laid out for the picture!"

"Sure," I lie. I print the surviving frame, trying my best to burn in

detail on what appears to be two and a half ghosts dribbling balls next to two and half humans. When the print dries, I try to draw faces onto the ghostly players with spotting colors. Now they look like ghosts with Happy Faces.

We run the picture anyway. It looks awful.

Moral: Never trust a photographer who can't draw.

There, now don't you feel better?

Requiem for Daily News

08/12/94

She was always a compliant, if not always comprehending, partner in our photography. Whether it was a new lens to test, a new film to try, or another shot for the Christmas card, Daily News—whom we really believed to be the world's friendliest golden retriever—always was there to pose for Judy and me, regardless of how silly the assignment seemed.

Fittingly, she came into our lives as the result of a portrait shoot. Judy was photographing the children of a friend and during the session was amazed at how sweet and smart was the family's golden, Chelsea. "Let us know when you breed her," Judy said. Thus, a little over ten years ago, an eight-week-old puppy whom we named after my old newspaper, bounded into our home and into our hearts.

The first indication came in early June when one morning Daily, who usually inhaled her food, wouldn't eat. She seemed disoriented and weak and, for virtually the first time since she was young, she had an accident in the house.

She was a beautiful girl—in fact we often said she got a double helping of looks instead of brains. Her father was a big-name champion, but Daily seemed to have a champion disdain for discipline, at least for the way Judy and I practiced it. We took her to two obedience schools and she was great with the trainers both times. When she was with us, however, all bets were off—she knew two patsies when she saw them.

But who could be angry at a dog who seemed to greet each day as a gift, who was glad to see anyone, who suffered the poundings and pokings of innumerable neighborhood kids with benign indifference, and whose limpid brown eyes beamed trust and comfort?

"What a wonderful dog!" my late father would say, so often that it became a laugh line in the family. But Pop was right.

Daily bounced back quickly from that first episode, and Judy and I were happy to pass it off as a bladder infection. But her doctor, noting the enlarge-

Daily News, the world's friendliest golden retriever, after a swim in the icy cold waters of coastal Maine. It broke our hearts when she died, but the pictures we took keep her memory alive. © Frank Van Riper

ment of her heart in the X-rays and secretly fearing something worse, referred us to a specialist.

Daily's first brush with photographic fame came in 1989 when my photo of her exulting in the back seat of the car as Judy sped down a wooded road in Maine appeared in a Washington-area calendar. The shot was part of an assignment I'd been given at the Maine Photographic Workshops to document a day in the life of my dog. (I've always felt that Neil Selkirk, who taught the course and who had a golden himself, figured I had worked hard enough during the previous week to be given an assignment he knew I would love.)

But if Daily lacked the discipline to be a real model or actor ("See, other dogs work for a living," we used to tell her, pointing to the TV screen), she was a natural for our Christmas cards. One year, as Judy and I faced our perennial Christmas rush, we hit on the idea of pasting color Polaroids of her on each card.

With the understanding that she would not be displaced from a favorite spot on the living room rug, Daily lay stoic and brown-eyed as I positioned a small neon Christmas tree ornament near her face, then shot a series of ultrawide-angle Polaroids, which I later cut and pasted into a collage. Then, with desperation born of the approaching holiday, I made thirty separate Polaroids of the collage, which I pasted onto thirty pieces of cream-colored card stock. Everyone loved them.

I'm glad now that I kept one for us.

She lay quietly on the examining table as the cardiologist readied her for the sonogram. I was fascinated to see how good the sound-generated video was as the vet moved the sensor over her rib cage and near her heart. The tumor already was the size of a golf ball and growing fast.

What do you do when a companion you love has been given a death sentence? "Quality of life is the most important thing," the vet said.

"I'd like to give her one last summer in Maine," I said. "It's her favorite place of all."

Daily News never saw that final Maine summer. After a week of seemingly defiant good health, her body finally rebelled. The change over twenty-four hours was heartbreaking, and it was obvious what we had to do. We called the cardiologist who, after listening to her symptoms, concurred. "I'm sorry you couldn't have more time with her," he said quietly.

I had to carry her into the station wagon—where so often before she had bounded soaking wet after romping in Rock Creek, the C&O canal, or innumerable places in Maine. They needed a gurney to take her into the hospital. Judy and I held her until the end.

Daily was arguably the most photographed member of our family, and those photographs provide a measure of comfort, if not closure. No event seemed to occur for us over the past ten years without Daily taking part. Not even going to a Halloween party dressed as Maurice Sendak monsters could occur without our first snapping pictures of Daily wearing our yellow felt horns over her silky golden ears.

She was there every Easter with my cousins for our annual Italian feast. She was there every summer in Maine, flying off the rocks into the icy cold water she loved. This year Judy and I carried her ashes with us and, on a late afternoon of golden light in which we had photographed her so often before, we buried her ashes by the home and the coast that she loved.

But not before we threw a stick into the water one last time.

Xmas Memories/
Presidents,
Hostages

12/23/94

I got to thinking about all the times around Christmas when I wished I'd had a camera, but didn't. Having spent the better part of my earlier years as a newspaper reporter, the Christmases I spent on the road were spent in the company of a tape recorder, notebook, and Olivetti portable (later a laptop), rather than a Nikon or Hasselblad, and I'm sorry now that I didn't tote along even a little snapshooter to help me now wander the halls of memory. For memory fails; images do not.

It would have been nice, I think, to make an available-light shot of the modestly decorated Plains Baptist Church when Jimmy Carter attended Christmas services in that tiny hamlet that drew the world's curious attention during the four years of his presidency. Wes Pippert, then with United Press International, and I were among the handful of "pool" reporters who accompanied Carter into the white clapboard church, its walls festooned with wreaths and garlands and Christmas candles.

There was nothing really to report—Carter did not speak from the pulpit; he was there to worship along with his friends and neighbors—so Wes and I contented ourselves with following the service. It ended with "Joy to the World," and doubtless the good folks of Plains found it a little strange to see two guys with press cards and hymnals bellowing the words to that stirring song with a fervor they probably didn't expect from a couple of reporters.

My first Christmas away from home was in 1968, shortly after Richard Nixon was elected to his first term. I was the junior guy in the *New York Daily News* Washington bureau, so naturally I was tapped to baby-sit the President-elect over the holidays as he basked in the goodwill of everyone in those pre-Watergate days, setting up a transition headquarters in the Pierre Hotel in New York City. What I remember most was how bitterly cold it was in those Manhattan canyons—and how little I was able to enjoy the city of my birth, dressed in its Christmas finery. At twenty-two, I was

paranoid about missing anything, so I stuck close to the cluttered press-room every day. I would love to have had snapshots of my colleagues—all of them much older (and, I thought, wiser) than I—to better relive the first of several presidential transitions I've covered.

But I don't, so my memories are a jumbled mix of impressions: cold doughnuts and even colder coffee in the pressroom; having a drink with Ron Ziegler, Nixon's then-boyish press secretary and thinking I was getting in tight with movers and shakers, only to find later that night I had been scooped by the *New York Times* on the latest cabinet appointment; never doing any Christmas shopping at all.

It was a much more relaxed and happier time six years later, in Vail, Colorado, when a horde of us newsies, accustomed by then to the warm climes of Nixon's Key Biscayne and San Clemente, found ourselves thrust into subzero cold with a ski-loving Jerry Ford. This guy knew how to enjoy himself and was out on the mountain every day. Having never been on skis in my life, I decided I'd let my colleagues fill me in with news from the slopes. It was a wise move.

On the trip home after Christmas, the press corps included two people on crutches with broken or badly sprained legs; and one with a broken arm. I did manage a little ice-skating, though, and if I'd had a camera with me, I'd now have a shot of Ron Nessen, the ex-NBC correspondent who became Ford's press secretary, trying manfully not to land on his keister, as I did repeatedly.

But if Ford's Christmas was happy that year, it was bleak six years later for his successor, Jimmy Carter, who had tried his best to have the Americans held hostage in Iran home for Christmas in 1980. Already defeated at the polls the previous month, Carter had hoped for one final triumph, but it was not to be. Still, that period and its aftermath hold for me one of my warmest holiday memories as a journalist.

On Jan. 21, 1981, I accompanied Carter, one day out of office, as he flew to a U.S. military base in Wiesbaden, West Germany, to greet the American hostages returning from Iran. It was freezing and dark when the motorcade arrived at the military hospital, where the ex-hostages were being examined. Carter met briefly with them, returned to the air base for a press conference, then flew immediately back home—a long, exhausting trip for all of us, but one none of us would have missed.

The image I wish I had made? Of two young Marine guards, clad only in striped pajamas, as they called down to us in the hospital courtyard from several stories above, peppering us with questions about all they had missed, including how the Dallas Cowboys were doing.

Christmas was late that year. But it had come after all. It would have been nice to have a picture.

Dancing Bears

I must admit to the suspicion that some of photography's earliest examples, many of which are today viewed as works of art, may simply be dancing bears.

You recall the refrain about the dancing bear—it's not that the bear dances well, but that it dances at all. So, too, I feel that some early photographs elevated to the high altar of fine art are so honored simply because someone had the gumption—and, often, the upper body strength—to lug a camera someplace and trip a shutter in order to see what, if anything, emerged on a glass negative way back when.

Some of the earliest known examples of photography—rooftop scenes of Paris or London—are a good test of the dancing bear analogy. Pictures like these illustrated the fledgling medium's ability to document, but not necessarily to create, anything beautiful or lasting. It's not that the pictures were good, but that they were made at all.

I would even include here many of the Civil War battlefield scenes made by Mathew Brady and his associates. Because of the limitations of the medium—the sheer bulk of the equipment, the need for minutes-long exposures—Brady and company could never think of capturing the mad immediacy and violent motion of war. Their images, of necessity, had to be made after the smoke had cleared, when all who remained were the dead. These pictures were, literally, postmortems and, gripping though they were, they had significant competition from the work of battlefield artists who had also viewed the action but who could translate what they had seen into riveting drawings at their leisure. These action-filled drawings were later transformed into engravings for the periodicals of the time.

By contrast, the static battlefield photographs, strong as historical documents, fall short as works of art. It is Brady and company's Civil War-era portraits—often haunting depictions of presidents, generals, and ordi-

nary people—that rightfully hold their own with the painted portraits of the era.

The landscape and the still life are where early photography flourished and offered a first glimpse at what this emerging art form could become. The soaring vistas of the American West, for example, gave early photographers the chance to make maximum use of the incredible detail that could be captured even on the primitive glass plates of the time. Working slowly, seeking the right juxtaposition of background and foreground elements, and waiting for the right light, these early practitioners worked much as the great landscape photographers do today. Look at the beautiful, century-old work of Edward S. Curtis, and you will see what I mean. Look, too, at Alfred Stieglitz's early still lifes, and see how his eye for composition foreshadowed the work of Edward Steichen and Edward Weston.

In subsequent decades, as photography technology improved and as plate and film emulsions became more light-sensitive (allowing for much shorter exposures), photographers could work with the camera handheld, or much more quickly with the camera on a tripod. Photography no longer was a scientific magic act or parlor trick. It also was becoming much more accessible to the average person. The snapshot was born.

One such snapshooter was Edward Steichen, fascinated with the freedom afforded by the new technology. Yet I must say that I find a number of Steichen's early pictures—of people in their Sunday finery, attending races and other social events—pedestrian and poorly composed. As historical records they are fascinating, but as photographs they are banal. The pictures are relevant only insofar as they illustrate Steichen's subsequent mastery of the medium that made him justifiably famous.

So where does that leave us today? If photography is the easiest to master of all the arts (up to a point, of course), it also may be the most demanding. Everyone assumes you can produce a decent print or slide nowadays.

Having something to say is another thing.

Colonel Teague's Wartime Film Lab

06/06/97

In some ways, the World War II career of retired Army Lt. Colonel Walter Teague rivals the fictional adventures of *M*A*S*H*'s Hawkeye Pierce. On *M*A*S*H*, Hawkeye and friends jury-rigged a still to produce the hooch that oiled their off-duty activities. In the Philippines, where Teague served in the Army's 44th General Hospital in Burauen, he figured out a way to develop "surplus" Army photographic film in 100-degree heat that was every bit as ingenious as making a moonshine machine.

Teague, of Brinklow, Maryland, was one of the 44th's administrative officers, a gangly young man with an easy smile and an amateur's love of photography. With the most rudimentary equipment—a small 35mm Kodak that featured only a sportsfinder to view through, and 35mm film he scrounged from the aerial reconaissance unit—he made a remarkable visual record of wartime life. He shot his colleagues, his patients, water buffalo—anything that struck his eye—all with his camera set at "f/8, $\frac{1}{100}$ of a second, and infinity."

A traveling exhibition of Teague's photographs has been making the rounds of military hospitals and other sites over the past two years, a kind of visual movable feast that Walt and his wife, Eda (actually, Capt. Eda Teague, one of the many nurses who served in the 44th), put together as a photographic tribute to their surviving colleagues to mark the fiftieth anniversary D-Day and V-J Day celebrations.

Now, thanks to the Teagues' efforts—as well as a big boost from Eastman Kodak, which is making show prints from Teague's negatives—a major exhibition of his photographs will be part of the Philippines' national celebration next year, marking that country's century-long relationship with the United States.

In wartime Burauen, Teague got his film from the Army Air Corps photo lab, which used 250-foot rolls of high-definition 35mm Kodak Supreme Pan for the reconnaissance cameras on fighters and B-25

A Philippines army hospital—not unlike that seen in *M*A*S*H*—was recorded beautifully by Walter Teague, who used purloined film and an ingenious developing method to create his images. (© Walter Teague)

bombers. "When the fighters and bombers returned [the lab] would develop [only] the film that was exposed," Walter recalled. "We could [then] scrounge the less-than-full cans, because they always wanted to send the planes out with a full roll of film." (That still meant Walter had to laboriously load this bulk film into individual 35mm cassettes.)

But processing his personal film was a problem, especially in the 100-degree heat. How to bring the temperature of the developer down to a reasonable level that wouldn't cook the film? Remember, this was before the era of ice machines.

"My method of cooling the developer was to set the [quart] bottle in a pan of water and wrap a wet hand towel around the bottle for evaporation during the night," he recalled. He stowed the bottle in his footlocker, out of the sun and heat.

In most cases, this slow overnight process brought the developer down to 68 or 70 degrees—plenty cool for perfect development. That was fine for developing film, but since Walter had no darkroom of his own, he rarely could have prints made. So out of simple necessity, once the film was dry, he wound it tightly and stored it in metal 35mm film cans. It hardly was textbook archival storage, but the negatives stayed that way for half a century.

Three years ago, with end-of-war celebrations looming, he wondered if there might be anything on those old negatives. Gingerly, he extracted one roll from a canister, then another, then another. To his delighted surprise, the images appeared to be fine. Now all he needed was a darkroom in which to make prints.

Enter Gene Orndorff, chairman of the art department and instructor of photography at Sherwood High School in nearby Sandy Spring. With the only proviso being that the Teagues supply their own chemistry and paper, Orndorff allowed the two vets access to Sherwood's newly renovated darkroom facilities at the end of the school year. For three weeks, they cranked out prints, bringing back to life the visual journal that had been created a half century earlier.

Oi Veerasarn Remembered

10/01/99

Pinhole photography is based, above all, on simplicity. It is a simplicity that strips away the barrier of technology that can stand between the photographer and his or her vision.

Done right, it is eloquent photography.

Perhaps because this kind of shooting lends itself to contemplative scenes, often shot with available light during long exposures on a tripod, I find the resultant images have a serene, spiritual quality that I love to linger over.

My friend Oi Veerasarn was as masterful a pinhole photographer as I ever have seen. It is no accident that he also was one of the most gentle people I ever knew.

He could astound you with what he accomplished with the barest equipment. (Readers may recall the gorgeously simple nude photography featured in his 1997 book *Eye to I.*)

"Oi prided himself on using a minimum of fancy equipment," his life partner Lisa McQuail wrote. "For his masterful nudes, Oi exclusively used a 50mm lens for his Hassy [Hasselblad medium-format camera] and a single ceiling-mounted light. Oi made his backdrops himself, dyeing and re-dyeing the simple cotton cloths until they were works of art in themselves." Again, simplicity; again, eloquence.

Veerasarn could lift my spirits on the lousiest day with his wide smile and his boundless energy. He could make me laugh at even the lamest of his jokes because he'd be laughing so hard himself before the punch line. He knew the best Thai restaurants in town, too. Oi Veerasarn knew a lot of things—except how to live long.

Veerasarn died in June of a massive heart attack at age forty-five. "To Buddhists, Oi's short life is a sign that he was too good for this world," McQuail wrote in a touching biographical profile. The fact that he died suddenly, without suffering, also made his passing special.

A pinhole camera image of a contemplative garden by the late Oi Veerasarn calls to mind Oi's own gentle nature. He was a great photographer and a dear friend who died much, much too young. © Oi Veerasarn

"His faith in Buddhism promises him a swift rebirth as a superior being," McQuail said. It may not be rebirth, but long after his death Veerasarn's voice was still on his answering machine. I found that comforting.

An exhibition of Veerasarn's pinhole work is at the Black & White Custom Lab in Arlington. The Washington Center for Photography will

host a month-long show of Veerasarn's nude photography, and later this month, Gallaudet University will host a daylong workshop called "Oi Veerasarn Pinhole Photography Day."

It was fitting that when Veerasarn began to shoot with a pinhole camera, he did so from the bottom up—with, as McQuail recalled, "five dollars worth of cardboard, plastic, gaffer's tape, and film."

"In the past year," McQuail said, "he also adapted several old cameras, took them completely apart and removed the lenses. And rebuilt them into working pinhole cameras."

To me, the most interesting technical aspect of pinhole photography is the fact that pinhole images tend to be surprisingly sharp, even with the absence of optics. Because what little light reaches the film enters through a tiny pinhole (that is, a hole literally made with a pin or similar pointed object), it is comparatively distortion-free, unbent by an expensive lens to a precise point of focus. Thus, while the overall picture is never "tack sharp" in the classic sense, the overall image appears comparatively sharp foreground to background.

Artistically, this creates a pleasant tension between soft and sharp that produces an image that is at once technically sophisticated and technically naive.

A fair description of Veerasarn, I think.

In its current newsletter, the Washington Center for Photography devotes the entire issue to Veerasarn and accompanies his photographs with reminiscences and tributes from friends and colleagues.

The most eloquent tribute comes from lab technician Dave Rockwell. "Of course, the world may hardly note [Veerasarn's] life or passing; but I believe against all evidence that the ripples sent out by the lives of thousands of amazing people like him do not simply fade into the bland ocean of our species' existence, but form over the centuries a harmonic wave that ever so gradually improves the whole."

"I mean this not in any mystic way," Rockwell says, "I simply mean that when a person radiates warmth from an open heart, the emanation is not wasted, but will be passed on from each of us to the next. Nothing is wasted."

The Day I Shot Aaron and DiMaggio

10/27/00

I grew up in New York, in the Bronx, literally blocks from Yankee Stadium. I'm lucky to have been a kid when the World Series meant that, in most cases, the New York Yankees were going to play (and beat) the Brooklyn Dodgers. That is, until 1955 when, after a phenomenal *five-year* run of Yankee championships (1949–53), the Brooklyn Bums beat the Bronx Bombers in seven games for the Dodgers' first-ever championship.

(For the trivia minded, the 1954 World Series was between the then–New York Giants and Cleveland Indians. The Giants swept. You could look it up. I did.)

So you can understand why I've spent so much time this month in front of the television.

And you can understand, too, why I never will forget the day I photographed baseball legends Hank Aaron and Joe DiMaggio—in uniform on a baseball diamond.

The job came about because of a wedding—one that was fairly typical of the ones Judy and I shoot in and around Washington. The bride worked on the hill, for then-Senator Daniel Patrick Moynihan of New York. Her fiance was (guess what?) a lawyer.

Only Bob wasn't your everyday kind of lawyer. He was a sports lawyer and he was a big baseball fan.

How much of a fan?

As a surprise, his wife topped their wedding cake with a baseball autographed by the Yankees. (To this day, Bob doesn't know how close he came to having his wedding surprise swiped.)

We had a great time photographing "Baseball Bob" and his wife. And a few years later, Bob hired us to photograph an Old-Timer's Day at Washington's RFK Stadium.

Happily, the job did not entail serious sports photography—i.e., we did not have to shoot the action, even the slowed-down action of the old-

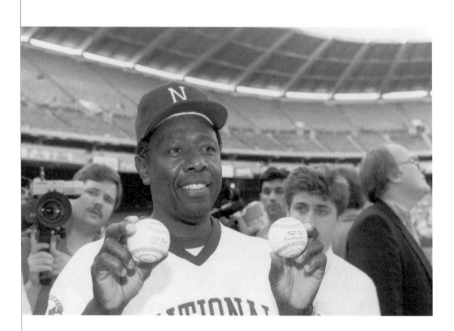

Hank Aaron could not have been more cooperative the day I photographed him and Yankee Clipper Joe DiMaggio at an old-timer's game in Washington, D.C.

timers. The sponsors for the event were Bike Athletic Products (who probably do not like to be called the jockstrap people) and Worth, the baseball bat makers whose products were trying to dent the virtual monopoly of the Louisville Slugger. All Judy and I had to do was photograph the players during the pre-game interviews, posing with the products. (And, *no*, wiseguy, that did not mean shooting ex-catcher Joe Garagiola or ex-pitcher Ralph Branca in their jocks; Bike made the uniforms as well.) I was to learn the hard way about covering sports a few years later, on the fifty-yard line during a football season opener at RFK between the Washington Redskins and the New York Giants. Luckily, I was there on my own, on an extra press pass tossed my way by a former colleague on the *New York Daily News*, who was there to actually shoot the game for the paper.

Oh, I looked the part: photo vest, two cameras, each with a long lens, tons of film, etc., etc. Only it was worth my life to get even a passable image, so bad was I at, not just capturing the right moment, but in anticipating it.

My friend Harry, however, prowled the sidelines like a cat and seemed to know exactly where to be—and how to avoid being run over by the mobile TV camera platform that also tracked the ground-level action. In that predigital time, Harry and I raced to the Associated Press bureau in downtown D.C., after the game to have the AP soup his film. He edited the negatives on the fly, notching keepers on the edge of the frame with a hole

punch, and then had the wire service transmit a handful of great shots in plenty of time for the final edition.

If the *Daily News* had had to rely on my output that evening, I'm sure I'd have been out of a job by morning.

But that was the last thing on my mind on a balmy spring evening some fifteen years ago, as the crowd started arriving at RFK for the old-timer's game.

Joe Garagiola, the journeyman catcher-turned-broadcaster, was in great form, delighted, I'm sure, to be back in uniform, even if only for an evening. Ex-Dodger Ralph Branca, who gave up the famous home run "shot heard 'round the world" to the Giants' Bobby Thomson in 1951 and thus gave the Giants the pennant, seemed to have put that bit of ancient history far behind him. He and ex-Cardinal Garagiola had a great time shooting the breeze by home plate—and the pictures reflected it.

But clearly the two stars of the evening were DiMaggio, the great Yankee hitter and centerfielder, and Aaron, baseball's all-time home run champ. DiMaggio, as always a somewhat aloof presence, did not mix it up with the pressies on the infield grass. His appearance was comparatively brief—tipping his hat to the public as he emerged from the dugout, waving to fans as he walked the area behind home plate, then signing a handful of autographs for the lucky few kids who happened to be near the AL dugout. Of course, he was long past his playing days, but he *was* in uniform (though I recall his "spikes" looking more like black leather oxfords). I did manage to make several good shots of the aging hero as he came out onto the field. I used a big 300mm f/2.8 Nikkor mounted on a monopod.

Aaron, however, was a whole 'nother story. He easily put up with the crowd of press people that clung to him, and gamely answered their questions and posed for their pictures. I'm sure the Worth people loved one picture I made showing Aaron from behind, leaning on a Worth bat (label showing), with the letters AARON emblazoned across his back.

Finally, all the announcements and promos had been made and it was time to play ball. I felt like a kid being told it was okay to play hooky. Judy and I stowed our gear near our front-row seats behind home plate. I ordered a beer and a hot dog and then let the baseball greats of years gone by relive their triumphs before my eager eyes under a forgiving spring sky.

Revisiting a Classic: the Legendary Leica M6

07/21/00

The first time I encountered a Leica was nearly forty years ago in a leaky rowboat in Central Park Lake.

My friend Marty, a very serious, very good photographer on our high school newspaper, had managed to scrape up enough money to buy a brand new Leica M2, and he proudly showed it off one sunny day as we went out shooting together in Manhattan, winding up at the Central Park boat basin. If I remember correctly, my camera back then was a Dejur "Dekon," a comparatively inexpensive SLR obviously trying to trade on the name "Nikon" and doing a pitiful job of it.

Even to a young teenager, the quality of this Leica camera was obvious. The silky way the lens worked, the comfortable, authoritative heft of the camera in my hand. But what stuck in my mind that day was the sound of the shutter—unlike any I ever had heard. It was a soft, enticing, gentle sound, so unlike the loud clatter of an SLR.

I didn't know it then, but I was hooked. It would take four decades for me to finally come around, but come around I did. The current incarnation of the legendary Leica rangefinder camera—my TTL M6—may be the finest camera I ever have used, including my Nikons, my Hasselblads—even my Zone VI 4 × 5 view camera.

But I'm getting ahead of myself. Let me tell you about the rowboat.

Marty and I would regularly shoot together—sometimes cutting classes to do it. Once, don't ask me how, Marty managed to get a tryout with one of the top fashion magazines (*Vogue*, if memory serves) and before I knew it, we were cutting school again, picking up a drop-dead gorgeous model at her midtown apartment and spending the better part of a morning photographing her around Times Square. (Actually, Marty did all the shooting. I tagged along to carry and load his cameras—as well as to ogle the model. Hey, I was fifteen, okay?)

The Central Park near-disaster happened suddenly, during one of

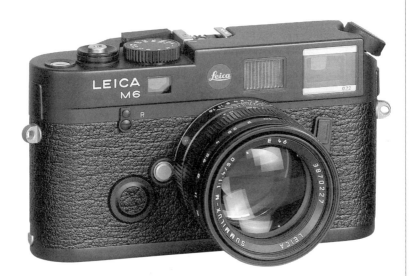

The Leica M6 may be the most rugged, beautiful—sexiest—camera I've ever owned. It is the standard by which all other 35mm cameras are measured.

those springtime-in-New York days that make people write songs. We had rented a rowboat, figuring there might be some pictures to be made from the water, and managed to dope out the oars and oarlocks sufficiently to make it to the middle of the lake.

That's when we noticed we were taking on water. A lot of water.

"My goodness," we observed (or words to that effect).

If Marty's Leica had been a new car it would still have had that new car smell, it was that fresh out of the box. Even I was more concerned about Marty's camera. We rowed like hell and, thankfully, made it to the shore with only our shoes and trouser bottoms the worse for wear.

Not surprisingly, our enthusiasm for boating had been, well, damp-ened, so we resumed our picture-taking on foot.

But the memory of that M2 stayed with me.

Segue ahead forty years. I had been using Nikons almost exclusively for my 35mm photography; Hassys for my medium format work, and every so often a medium-format Mamiya 6 rangefinder. Still I could not help but be aware of what only could be called the cult of Leica.

No other camera seemed to have such a diverse or devoted following. People collected them almost as sculpture. They held their value amaz-ingly well. My fellow journalists swore by Leicas (both rangefinder and SLR) for their unsurpassed optics, even if many of my colleagues were forced by their publications to switch to digital.

I had to get a new Leica to see if what enchanted me as a teenager could still dazzle me as an adult.

Hoo boy.

Leica sent me a loaner M6 shortly before my trip to Prague, and it didn't take long for me to figure I had to buy it. And, yet, in today's auto-focus, Program-mode, motor-driven world, this is not the camera I ever would recommend to someone just starting out. Even if that person were able to easily afford a $2,000 camera body and lenses that run roughly the same amount apiece, the rangefinder Leica M6 is a camera one steps up to as a photographer, not steps into as an amateur.

And yet . . . and yet . . . this is a camera that is stripped of all pretense and electronic hoopla. It is an all-manual camera. Rangefinder focusing, once the most common form of focusing in the days before single-lens-reflex cameras, can in many ways be more accurate than manual SLR focusing, especially in low light. The camera is unobtrusive (no loud motor drive or mirror housing). It is built like a tank, albeit a tank made by Mercedes-Benz, but a tank nonetheless. So, in theory, anyway, this could be the perfect camera on which to learn the basics of exposure and composition.

In practice, though, I regard the M6 as a very specialized tool, and therefore, one that the average amateur might find too limiting. Its flash sync speed is an anemic ⅟₅₀ of a second, meaning that one could never shoot fill-in flash, or "synchro-sun" pictures outdoors. (In fact, you could not shoot any flash pictures unless you had at least a separate, hot shoe-mounted portable unit; the M6 does not have a pop-up flash.) Because it is a rangefinder camera, the M6 does not take long telephoto lenses above 135mm, nor conventional, SLR-type lenses.

And unless you're really into retro, manual film advance and manual exposure setting easily may turn into hassles, if you're used to your camera doing all the work for you. And I haven't even mentioned the fact that, in order to load the camera, you have to totally remove the baseplate and load film into an open camera bottom. (When I asked a Leica exec recently if there ever was a chance Leica would redesign the M6 to have a hinged back like that on virtually every other camera, he replied that to do so would lessen the rigidity of the M6 body, and that would simply be unacceptable.)

So what does make this camera so marvelous?

Very simply, the Leica M6 is the most beautifully engineered, most ruggedly built, quietest, sharpest—oh hell, sexiest—camera I've ever held in my hands. As a professional, I will use my M6 for specialized purposes and apologize to no one for spending thousands to have precisely the right tool for the right job. I will use this camera for available light shooting with my medium wide, razor sharp, and very fast f/2, 35mm Summicron—just as Cartier-Bresson did, with such hauntingly beautiful results.

This is a camera that insinuates itself into your life, so elegant and unobtrusive is it. Already I carry it with me almost every day.

I'm sorry now it took me forty years to realize this.

Index

V

Vander Zee, James, 276
Vanishing Breed: Photographs of the Cowboy and the West (Allard), 232
Veerasarn, Oi, 290–292, *291, 293*
Venice, 123–125, *124*
Vietnam, 272, *273*, 274
view cameras, 35, 132–133, *182*

W

Waiting for Godot, 255
Walker Evans First and Last, 230
Walker Evans: The Lost Work, 230
Wallace, Mike, 163
Warner, Stephen H., 272, *273*, 274
war photography
 Brady's Civil War, 212–213, 285–286
 Larsen's Kosovo, 259–261, *260*
 Tartt's collection of, 218–220, *219*
 Teague's, 287–289, *288*
 Warner's Vietnam, 272–274, *273*
Warren, Earl, 211
Washington Center for Photography, 291–292
Washington, D.C., 77–78
Washington Post, x–xi, 9
Washingtonpost.com, xi
Water's Edge (Callahan), 232
water-soaked photos, saving, 158–159
Weaver, Hal, 94
Weber, Bruce, 249
WebMaster Magazine, 91
wedding photography, 73–75, *74*, 270
 copyright and, 66
 in day in life of photographer, 3

Delta 3200 film and, 194–195
 fees and, 58, 66
 laws of photography and, 156, 157
Wegman, William, 245–246
Weston, Brett, 30, 32, 179
Weston, Edward, 286
White, Clarence, 108
Whitney Museum (New York), 227
wildlife photography, 248
Winogrand, Garry, 204
"Winter Sunrise Sierra Nevada" (Adams), 216
Wirth, Ray, 39–40
Wizard of Oz, The, 169, 170
Wolff, Tom, 101–103
Workers: An Archaeology of the Industrial Age (Salgado), 231
work-for-hire, 65, 67
workshop, "Assignment Cuba," 42–44
Worswick, Clark, 230
Wright, Frank Lloyd, 18
writing, compared to photography, 68–70
Wroe, Duggins "Doogie," 12, 14

Y

Year of Living Dangerously, The, 239–240
Yellow Dog, The, 239
Yellow Line (Fleres), 129
Yocum, David, 130
Yosemite and the Range of Light (Adams), 232

Z

Zeiss Optical, 197

Books from Allworth Press

How to Shoot Stock Photos that Sell, Third Edition
by Michal Heron (paperback, 8 × 10, 224 pages, $19.95)

**Pricing Photography: The Complete Guide to Assignment and Stock
Prices, Third Edition** *by Michal Heron and David MacTavish*
(paperback, 11 × 8½, 160 pages, $24.95)

Business and Legal Forms for Photographers, Third Edition
by Tad Crawford (paperback, with CD-ROM, 8½ × 11, 180 pages, $29.95)

ASMP Professional Business Practices in Photography, Sixth Edition
by the American Society of Media Photographers
(paperback, 6¾ × 10, 416 pages, $29.95)

The Photographer's Internet Handbook, Revised Edition
by Joe Farace (paperback, 6 × 9, 232 pages, $18.95)

Photography: Focus on Profit
by Tom Zimberoff (paperback, 6¾ × 9 7/8, 416 pages, $35.00)

**Re-Engineering the Photo Studio: Bringing Your Studio into
the Digital Age** *by Joe Farace* (paperback, 6 × 9, 224 pages, $18.95)

The Photographer's Assistant, Revised Edition
by John Kieffer (paperback, 6¾ × 9⅞, 256 pages, $19.95)

Mastering the Basics of Photography
by Susan McCartney (paperback, 6¾ × 10, 192 pages, $19.95)

Travel Photography, Revised Edition
by Susan McCartney (paperback, 6¾ × 10, 360 pages, $22.95)

The Photojournalist's Guide to Making Money
by Michael Sedge (paperback, 6 × 9, 256 pages, $18.95)

Mastering Black-and-White Photography: From Camera to Darkroom
by Bernhard J Suess (paperback, 6¾ × 10, 240 pages, $18.95)

**Historic Photographic Processes: A Guide to Creating Handmade
Photographic Images** *by Richard Farber*
(paperback, 8½ × 11, 256 pages, $29.95)

Photography Your Way: A Career Guide to Satisfaction and Success
by Chuck DeLaney (paperback, 6 × 9, 304 pages, $18.95)

Please write to request our free catalog. To order by credit card, call 1-800-491-2808 or send a check or money order to Allworth Press, 10 East 23rd Street, Suite 510, New York, NY 10010. Include $5 for shipping and handling for the first book ordered and $1 for each additional book. Ten dollars plus $1 for each additional book if ordering from Canada. New York State residents must add sales tax.

To see our complete catalog on the World Wide Web, or to order online, you can find us at *www.allworth.com.*